STEALING THE SHOW

STEALING THE SHOW

A History of Art and Crime in Six Thefts

JOHN BARELLI

Former Chief Security Officer,
The Metropolitan Museum of Art

with Zachary Schisgal

Guilford, Connecticut

An imprint of The Rowman & Littlefield Publishing Group, Inc.
4501 Forbes Blvd., Ste. 200
Lanham, MD 20706
www.rowman.com

Distributed by NATIONAL BOOK NETWORK

British Library Cataloguing in Publication Information available

Library of Congress Cataloging-in-Publication Data available

ISBN 978-1-4930-3823-7 (hardback)
ISBN 978-1-4930-3824-4 (e-book)

♾™ The paper used in this publication meets the minimum requirements of American National Standard for Information Sciences—Permanence of Paper for Printed Library Materials, ANSI/NISO Z39.48-1992.

For my parents, John and Josephine Barelli, my loving wife, Anna, whose humor and devotion to family enhanced my career at the Met, my sons, Peter and Andrew. Without their encouragement and support, this book would not have become a reality.

Contents

INTRODUCTION

I PUT MY TEA DOWN AND LOOKED ACROSS THE TABLE AT ADAM Page. "What a professional must learn," Adam said, "is that [crime] of opportunity. Know what you are going after. Alarms pose no problem if you know where the object is and how long it will take to get."

Adam was well educated with some background in the study of art at the university level. We sat over tea and biscuits in the visiting area of Blundeston prison in Lowestoft, England. "I was knowledgeable in the area of art and saw where I could make a profitable living at it. On average I would say over the last twenty years, I have averaged approximately £50,000 a year."

I found Adam through a contact at London's Scotland Yard. I was in England to work on my doctoral thesis—an exploration of the market for stolen art and the professional art thief—and Adam was one of the professional thieves willing to talk to me. Unlike the United States at the time, England (as well as other European countries including France and Italy) had detailed databases for art and antiques theft at museums, churches, private homes, and public spaces. These directories were used to catch thieves, but more importantly, from my perspective, to aid in the recovery of stolen artwork. These nations had centuries of wealth accumulated in country manors and town churches. Much of it was in the form of silver and gold that could be melted down, but there were also countless paintings and rugs, as well as furniture and sculpture. These could be sold on markets both illegal and legal, and as I learned would move quickly between countries and jurisdictions.

I had already studied criminal justice when I received my master's degree at New York City's John Jay College of Criminal Justice. I had been a police officer in the city of Richmond, Virginia, and the security director for the Botanical Gardens in the Bronx. It was my current job, however, which brought me to that visiting room to try to identify and understand the working thief. At the time, I was the assistant security manager at the Metropolitan Museum of Art. In my nearly forty-year career there, I would go on to become the chief security officer, responsible for every aspect of safeguarding the museum's staggering collection—in my opinion the best in the world.

My time in England, learning from Scotland Yard and exploring everything from the statistics of theft to the personal motivations to the prosecutions, yielded both good news and bad news for my job. On the good side, the professional thief largely stays away from museums. While most of us are familiar with the famous Gardner heist in Boston on March 18, 1990, or thrilled to movies like *The Thomas Crown Affair*, serious art theft is more likely to occur in places like private homes or churches where the defenses are lower and the risk/reward ratio is better. But on the downside, professional crime is not the *only* type of crime that occurs. I already knew what it felt like to look at an empty pedestal with bits of broken wood and plaster and to wonder, in today's parlance, WTF.

The Metropolitan Museum of Art covers a roughly twelve-acre footprint, 2.2 million square feet, in twenty-one interconnected buildings, housing seventeen curatorial and five conservation departments, on the eastern border of New York's Central Park. Imagine taking the Empire State Building, turning it on its side, and then packing it with five thousand years of some of the world's richest treasures. Unlike London's National Portrait Gallery (mostly paintings) and Madrid's Museo Reina Sofia (modern art), the Met has everything. Its seventeen curatorial departments span

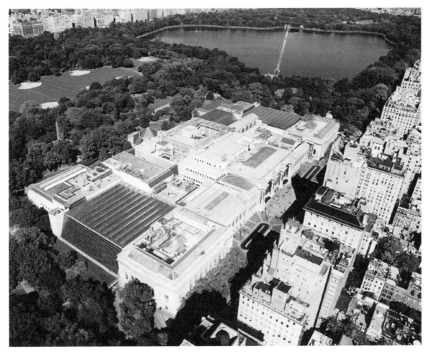

The Metropolitan Museum of Art in Central Park stretches horizontally over twelve acres, covering 2.2 million square feet in twenty-one interconnected buildings. THE METROPOLITAN MUSEUM OF ART

art created at the dawn of civilization in Sumeria and Mesopotamia to works of abstract expressionism, video, and multimedia. In between, there are mummies, crucifixes, and works by Goya, Matisse, Warhol, Duccio, Picasso, Michelangelo, and da Vinci. There are massive pieces of sculpture and chairs and rings and coins, vases and paintings and tapestries of all kinds. The Met's expansive collection and my responsibilities extended to the Cloisters, housing the Medieval Collection in a stone fortress opened in 1938 in upper Manhattan's Fort Tryon Park, and beginning in 2016 the newly minted Breuer Museum for Contemporary Art on 75th Street and Madison Avenue. As I write this, the Met has

announced plans to leave the Breuer Museum in a few years with the Frick museum as the next likely tenant.

The personnel lifeblood of the Met, and any museum, is its curators. This incredible and passionate team of experts is responsible for acquiring, preserving, evaluating, and ultimately displaying the great works in a museum's possession (as well as arranging for visiting exhibits and touring pieces of our own collection). Curators have to deal with a different form of art theft—forgery—which has its own intertwined place in the history of art and crime.

Curators want the most people to see the most objects. Seven million visitors enjoyed the Met in 2016 and that number is only growing. It's at this intersection of the museum and the public where my department plays its largest—but not its only—role. Of course, we've all seen the guards who walk museum galleries, and this is one basic layer of defense. When I started at the Met, there wasn't much more than that. During my tenure, there was an explosion in both the number of visitors and the sophistication and efficiency of our security.

One of the most difficult challenges a security professional faces in a museum is securing priceless art objects that are displayed throughout the galleries. The curators and designers want the art displayed to give the visitor a visual experience while minimizing obstructions such as barriers and vitrines (display cases). They want to have the visitor get as close to the art as possible, but still heed the "Do Not Touch" signs. This philosophy comes in direct opposition to security's mission of protecting art objects to reduce the opportunity for theft and damage—thus, the challenge.

⬤‿⬤

As a native New Yorker, my personal history with the Met began in 1963. In February of that year, my mother and I stood in the bitter cold on a long line that snaked out the Met's front entrance and down Fifth Avenue. We waited to see one of the world's most renowned

art treasures—Leonardo da Vinci's *Mona Lisa*. On any given day for the duration of the exhibit, thousands of people glimpsed the masterpiece as it hung in the Met's Medieval Sculpture Hall.

First Lady Jackie Kennedy had requested the loan by the French government, and it was the first time that the painting had left the Louvre—legally. In 1911, a former employee at the Louvre—Vincenzo Peruggia—stole the precious painting of the woman with the world's most famous (and enigmatic) smile and spirited it to Italy.

Some French officials were against allowing Leonardo's portrait to travel abroad, concerned that it might be damaged in some way—or worse. It was heavily protected during both its sea voyage and its time in the States. At the Met, it was protected by bulletproof glass, flanked by guards, and under the watch of detectives who lingered at the back of the crowd.

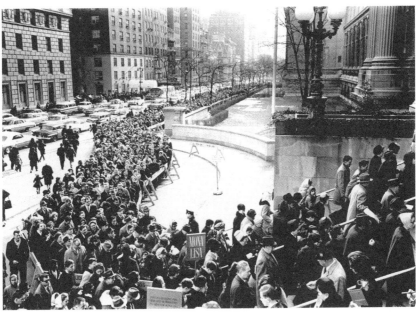

Mona Lisa exhibition lines outside the Met, 1963, the line I stood in on a cold February day with my mother. THE METROPOLITAN MUSEUM OF ART

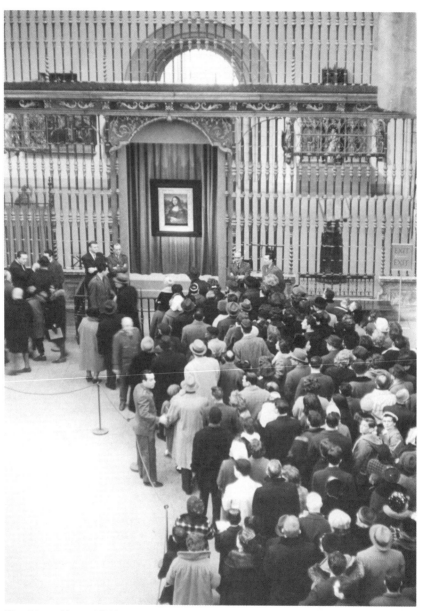

The *Mona Lisa* exhibition inside the Medieval Sculpture Hall. Note the security guard to the left center of the line; that is Charles Kelly, the custodial worker who stole Celtic coins and early Christian jewelry. THE METROPOLITAN MUSEUM OF ART

On that first visit, I took for granted the question of security. But now I know that somewhere in the building, Captain Walter Cadette, a retired fire captain who was then the Met's security director, was carrying concerns I would one day inherit. His professional credentials also serve as a reminder that fire poses as much of a threat to the integrity of a museum's collection as any malevolent act. In fact, up until 1974, the Met's Security Department was structured like the FDNY and the head of security was titled captain and his assistants were lieutenants. After 1974, the NYPD became the model with the security manager as boss and assistant security managers supporting. Before my tenure, four retired fire captains and then two retired NYPD officers ran the department. During my tenure, I transformed the Security Department management team from a law enforcement–based department to a team of security professionals who had expertise in all aspects of the security profession including recruiting and training, security technology, investigations of all types, fire protection (prevention, detection, and suppression), and numerous security applications.

After I graduated from college, I backpacked through Europe and visited some incredible museums. I visited the Kunsthistorisches Museum in Vienna. I traveled to the city of Vinci and visited Leonardo da Vinci's home and the fount where he was baptized. For a boy from the Bronx, it was a transformative experience. The highlight of my time abroad was the two weeks I spent in Florence—a jewel of Renaissance Italy's life and art that is a must-see destination for travelers from across the world.

In the Loggia dei Lanzi, I saw Benvenuto Cellini's *Perseus with the Head of Medusa* and was awestruck by the breathtakingly huge bronze sculpture. While it stands eighteen feet high, Renaissance art historians like Frederick Hart point to the fine details of the classic figures to illustrate the artist's training as a goldsmith.

Because I had read Cellini's autobiography, I wanted to see the Basilica della Santissima Annunziata up near the Academia. When I arrived, the church was almost completely empty. In my workable Italian, I asked the sacristan, "*Vorrei vedere la tomba di Benvenuto Cellini?*"

In reply, he presented me with a ring of skeleton keys and stood with me as I pushed open an ancient door. There in the floor of the chapel of the Cloister of the Dead was Cellini's tombstone.

"Thank you, thank you," I said. "When you're done," he replied, "lock the door and put the key back."

In the quiet chapel, I paid my respects to the great artist. I couldn't help but notice the beautiful bronze wreaths that decorated the walls. The realization that I—that someone—could easily take these wreaths had a lasting impact. I now believe that the line between art admirer and art thief is a thin one. Like swiping a pair of earrings unattended on a store counter, art theft is akin to vertigo: Is it the fear of falling or the fear of jumping? What happens when that momentary thrill becomes an addiction or a source of "reliable" income? Don't we all love having beautiful things? I trace my interest in preventing art crime back to that experience.

Adam Page graduated from the finest English preparatory schools and universities. He went to work for the English government. But he was forced to resign because of crimes not related to theft and no longer illegal today. His family disowned him and he was left with nowhere to go to make a living. By the time I met with him, he was twenty years into a life exploiting his education in the pursuit of stolen goods. What makes an art thief is not always what we think. Upon finishing my thesis, I concluded that there were three types of art and antiques thieves. Adam was what I called a professional opportunist.

Vincenzo Peruggia was an internal opportunist—an inside man. At the beginning of a series of events that gripped the world for two years, Peruggia hid overnight in one of the Louvre's closets reserved for artists' materials. If you've visited the Louvre, you know it has a valued tradition of allowing artists to stand with easel and canvas and copy works in its collection. He knew that when he emerged, the museum would be closed to the public. Donning an artist's smock, he was able to get the *Mona Lisa*, which is not on a canvas but three heavy wood boards, as far as a locked door. As recounted in the book *The Crimes of Paris* by Dorothy and Thomas Hoobler (and reported on the front page of newspapers around the world at the time), the plan almost came to an ignominious end until a helpful plumber was only too happy to let the thief out. The plumber was the only person to see the world's most famous thief.

The theft raised the *Mona Lisa*—already considered a jewel of the Louvre—to a new level of international attention. The failure of the French police to catch the criminal, and the ease of the theft to begin with, rocked the French government. Whether Peruggia was seeking to profit from the painting or return it to Italian soil as he later claimed, he approached Italy's Uffizi Gallery with an offer to sell the painting. The museum's director, Giovanni Poggi, authenticated the painting and turned the thief in to authorities. Peruggia's defense boiled down to: *I stole it because you stole it.* He was convicted and sentenced to seven months in prison.

Peruggia's "defense" that the French had stolen the *Mona Lisa* and he was only winning it back for Italy points to a much different kind of theft—one which I'll only touch on here and one which is a matter more for international law than criminal: governments looting art from other countries or their own citizens. In Germany, the return of artwork to Jewish descendants continues to this day. For example, in Munich in 2012, while prosecuting a tax case, officials found more than a thousand works of art valued at as much as a billion euros stored in an apartment. Many were suspected of

having been stolen during the war, but the majority of the collection, after years of legal dispute, ended up in the Museum of Fine Arts in Bern. The Greek government still demands the return of the *Elgin Marbles*, taken in the early nineteenth century, which can be found in the British Museum. During my tenure at the Met, the *Euphronios Krater* and the *Morgantina* silver were returned to Italy, because of questionable provenance.

The third category of thief and the subject of chapter 1 is the outside opportunist. Just as dangerous although not as prolific, the outside opportunist is a stranger to the institution who identifies a vulnerability—a weakness—and gives in to the desire to capitalize on it. When I tell you later in the book about a gold ring that belonged to Ramesses VI carried out of the museum in the mouth of a high school student, you'll understand why cracks in our defense were literally that.

The security of the museum's art was my primary responsibility, but not my only one. As one of New York City's landmarks, the Met is also a cultural center of the city and hosts events that draw the world's leaders. The annual Costume Gala benefit is one of society's biggest parties and has only grown since social media arrived. From Lady Di to Lady Gaga, I shepherded and protected presidents and princesses, rock stars and media moguls. The recent star-studded movie *Ocean's 8* has some fun imagining a jewelry theft in the middle of the party. And after 9/11, we realized that the safety of our visitors required additional planning as the world woke up to the challenges of terrorism. In addition to the FBI's Art Crime Team (ACT), the New York City Police Department, Scotland Yard, and Interpol, I worked with the Secret Service, the State Department, and other federal agencies to keep our art and our guests safe. I'll share some of these stories throughout the book.

In *Stealing the Show*, I'll use the untold stories of six major art thefts at the Metropolitan Museum of Art to explore the world of art and the art of the world. I'll take readers onto the loading

docks and into curatorial offices, to the Temple of Dendur and the American Wing and its magnificent Charles Engelhard Court, the majestic Main Hall where I stood at opening many mornings as the world poured in, the Astor Court, and Vélez Blanco Patio. In our Arms and Armor Department, I'll point out that museum staff helped create the helmets that our soldiers used in World War I, and maybe, just maybe, I'll share with readers what happens to the coins in our fountains (and no, there were no uninvited overnight visitors under my watch). At the heart of the story, there will always be art—those who love it and those who take it, two groups of people that are far from mutually exclusive.

Each of the chapters that follow has at its center one of these thefts. I'll explore what motivated the thief and how we conducted our investigation, and I'll unfold my own understanding of what has driven art thieves at different points of history. To tell this full story, I've spoken with many of my former colleagues in departments across the museum, especially curators and the museum's administration, and I'm enormously grateful for the help I received.

Be My Valentine

I ARRIVED AS ASSISTANT MANAGER OF SECURITY AT NEW YORK'S Metropolitan Museum of Art at one of the most exciting times in the museum's history. In New York in 1978, there were still checker cabs. Ed Koch had just been voted in as mayor. While subway cars were still covered in graffiti, the blackout of 1977 was a thing of the past. Billy Martin led the New York Yankees to a World Series championship even as his tempestuous relationship with George Steinbrenner filled the sports pages. The Met, as it's affectionately called, was 108 years old.

The museum's first paid president, William Macomber, and legendary director Philippe de Montebello oversaw the museum's administrative and art departments respectively during an ongoing period of major expansion—both of the museum's physical footprint and the breadth and depth of the collection. They had opened the Temple of Dendur to the public in the new Sackler Wing, accompanied by a significant expansion of the Egyptian galleries.

Philippe de Montebello and William Macomber were in many ways complete opposites. De Montebello descended from French aristocracy with lineage to Napoleon. Fluent in French, Spanish, Italian, German, and Russian, he was admired for his encyclopedic command of art history, and his expertise in European paintings was second to none. He was a no-nonsense leader who focused on

the museum's mission to exhibit, conserve, protect, and educate throughout the collections. Macomber arrived at the museum following a diplomatic career, and he had no professional experience with art. His unconventional choices did not always sit well with Philippe. Philippe and William were co-equals and reported to the chairman and the trustees, but they did not always see eye to eye.

The opening of the Sackler Wing coincided with the arrival of perhaps the most famous and well-attended traveling exhibit in the history of museums—*The Treasures of Tutankhamun*. King Tut's American tour had actually been one of the last diplomatic acts of the Nixon administration. As Nixon's presidency was coming to a close thanks to Watergate, Secretary of State Kissinger was negotiating a deal with the Egyptian government—the deal being basically that if they sent King Tut's glittering possessions on a US tour, the United States would help them renovate the Cairo Opera House. The Met's previous director, Thomas Hoving, had also been instrumental in bringing this blockbuster exhibit to America.

The exhibition featured near priceless artifacts from the tomb of a boy pharaoh of the Eighteenth Dynasty. Tutankhamun's golden burial mask was the literal crown jewel of the exhibit and one of the most iconic and important pieces of art in history. By the time the exhibit arrived at the Met for its penultimate stop in America, Tut had taken the country by storm. Steve Martin's insane parody song "King Tut" actually went on to sell more than a million copies and reach the top twenty on the Billboard charts. Beyond the humor, people were gripped by the beauty and mystery the mask represented. The reign of the pharaohs occurred at man's transition from savage to civilized—a time when biblical figures were said to walk the earth.

That King Tut's treasures had a more than half-century link to the Met also added to the prestige of the exhibit. When the tomb of King Tut was discovered in November of 1922, the British team led by Howard Carter (and financed by George Herbert—the fifth

Earl of Carnarvon) turned to experts at the Met for assistance. Albert M. Lythgoe—the Met's curator of Egyptian art at the time—offered the talents of veteran photographer Harry Burton. Burton was dispatched to the Valley of the Kings where he chronicled what is still regarded as one of history's greatest archaeological discoveries: the long-sought tomb of the boy who became pharaoh at nine years of age and died about a decade later.

Tut's treasures were nothing short of astounding. More than five thousand objects—many made of gold—were removed from the spectacular find. When Carter first glimpsed Tut's tomb, Lord Carnarvon (who had traveled by train and ship, then ferries, and, finally, donkey just to get there from England) reportedly inquired, "Can you see anything?" And Carter enthusiastically replied, "Yes! Wonderful things!"

Dr. Christine Lilyquist, the Met's curator of Egyptian art at the time of the exhibition, was responsible for choosing the fifty-five specific pieces that comprised the "Treasures." The order of objects in the exhibition was determined by the different chambers in which they were discovered: first the ante chamber; then the burial chamber; and finally the Treasury. Later in her career at the Met, Dr. Lilyquist spent an eleven-year span restoring and mounting forty thousand pieces in the museum's Egyptian collection.

From the perspective of the new assistant manager of security along with the entire department, *The Treasures of Tutankhamun* was an unprecedented challenge. From December 20, 1978, through April 14, 1979, Tut drew 1.3 million visitors—five hundred tickets were sold for every half hour the exhibit was open. To accommodate this crowd, we decided to keep the museum open twelve hours a day, seven days a week. But that wasn't even close to everything. The permanent collection along with other popular special exhibitions—*The Splendors of Dresden* and *Diaghilev: Costumes and Designs of the Ballets Russes*—drew an additional 3.4 million visitors.

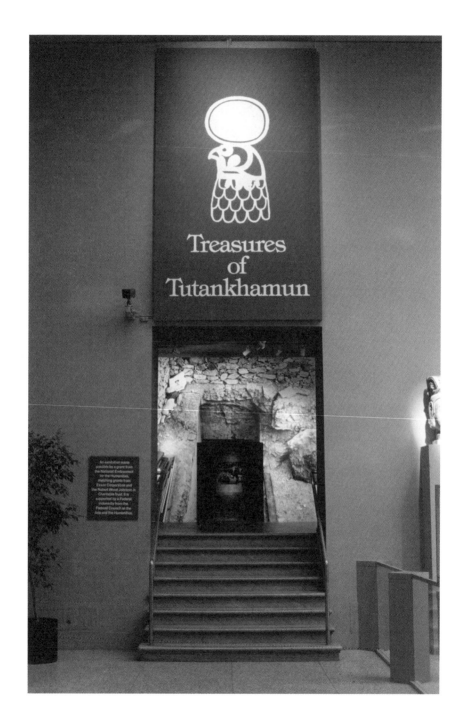

The Tut exhibition entrance gallery, 1979. THE METROPOLITAN MUSEUM OF ART

When I started at the Met, I was in charge of the nighttime security division. I was responsible for closing the museum to the public each evening. I performed these duties before, during, and after the Tut exhibition.

At a specified time, the closing procedure began with the museum's security officers announcing to the visitors that the museum was closed. When all of the visitors had exited the museum, the exhibits—and specifically the Tut exhibit when it was in New York—were checked. Security protocols began a nighttime setting. Extra security personnel, alarms, and special procedures were implemented to put the boy king to bed. I performed and oversaw this procedure for the run of the Tut exhibition with no incidents or problems. However, we did have security personnel who were genuinely concerned about the curse of King Tut. The story of this curse had traveled with his treasures ever since they were exhumed in 1922. These fears were so serious we had a couple of staff resign

rather than spend the night with the treasures. And this was before *Night at the Museum* was even a thing. But from a security viewpoint, our operations successfully protected the treasures while allowing huge public access.

From a personal perspective, the feeling I had when the Met emptied out of visitors was a silence that enhanced the beauty of the art and architecture. Walking through the majestic Great Hall, the Temple of Dendur, or the architectural splendor of the American Wing courtyard created a feeling of calm and pleasant loneliness. I could walk through the Tut exhibition after closing and it was a magical experience. I viewed the beauty of the art in absolute silence and let my imagination travel back in time through the presentation of the priceless objects.

When we weren't walking the halls of the museum, security operated out of two cramped offices within the European Paintings Department near the European Painting galleries on the mezzanine. There were nine of us (eight security personnel and a secretary) and together we were responsible for . . . well, everything. A lot of my hours at the museum were spent in the blank spaces—the spaces that appear to be empty on the visitors' floor plan, or floors of the museum that aren't even mentioned, where curators, restorers, accountants, and administrators work every day.

A month into the exhibit, we were feeling a mixture of relief combined with continued vigilance as the huge crowds continued to pour into the museum daily. Our routine was to meet periodically, and at 3:30 on the afternoon of February 9, 1979, Jack Maloney, Ed Ryan, and I—three assistant security managers—huddled in our offices to review security status before the evening.

The phone rang and Maloney took the call. It was our communications center ("Dispatch") informing us that a security attendant in the Greek and Roman galleries was reporting a suspected theft. He held the receiver down for a second and said, "Dispatch is saying one of the Greek heads is missing. Center west gallery."

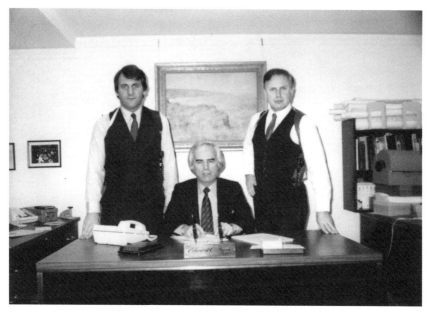

Assistant security managers, left to right: myself, Ed Ryan (the Gray Fox), and Jack (the Monsignor) Maloney. In the Met's security office, 1981. AUTHOR'S COLLECTION

A pedestal on the first floor off the Cypriot corridor was missing its head. Less than a year into my tenure at the museum at a time when the eyes of the world were focused on our enormously popular exhibits, it looked like we were victims of the first major art theft in the public galleries in the museum's history.

In a matter of minutes, the three of us stood in the Greek and Roman galleries looking at the empty pedestal intended to hold the head of a herm—the word used to describe a rectangular pillar that often had the head of Hermes, god of roads and entrances, at the top. Sculpted in fifth-century BC Greece (then gallery #8w; #156 today). After the discovery, the gallery had been closed to the public.

The first course of action once we could confirm the herm's absence was to notify all of our security personnel to search everyone leaving the museum. I contacted Dispatch, and radios crackled

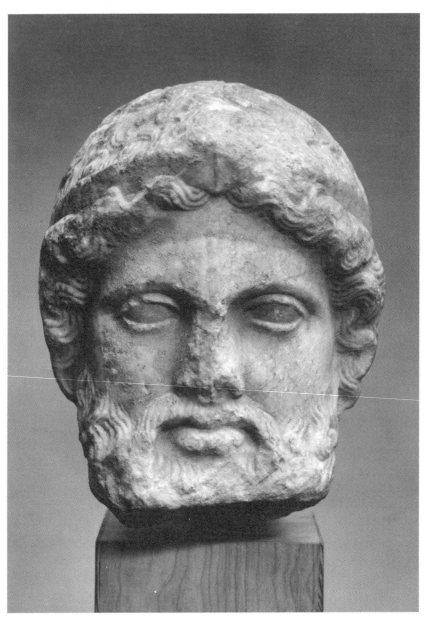

Greek head of a herm stolen from the Metropolitan Museum of Art in 1979. Note the original heart carved in the forehead over the left eye. THE METROPOLI-TAN MUSEUM OF ART

and phones rang throughout the museum. Our protocol would never call for something as severe as locking the museum down; an action like that could cause panic.

Next, a search of both the public and work areas was conducted by security personnel: the public areas to be sure that someone had not stashed the head only to return at a later time once our guard was (again) down, and the art storerooms and conservation areas because, as we'll see in stories that follow, sometimes what presents itself as a theft really ends up being something else. But looking at the chips of wood and plaster where the head had been, it was clear to all of us that the herm had been inadequately secured. Someone had simply yanked the head off its base and carried it away.

And of course, as all of this unfolded, the head of my department notified the VP of operations, the president, the director, and the Greek and Roman curator Joan Mertens. We took a day to make sure our search of the museum yielded nothing, and the next day we notified the New York Police Department. A sergeant from the Central Park Precinct, which sits in the middle of Central Park on the 86th Street transverse, came to our office at the museum. We had also notified the NYPD's Property and Recovery Squad. We contacted FBI agent Thomas McShane, who was responsible for art theft in the bureau's field office. Today, the first call would be to the FBI's Art Crime Team (ACT).

Contacting law enforcement was far from a given for museums. Following a theft, executives were afraid of negative publicity and criticism of security, and often they were just downright embarrassed. In this case, however, the Met and its executives, including Richard Dougherty, VP, information officer, decided to notify the New York media. On Sunday, February 11, two days after the theft, the *New York Times* ran a front-page article with a picture of the stolen artwork. The article outlined the specifics of the theft, and other papers across the country followed with their own stories.

$150,000 ART THEFT IS REPORTED BY MET

$150,000 ART THEFT IS REPORTED BY MET

Continued From Page 1

10 minutes in which the statue was believed to have been taken from the pedestal, Mr. Dougherty said.

Immediately thereafter, the museum, which has more than 300 galleries encompassing 900,000 square feet, was put on special alert. All outgoing visitors were searched and their briefcases and packages — which are required to be checked — were examined as they left the premises. Every room and storage area in the Met was searched, too, Mr. Dougherty said, including the museum's restaurant, which is near the Cypriot gallery from where the statue disappeared.

The specific date of the marble head, known as a herm, is believed to be the

Metropolitan Museum of Art

Marble head about 2,500 years old is missing from Metropolitan.

third quarter of the fifth century B.C. The herm was believed to be part of a smooth marble shaft marking boundaries in Ancient Greece.

Mr. Dougherty, the museum spokesman, said that three or four other such marble heads were positioned inside the Cypriot galleries.

"We have no idea why this head specifically was taken," he said.

Yesterday, museum officials said they had been joined in their investigation by outside security experts, including officials from the Federal Bureau of Investigation and the New York City Police Department.

The disappearance of the marble statue from the Met comes at a time when Federal officials say there is a dramatic increase in the thefts of valuable art works from museums, galleries and private collections in the United States.

Law-enforcement authorities interviewed recently suggested that nearly $50 million worth of art is stolen each year from public and private displays in the United States.

Even this figure has been termed conservative by private art experts. These experts say that many museums are generally reluctant to disclose thefts, fearing that disclosure would generate adverse publicity that could affect their fund-raising and acquisition efforts.

$150,000 ART THEFT IS REPORTED BY MET

Stealing of Greek Head Is Termed Museum's First Major Crime

By PRANAY GUPTE

In what officials of the Metropolitan Museum of Art described as the first major theft in the institution's 110-year history, an ancient Greek marble head valued at $150,000 was stolen Friday, the museum said yesterday.

"There isn't any doubt that it was stolen," said Richard Dougherty, the museum's vice president for public relations. "Everything has been searched. There is no possibility that the statue was mislaid. It was taken. It was wrenched from its wooden pedestal."

The Metropolitan, which has been credited with having one of the most advanced museum security systems, spends more than $3 million a year on security, a sum to which New York City contributes.

Other Estimates of the Value

The 2,500-year-old marble head was acquired by the museum from a private collection 20 years ago for $15,000. Private art dealers suggested yesterday that the Met's estimate for its present value of $150,000 was conservative and that the market price for the statue could be twice as much.

The untitled statue, in the style of those done around the time the Parthenon was constructed, depicts a bearded man with wavy hair. The nose is slightly damaged. The head, almost life size, is 9¾ inches high and 8 inches deep, and the width of the face is 7½ inches. The statue weighs 20 pounds, Mr. Dougherty said.

According to Mr. Dougherty's account, the theft occurred between 3:15 and 3:25 P.M. Friday during an interlude when a guard was being relieved by his replacement. The marble head, fastened to a 5-foot wooden pedestal on the west side of the Cypriot gallery corridor, had been seen in its usual place by a guard just before he was scheduled to be relieved by a colleague.

No guard patrolled the area during the

Continued on Page 35, Column 1

Security System Evaluated

The Metropolitan's yearly security budget of more than $3 million and its overall budget of $40 million are the largest of any art institution in the world. Metropolitan officials refuse to disclose details of the facility's security system, but they characterize it as the most sophisticated of any museum in the world.

In recent months, the Met has stepped up its security measures, especially because of the King Tutankhamun exhibit, which is currently on show until April. The museum disclosed recently that it spent $22,000 for each electronic "brain" installed in the Met's Egyptian gallery — equipment that makes it possible to detect the most minute security violation.

But officials also acknowledge that not all the Met's galleries are as tightly protected. Each year, more than 3.5 million visitors come to the museum. For the King Tut exhibit alone, some 1.5 million visitors are expected.

The Theft of 1972

While the disappearance of the Greek marble head was said by museum officials to be the first major theft at the privately operated insitution, there have been minor thefts at the Met.

The last theft occurred in 1972, museum officials said, when a man named Theodore E. Donson was convicted of stealing Old Master prints in what the New York police described as an ingenious portfolio rigged so that it could be inconspicuously unsealed and resealed in the museum.

Mr. Donson, who has since written a book on prints as investments, is now a noted 57th Street art-print dealer.

New York Times front-page article outlining the theft of the Greek head of a herm, February 11, 1979. NEWSPAPERS.COM

In addition to notifying the newspapers, the Met—this is what it meant to go viral in 1979—printed hundreds of "missing" flyers. They featured a picture of our abducted herm like a kid on a milk box. They went to law enforcement, media, but also art dealers and auction houses. The flyers read:

MISSING FROM THE METROPOLITAN MUSEUM OF ART, NEW YORK

A BEARDED HEAD OF A MAN, FROM A HERM. GREEK, THIRD QUARTER OF THE 5TH CENTURY B.C.
Height: 9⅞ inches Depth: 8 inches
Weight: About 20 pounds

ANY INFORMATION CONCERNING THE PIECE SHOULD BE DIRECTED TO: SECURITY DEPART-MENT, METROPOLITAN MUSEUM OF ART TELE-PHONE NO. 535-XXXX, TELEX XXX676 NEW YORK, NEW YORK 10028

As discussed above, thieves want to move art quickly. If a stolen object gets passed around over days or weeks, more and more individuals—what I'll discuss later as links in the chain—get involved, all of which makes tracking down the artwork increasingly difficult. The sad truth is that stolen art or antiquities are difficult to recover—in fact, in a typical year, recovery rates for such thefts are usually less than 10 percent.

The Greek head itself was, of course, valuable. The museum valued it at $150,000, but there were some outside experts who speculated that it might be worth twice that amount if sold on the open or black market (I'll talk about the concept of Markets Overt elsewhere in the book).

It's difficult to place an exact value on an ancient artifact. This particular marble head was believed to have been sculpted about the same time the Athenians were constructing the Acropolis and the Parthenon. It depicted Hermes, a son of Zeus and the god of messengers and travelers. These marble herms served different purposes: They were sometimes placed along roads, sometimes as a halfway marker to a destination, or in doorways to serve as a protector of houses or public spaces.

Our missing herm also had two peculiarities. There was a modest amount of damage to its nose, and, curiously, there was a small heart-shaped carving above its left eye. Both of these markings—along with an accession number of 59.11.24 stenciled at the bottom back of the neck—would help us identify the piece in the event we were lucky enough to track it down.

All artwork that enters the Met either through purchase or gift is assigned an accession number. This unique number identifies first the year it entered the collection, the department, and category within the department. The herm's accession number 59.11.24 means it entered the museum in 1959 and was assigned to the Greek and Roman Department. These numbers are inscribed in ink on each object by a staff person in the Registrar's Office. (The Met was founded in 1870. To avoid confusion art objects entering the collection after 1970 have the full date inscribed on the object.)

The first real lead seemed to come with a call to our hotline on February 12, three days after the theft. The caller was male but refused to identify himself. He said that he was visiting the Met on Friday, February 2—a week before the theft. He was in the Greek and Roman galleries at about 3:00 p.m. and he noticed something unusual. As he passed through the gallery, he saw a young man (white, approximately early twenties, 5'9", 120 pounds), hippie-ish with a knitted cap and insulated jacket. The young man was in an intense, almost hypnotic state studying the head, which our caller had seen a week later in the

papers. Our "hippie" then left the gallery without looking at any other objects.

On the evening of Wednesday, February 14 (8:42 p.m. to be precise), our case broke wide open. An NBC security guard at 30 Rockefeller Plaza got an anonymous call from someone claiming, "If you are looking for that head, you will find it in locker #5514 at Grand Central Station."

The guard notified the New York City Police Department. Two detectives—Michael Williams and Robert Patterson—took the call as it came in. They raced from their office in the Manhattan South Precinct building to Grand Central Station and the baggage lockers located above the Lexington Avenue line. Then, using two knives, they pried open locker #5514. And, inside, as promised, they found the Greek head, somewhat unceremoniously wrapped in a grimy white bedsheet.

Little did the thousands of commuters on the 4, 5, and 6 trains realize that—at least for the better part of a week—they'd been watched over by the Greek god of travelers.

The detectives called us down to the Manhattan South Precinct to see if we could positively identify our man. Although the accession number had been filed off, it was a rather simple task to ID the Met's herm. I brought along our case folder, which included photographs of the sculpture from different angles. The head matched the photos exactly.

As the *New York Post*'s lead paragraph noted the next day: "A 2500-year-old Greek statue stolen from the Metropolitan Museum of Art, was recovered last night in 'marvelous condition' except for a small valentine scratched over its right eye."

In the article, Allen Gore, my boss and chief of security at that time, noted, "A small heart appeared over the left eye originally, and now there's another one over the other eye."

And so it was. Our herm had come back to us on St. Valentine's Day with not one but two hearts. We did have a theory about who

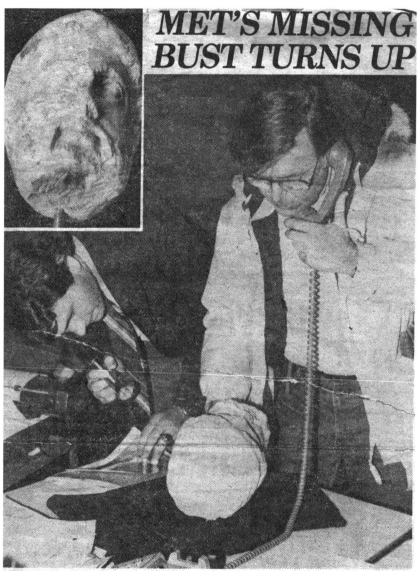

Security men at the Met inspect the Greek statue (inset) recovered last night

New York Post 1979 photo of the recovery of the Greek head of a herm. That is Allen Gore, security manager, and myself inspecting the head to verify it was the one stolen from the Metropolitan Museum of Art. NEWSPAPERS.COM

our thief might have been. There was a guy who often hung out around the museum restaurant. But after the head went missing, we never saw him again.

Coincidence? Our suspect was suddenly conspicuous by his abrupt absence.

If it *was* the guy we suspected, he would have been quite familiar with the museum's layout. He might have even known about a seldom-used exit designed for the handicapped. He could have pried the Greek head off of its poorly secured pedestal, tucked it under a coat, and scurried out onto the crowded sidewalks of Fifth Avenue on a late winter afternoon.

In my opinion, it was a classic crime of outside opportunity (though perhaps with some amount of pre-planning and "should I or shouldn't I?" internal wrangling as evidenced by our witness). Whoever did take the head had to do nothing more than lift it off at the right moment and escape the museum without being caught—no tools, no break-ins required.

As for motive, things get even more speculative. Perhaps our suspect swiped the Greek head, added the *second* heart, and presented it to his sweetheart as some sort of grandiose Valentine's Day gesture? Did the recipient then see his or her gift splashed across the pages of New York's newspapers and freak out? Is that the person who called the crime in or did the thief have second thoughts and leave the herm in a locker for us to find?

In addition to the second heart, someone—presumably the thief—had carved PERI on the lower side of the herm's neck. Was "PERI" the thief or the would-be recipient? We can only guess, because nobody was ever arrested for this crime. The only person who could tell us for sure is the person who stole the head on that day in February 1979. (If that person or someone who knew them is reading this, I've created a Gmail address—istolefromthemet@gmail.com—and I invite you to touch base with me now.)

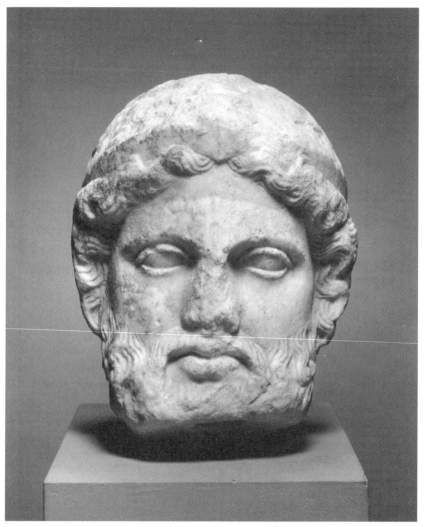

Greek head of a herm recovered in Grand Central Station locker #5514. When recovered, a new heart had been carved in the forehead over the right eye.
THE METROPOLITAN MUSEUM OF ART

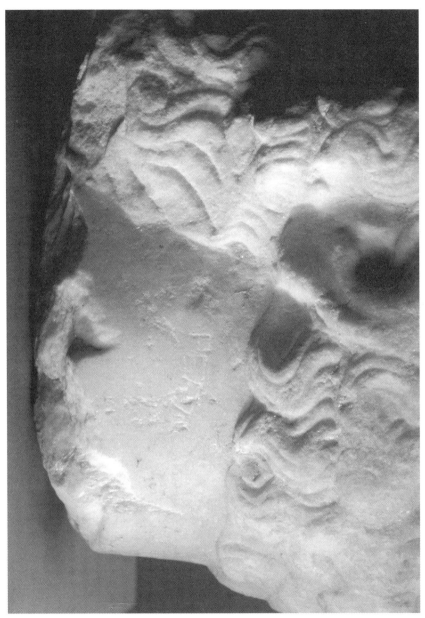

The Greek head of a herm. When recovered in the locker in Grand Central Station, the letters PERI had been carved in the neck area. THE METROPOLITAN MUSEUM OF ART

As for the herm, it still resides in the Met's Greek and Roman galleries, although in a slightly different location, gallery #156 on the museum floor plan. Both hearts and the "PERI" were subtly obliterated.

For the Met's security team, the theft of the herm presented some hard-earned lessons. While the publicity was painful, it was effective. In some of the other cases I'll recount, publicity was not the right way to go. But our decision to "advertise" the herm's theft loudly and publicly got the desired result and set a precedent for how art institutions approached theft from that point on. Since there was never any threat to our visitors, the publicity did nothing to slow the tremendous daily attendance at the museum.

The museum has always taken security extremely seriously, but we realized that there were other pieces in the Greek and Roman galleries that were not secured properly. This required either solidifying the art's connection to its base or using a Plexiglas vitrine to cover the piece—which is how you'll find many of the pieces, especially fragile pottery and precious metals, today.

The theft had occurred during a change in guards when the gallery was unattended. When I started working at the Met, the guards were largely untrained and, it's hard to believe looking back, were responsible not only for guarding the galleries but cleaning them. Clearly, these shared duties did not allow us to find and train the best security staff, and one of the major changes I accomplished was to upgrade the hiring, training, and operational efficiency of our guards, including in 1984 the elimination of the guards' cleaning duties, and changing the guards' title to security officer. Our alarm system was primitive and might have led to nothing more than a horn sounding in a specific gallery. The walkie-talkies we used at the time were not an efficient way to communicate on a museum-wide basis. Lastly, there were no cameras. Over the decades, as technology improved, I helped take the museum from one without surveillance to the state-of-the-art facility we have today.

Later that year, *The Treasures of Tutankhamun* began its voyage back to Egypt, where the artifacts remain today. The Egyptian government moved much of the collection from the Egyptian Museum in Cairo to the Grand Egyptian Museum west of the Giza pyramids. The Ministry of Antiquities brought together experts from around the world to consult in the safe transfer of these relics. In 2014, workers accidentally knocked the beard off Tut's golden mask and a surreptitious and hasty effort was made to epoxy it back on—there was international outcry over the damage done. It's amazing to look back and think that these pieces traveled the world safely and were seen by millions of people.

Allen Gore would retire from his position as security manager in 1982. His replacement, my new boss, was retired NYPD sergeant Joseph Volpato. Joe was a no-nonsense New Yorker and seasoned veteran of the NYPD. He was sometimes called Kojak by the museum staff because he looked a little like the lieutenant played by Telly Savalas in the popular TV show (the bald head helped). When he took over the Security Department, one of the first things Joe did with the blessing of our vice president of operations, Dick Morsches, was promote me to associate manager of security, second in command. When Joe was with the NYPD, he was a pistol-range officer, supervisor of the Robbery Squad, and a supervisor with the infamous "Stake Out Squad," formed in 1968 and disbanded in 1973. His last assignment was as a sergeant with the chief of detectives. Joe joined the Met in 1976, two years before I started there. He was an expert in firearms and chose the weapons used by police officers in the Robbery and Stake Out Squads. That weapon was the short-barrel Savage pump shotgun. Joe recommended this same weapon be used by the security that escorted the Tut exhibition to the six different museums in the United States. As the exhibit traveled on its American tour, trucking firm North American Van Lines had security vehicles in front of and following the trucks

carrying armed security personnel with Savage shotguns. Yes, literally riding shotgun.

Use of firearms in the Security Department at the Metropolitan Museum of Art has a long-standing history for protecting the vast art collection dating back some eighty-five years. In researching this book, I explored the Met's photo archives. To my surprise, I came across a photograph of the 1934 Metropolitan Museum of Art Security Department pistol team. In the photo, the team displayed a sterling silver trophy cup created by Tiffany & Company. In the 1930s and 1940s, the Met's Security Department formed a pistol team composed of uniformed officers. The team competed against the pistol team at the American Museum of Natural History, just on the other side of Central Park opposite the Met. The name of the winning team was engraved on the cup. When I

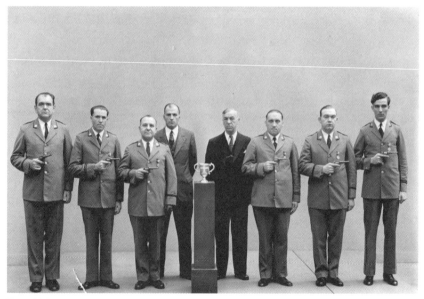

The 1934 Metropolitan Museum of Art Security Department pistol team with the sterling silver Tiffany & Company trophy cup. THE METROPOLITAN MUSEUM OF ART

arrived at the Met, there was no pistol team. It was discontinued in the early 1950s. However, I did discover that there was a pistol range in the bowels of the museum's lower basement. This range is where the pistol team would have practiced and held competitions. In the 1950s through the mid-1990s, this was also where selected armed security personnel would qualify and pass yearly safety training instruction. The firearms range was abandoned in the late 1990s due to safety concerns. Firearms training continues today off-site by an outside certified agency. The philosophy for using firearms at the Met has always been one of deterrence. That is to discourage anyone who wants to commit criminal activity. The carrying and display of firearms by properly trained uniformed personnel creates that deterrence. Crimes that occur at museums are all mostly nonviolent in nature. It is extremely rare to have an art theft involving a weapon and/or violence. In my long career of investigating and studying art theft, I have never investigated one involving weapons or violence. Let's keep it that way.

Joe Volpato retired in 1986, leaving the door open for my promotion to security manager in charge of the Met's Security Department, a position I held until my retirement in 2016.

On May 11, 2003, the *Saliera* by the great Renaissance artist Benvenuto Cellini was stolen from the Kunsthistorisches Museum in Vienna, Austria. As with his crypt in the Basilica Della Santissima Annunziata, I had visited the Kunsthistoriches specifically to see Cellini's work on my first European tour. When the news reached me a day after the theft, I remembered my Italian class at the University of Richmond with Professor Gino Adrean, who instilled in me the love of Renaissance art and in particular Benvenuto Cellini. Professor Adrean encouraged me to read Cellini's autobiography and learn about the artist, his time, and his work. In his memoir, Cellini described in detail the making of the *Saliera*'s—or

salt cellar's—waxed model. When I had finally laid eyes on the famous piece, standing in the middle of the Austrian gallery in a glass vitrine, I was not disappointed.

I remember being struck by its size: 10" × 13.2". Probably because of my modern preconceptions, I expected the *Saliera* to be a lot smaller. It was a magnificent object, and I still consider it one of the great works—able to stand alongside Tutankhamun's mask cast three thousand years before. Similarly, the *Saliera* is the only known object by Cellini made out of mostly gold and enamel that still exists.

Cellini, a goldsmith and sculptor, lived and worked at the height of the Renaissance. Born in Florence, Italy, in 1500, he was the son of a musician who performed for the Medicis. He learned to be a goldsmith at a young age in the workshops of Florence. While he worked for royalty throughout Europe, the *Saliera* was

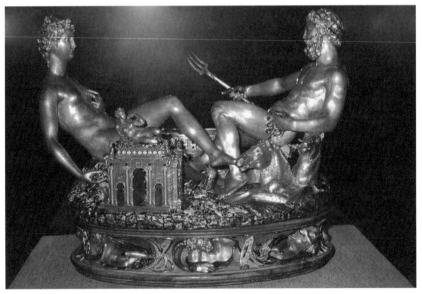

Benvenuto Cellini's *Saleria*, stolen from the Kunsthistorisches Museum in Vienna, Austria, in 2003, and recovered in 2006 buried in a lead box. PUBLIC ACCESS

made for France's King Francis I, between 1540 and 1543. Cellini died in his hometown on February 13, 1571.

The *Saliera* would have held salt on the king's table. As ostentatious as it appears today, in the sixteenth century, salt was worth its weight in gold and merited the exquisite vessel, although the court of Francis I wasn't known for restraint either. Cellini's salt cellar, which held a place for pepper as well, is sculpted from hand-rolled gold and portrays the gods of sea (Neptune) and earth (Ceres).

When the *Saliera* was stolen, thirty years after I had last seen it, I was in a unique position as the chief security officer of the Metropolitan Museum of Art. I knew that there was a good chance that an object like the *Saliera* would be melted down for its gold, which though significant would have been a fraction of its real value. I felt the same urgency I might as if it was one of my own pieces.

I picked up the phone and called Ian Wardropper, chairman of the Met's European Sculpture and Decorative Arts Department. Ian was a well-respected colleague, and we had worked together on exhibitions and security programs in his area. When I told Ian what I'd heard, I was not completely surprised to find that he already knew. For both of us, the theft of a work of this importance was a tragedy. It's not hyperbole to talk about the *Saliera* as the last remaining work of one of history's greatest goldsmiths. I told Ian that if he had any contacts at the Kunsthistorisches he'd pass along that I would be glad to give them any of my expertise and help. He promised to do that, but nothing further came of my offer.

From my perch at the Met, I followed the investigation. In addition to my personal connection to the work and the artist, I, of course, had a professional interest. The elements of the theft, and one would hope recovery and arrest, would become an object lesson in the weakness of the Kunsthistoriches's security system, and perhaps more importantly the opportunity that was presented to the thief. While each art theft is unique and has its own blueprint, those of us on the other side of the equation can study those plans

and relate them to our own environment. The challenge in all of this is that art theft is as diverse as art itself.

The *Saliera* was recovered on January 21, 2006, some three years later. Miraculously, it was nearly undamaged with just a few scratches. When I heard about the recovery, I called Ian to tell him the news, and was again behind the curve with the well-informed curator.

The theft of the *Saliera* was not unlike the theft of our herm in that the museum's security—or lack thereof—presented an opening for an outside opportunist, although in this case one whose motives were perhaps more straightforward than our thief's. In 2003, the Kunsthistorisches Museum was shrouded in scaffolding due to construction work. That scaffolding was the key the thief used to gain entrance in the early morning hours. Without the scaffolding, there would have been no theft.

The thief climbed the scaffolding, broke a window, and gained entrance to the gallery where the *Saliera* sat encased in what I can only guess was the same vitrine I had seen decades earlier. An alarm was activated but was ignored or for some reason disregarded by security personnel. Within a few minutes, the thief broke the glass vitrine and took the *Saliera*. He (as it turned out) exited the museum the way he entered.

Investigators in the case of the *Saliera* had to make some of the same decisions as we had and had to institute an investigative protocol. Officials decided to include the media, knowing that it might draw criticism (it did). An interview process included all administrative staff, all security staff on duty, and the construction personnel. I have learned from experience that construction sites are a real vulnerability to museums, not only for theft but also for fire and accidents that put art objects in precarious positions (just as with King Tut's beard). The first line of defense against theft should not be the museum proper, but the perimeter of the construction site. The Kunsthistorisches Museum should have alarmed

and incorporated personnel and CCTV systems around and within the scaffolding.

During the three years the *Saliera* was missing, an individual contacted the museum's insurer and twice demanded $12 million in ransom (its insurance value was roughly $60 million at the time). He went as far as leaving Neptune's trident in a park for authorities to find like a finger in a mystery novel. Authorities used these negotiations to try to ensnare the thief, and he was caught on video buying a cell phone. He was using what we'd call "burners" now—pre-paid cell phones used and discarded so as to be untraceable. His photo was distributed to the media, and soon one Robert Mang turned himself in to the police. Mang was a fifty-year-old Austrian . . . and a specialist in security and alarm systems. Cue the *Law & Order* "dun dun." He was a successful businessman with no financial problems or criminal record.

Mang acted alone. He first kept the *Saliera* under his bed, but during the ransom negotiations, he put the *Saliera* in a lead box and buried it in woods about fifty miles northeast of Vienna (the box was intended to protect the salt cellar from the elements). He took police to his burial site, and they recovered the legendary Renaissance masterpiece.

With most art theft recoveries, there is a real indignity to the "final resting places." Objects of such beauty and technical skill wind up in lockers in train stations (at least when they still had them), jewelry stores, car trunks, attics, and farmhouses; buried in the woods; or at collectible stores, pawn shops, precious metal dealers, art or rug galleries, flea markets, auction houses, or storage facilities. There is such a sense of accomplishment when a recovery of art is made and the objects are put back on display. After three years, this was the case for Cellini's *Saliera*, which was quickly re-installed at the Kunsthistorisches Museum for all to view and enjoy and learn.

As for Mr. Robert Mang, he was sentenced to four years in prison. After serving almost three, he was released. It has been my

experience that art thieves from museums around the world have been treated with leniency. The sentences in art-related prosecutions that I have pursued, in courts at both a local and federal level, have ranged from probation, fine, and house arrest to the maximum of four years in prison. In Mang's case, for a man who stole an important Renaissance object by that era's greatest goldsmith and tried to ransom it back, four years in prison with early release seems like a slap on the wrist. I'll discuss more prosecutions and their outcomes later in this book.

At his trial, Mang's defense was that he got drunk and saw the scaffolding. He climbed up, broke the window, and stole the *Saliera* to test the security and embarrass the museum. It's amazing how altruistic some of these thieves can be. However, the prosecutors didn't fall for it. They were able to show that Mang was observed in the *Saliera's* gallery a number of times before the theft and had to have planned beforehand. This was not a spur of the moment crime as his defense argued. Like Mr. Page, as a security specialist, he knew he had enough time between the alarm and the arrival of guards even if they had done their jobs properly, which they did not.

Mang was an outside opportunist because he was trying to capitalize on a weakness he saw in the museum's security. And even though his ultimate goal was financial gain, he had never done it before and, frankly, didn't really understand how to make money from his crime. He wasn't a professional opportunist.

Cellini's salt cellar, stolen in 2003, is the only piece I'll describe that was nearly stolen before it was ever made. In his autobiography, which is celebrated as one of the first narrative biographies, Cellini writes about meeting King Francis I in Paris and accepting his commission to complete the work. Cellini asks the king for "a thousand crowns of good weight and old gold," to which the king agrees. Cellini sets out to retrieve the gold himself from the king's treasurer, basket in hand. But as he's leaving in the dark of night, he

sees servants whispering, and he is soon set on by four swordsmen. He draws his own sword to fight back.

Approaching his residence, he yells out, "To arms! To arms! Out with you! Out with you! I am being murdered!" After fighting off the thieves, he writes, "We all sat down and supped together with mirth and gladness, laughing over those great blows which fortune strikes, for good as well as evil, and which, what time they do not hit the mark, are just the same as though they had not happened." An artist who might be welcome in any museum's security department.

Not long after the recovery of the *Saliera*, Ian Wardropper left the Met to become the director of the Frick Collection, a beautiful museum on 70th Street and Fifth Avenue—some twelve blocks south. The Frick Collection, housed in the former residence of Henry Clay Frick, has many European masterpieces as well as ever-changing exhibitions. Along with other museums along Fifth Avenue like the Guggenheim, El Museo del Barrio, and the Neue Gallery—together referred to as the Museum Mile—the Frick Collection is part of one of the most impressive collections of museums in the world. Before he left the Met, Ian sent me a beautiful little booklet that the Kunsthistorisches Museum published on Cellini's *Saliera*. It was filled with magnificent pictures and details about the time when the *Saliera* was put back on view. That is one little book I keep on my shelf and pick up from time to time, to enjoy the beauty of this masterpiece.

Chapter Two

A King's Ransom

Following our recovery of the herm and the excitement surrounding the King Tut exhibit, my department enjoyed a year of relative peace and quiet. That doesn't mean we weren't busy—there was always work to be done. As I mentioned, I was constantly involved in evaluating and improving our security operations. I had been reassigned from the night division to days by Dick Morsches. Dick oversaw operations, which encompassed most of the administrative and operational functions in the museum including security, building maintenance, the design department, the photo studio, restaurant operations, and human resources. In our discussions about the Security Department, we both felt that it needed to be restructured in a number of ways. I took on responsibility for specific elements: computerized scheduling, training, morale, recruiting, and the use of technology for alarms and security systems to protect both the collections and institution as a whole.

On a personal note, this was also the year that I started dating a Met museum sales supervisor whom I married in 1983. As of this writing, Anna and I have been married for thirty-five years, and I really do feel like I owe much of my good fortune to the halls of the Met.

New York throughout the 1980s was a city in transition—mostly for the better. But there were still issues like an eleven-day

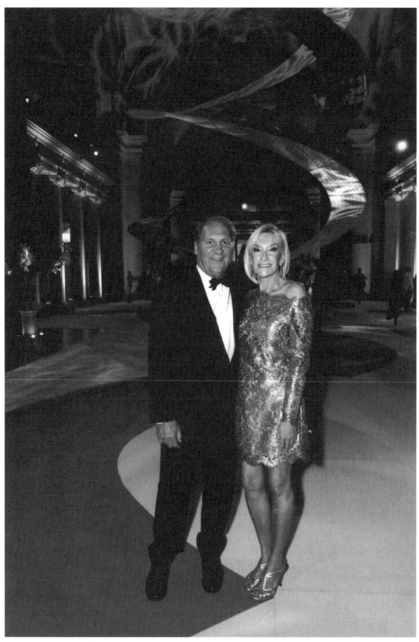

My wife, Anna, and I at the Met Gala in 2016. THE METROPOLITAN MUSEUM OF ART, PHOTOGRAPHER DON POLLARD

transit strike, infamous graffiti across the city and its subway cars, and a homelessness problem that has really never abated. But thanks to better management of city resources, New York was beginning a long climb towards safety and prosperity.

But after a year, the quiet was broken by a couple of incidents in the first months of 1980. Together, they show the kinds of challenges we faced and how hard it was to look around the sometimes proverbial and sometimes literal corners.

In February, the Met's administration thought it had a damaging theft on its hands—not one, but two Edgar Degas sculptures were missing. The statues were supposed to be in a temporary storeroom that was being used as a staging area for a forthcoming installation of his art. This installation was in the formerly named Andre Myer Galleries, which is presently the 19th- and Early-20th-Century European Paintings and Sculpture Galleries. In addition to his highly valued oil paintings of dancers, female nudes, and Parisian life, Edgar Degas's bronze sculptures are celebrated in museums and collections around the world as among the best Impressionist work. For this case, a little over a year into my tenure, the administration and Allen Gore determined that I'd take the lead, although we were not always in agreement about the case's nature.

On Tuesday, February 5, at approximately 4:30 p.m., a museum guard on evening rounds discovered the storeroom door in question was not secured. It was closed but unlocked. The guard notified the Security Department as well as Clair Vincent, a curator in the European Sculpture and Decorative Arts Department (within the museum, more often referred to as ESDA). Clair was the curator responsible for the room and its contents. When she surveyed the room, Clair believed that two sculptures were unaccounted for. These were two bronze ballerinas standing approximately 12¼" to 16" inches high. Each of these sculptures would have been valued then at approximately $150,000, and now easily a multiple of that figure.

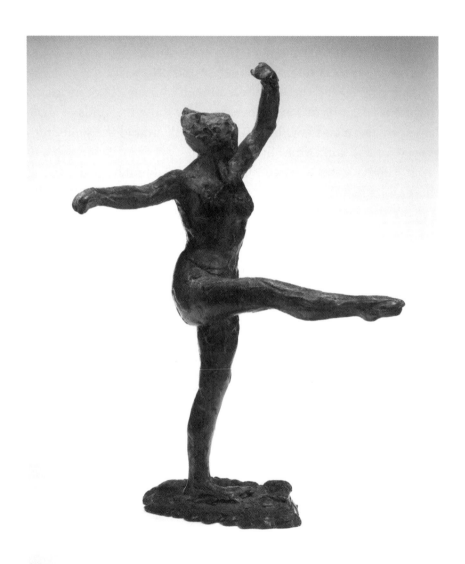

The two Degas ballerina sculptures reported stolen by the Met in 1980. Four days later, they were discovered by myself and Jack Maloney in a storeroom under the Main Hall staircase. THE METROPOLITAN MUSEUM OF ART

It wasn't a long walk from our offices to the storeroom, and when I got there, I saw Degas sculptures arranged on tables in an orderly manner. There were twenty to thirty sculptures there, on their way from storage to the gallery. Usually, art is gathered in a gallery space itself, which is closed to the public until ready for visitors. I believe there was construction that precluded this, so Clair had used nearby space for that purpose. As I looked around the room and its contents, I saw no sign that something was amiss. But at that point, I had no idea what was supposed to be there.

Again, this was a year after the theft of the herm, a loss—despite the recovery—which was still felt throughout the Met's administration and the Security Department. Allen Gore was a seasoned investigator. His gut told him—and he told me—that these statues had been stolen. Clair and I talked, and we agreed that she would put together an inventory of the art that she had gathered in the storeroom. Unfortunately, she didn't have a written record of works as she moved them. While she made this list from memory, I touched base with our alarm center and asked them to check their records for anything from the room. There was no sign of forced entry.

In 1980, the Met started the computer age with a Honeywell system that worked liked a teletype. Alarms came in a coded printout that had to be deciphered. In the next five years, computer screens were developed to read alarms with a description of the location, and hundreds of alarms could be connected to a central console. CCTV camera systems were in the developmental stage, and the ones we used at the time were large and lacked recording capabilities. That's what I was working with as I took on the responsibility of determining what might have happened to our tiny dancers.

The alarm center did have an alarm on record that indicated on the morning of the 5th, at 10:32 a.m., the storeroom door had been triggered. The alarm simply recorded that someone entered the

room that morning about six hours before the guard noticed the door was unlocked. The discovery of an alarm certainly raised our level of concern. It could have been a thief, but it also could have been anyone walking into the room without following protocol.

The only way we'd know if anything was taken was to check the pieces in the room against Clair's inventory. Based on her recollection and completed inventory of pieces, two ballerinas were missing from the storeroom. As with security, the curators now use technology to keep a more careful record of the whereabouts of the museum's artwork.

My initial review of the situation yielded these details:

1. A door that could have been accidentally left unlocked—or not.

2. An alarm that could be explained by a failure to follow protocol—or not.

3. No forced entry or disturbance in the storeroom.

4. No paperwork to back up the movement of the sculptures.

Based on the facts I had, I didn't think it was a theft. I recommended that we conduct a more extensive search of the museum's storage areas before reporting the missing works to authorities.

Allen and the administrators drew a different conclusion. They reported the missing pieces to the NYPD. On February 6, the *New York Times* again ran a front-page piece about missing artwork at the Metropolitan Museum of Art.

All thefts have a life of their own. You learn from each case, but sometimes it's hard not to let one case affect a subsequent one. The embarrassing loss of the herm followed by its quick and public recovery led to a decision to follow the same protocol. I just didn't see it. The storeroom would have been limited to curatorial, conservation, and registrar professionals to catalogue and move

objects—and these were not pieces that someone was going to hide under a coat the way someone probably did with our herm. Opportunity is always relative to the ease of theft. As I'll discuss in a later chapter, when it comes to the theft of artwork, size does matter. Especially when you rule out the professionals, opportunists will exploit what is easiest. And snatching a foot-high, oddly shaped bronze sculpture from the heart of the museum didn't seem easy to me—times two.

I felt strongly that the statues were still somewhere in the museum. With the assistance of security personnel, curators, and conservators, we continued to search the museum's storerooms and conservation areas. The Registrar's Office also checked to see if the objects in question were out on loan to another institution. By Saturday the 9th, four days after the guard turned an unlocked doorknob, we had nothing. This was my first big case as lead investigator, and a shadow of doubt crept into my assessment that the art had not been stolen.

That evening, Assistant Security Manager John Maloney and I were in the Main Hall dismissing the daytime security force after closing the museum's galleries. (Back then, we closed the museum at 5:30 p.m. Friday and Saturday; late evenings went into effect in 1989.) John Maloney, "Jack" as he was called, was a recently retired detective from the 19th Precinct Detective Squad. Jack came on board as a member of the Met's Security Department in 1979, just in time for the Tut exhibition. He was a great investigator who had a manner and personality that just made you want to like him. He looked and acted like an Irish Catholic priest. In fact, he was sometimes referred to by his fellow detectives and colleagues at the Met as Monsignor Maloney. His personality and way with people made him the investigator he was. He could charm anyone in an interview and get to the bottom of a case.

After dismissing our colleagues on the day shift, we talked about the Degas case. We both felt that we needed to know more.

We ran through everything we'd learned about the missing balle-rinas. As we were about to leave the Main Hall, we ran into our friend and colleague Charlie Moffett as he was leaving. We shared, "Good night, guys."

Moffett, a curator in the European Department specializing in Impressionist paintings, said, "Hey, I heard about the theft of the Degas statues."

"Yeah," I replied, "We were just running through the whole thing. Jack and I aren't certain that the works were stolen. We think they might be somewhere in the museum or still in storage."

"You know," he said, readjusting his shoulder bag, "we used some Degas bronzes in a special exhibition of his paintings back in the seventies. I think at the time we stored our Degas in the room under the main steps. Did you guys check there?" No, we did not.

The Monsignor and I exchanged looks.

"Great, thanks Charlie, we'll check it out. Have a good night."

As Charlie made his way out, Jack turned to me and said, "I didn't even know there was a storeroom under the main steps."

"I did, but I thought it was Greek and Roman," I replied. "We might as well give it a shot and check it out right now."

I called the control center and followed our security protocol so Jack and I could gain access to the space under the main steps. If you know the museum at all, you've seen the iconic steps that lead up from the Main Hall to the second-floor galleries and European paintings. Today, the space under the stairs is devoted to the display of Byzantine art and it's open to visitors. But that evening, to access the space, we had to remove a temporary wall and unlock a door. After we opened that first door, there was a vault door in front of us that was already unlocked. I stepped into the pitch-black storeroom. Although I've never stepped into a tomb the way Howard Carter did, I think I know what it felt like. I groped in the dark until I found a pull light in the middle of the room. As I looked around, I saw shelving that con-tained numerous storage boxes that in turn contained all kinds of art.

Jack offered to stay at the entrance; I think the storeroom spooked him. I started to poke through the boxes. I worked my way around the storeroom going from top to bottom. After twenty minutes, I reached the bottom of a bank of shelving. I came across an open box stuffed with tissue paper, and as I moved the tissue paper, I saw a foot sticking up. "Jack, I think I found something here!" I yelled.

I took the box off the shelf and carried it over to Jack. As I took the rest of the packing out, it looked better and better—there was not one but two ballerinas in the box. At first glance, they looked very much like our missing objects.

"You were right, John." Jack said. "They were here all the time."

"Hold on. Let's check the accession numbers before we celebrate."

Jack went up to our office for the case folder, and when he returned, we were able to match the accession numbers in the folder to the ones on the statues: 29.100.411 and 29.100.400. Bingo. We experienced a real thrill at solving our mystery, with an accidental assist from Charlie Moffett.

I notified the curator and the director and president that we found the Degas statues. We left them in the storeroom for the time being. There was great relief and surprise. Now the museum was faced with reporting back to the press—an embarrassing task.

The next day, the *New York Times* carried the headline "Met Museum Becomes Lost and Found Department for Two Degas Sculptures." "We're deliriously happy, but somewhat chagrined," commented Richard Dougherty, the Metropolitan's vice president for public affairs.

Though we'd had a year's respite before our ballerinas wandered off, we had days until the next theft occurred. The case of the stolen ring began on Tuesday, February 12, when Allen Gore took a call at his desk. The call was from an outside line.

The caller proceeded to tell Allen that he was in possession of a valuable gold Egyptian ring that belonged to Ramesses VI three

thousand years earlier. The ring was part of the Met's collection and should have been on exhibit in the Egyptian Wing. Asked to elaborate, he told Allen that he had just bought the ring from two young men for $5,000. He made this purchase after the teenagers told him they had taken it from its case. Allen scratched out notes as he

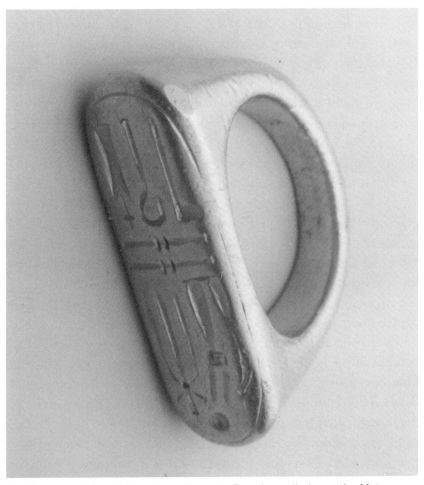

The Ramesses VI gold ring stolen from the Egyptian galleries at the Metropolitan Museum of Art in 1980. Note the indentation on the lower left side of the ring, which was caused when the ring fell to the floor. THE METROPOLITAN MUSEUM OF ART

talked and asked if the caller—who would not give a name or number—would call again in thirty minutes. Allen knew that nothing had been reported missing from any of the museum's departments, but there was enough information to take the call seriously.

Ramesses VI was the fifth ruler of ancient Egypt's Twentieth Dynasty and reigned from 1143 to 1136 BC. He was the son of Ramesses III and father of Ramesses VII. His royal tomb is located near Tutankhamun's in the Valley of the Kings. The hieroglyphs on the face of the ring identified Ramesses. It was only modern Egyptologists who gave the number connotations, so there is no translation of the VI. Shortly after his burial, his tomb was looted by grave robbers who hacked off his hands and feet in order to remove his jewelry quickly. Although our ring was not torn from his mummy, it was (supposed to be) part of the Met's rich collection of Egyptian artifacts. Its accession number was 26.7.768.

Allen came over to my desk and filled me in on his conversation. In turn, I called Dr. Christine Lilyquist and asked her to check the Egyptian Wing Phase 2 Galleries—which had opened a couple of years earlier—for the ring. We weren't familiar with this piece—there are thousands in the Egyptian Wing alone—but we knew Christine would be. Sure enough, when she went to check, the ring was missing. The rest of the collection, including the protective doors that separated the Egyptian artifacts from the public, remained perfectly intact: a locked door mystery.

A half an hour later, Allen's phone rang again. Now that he knew exactly what was missing, he asked the caller for a more detailed description. When the caller read him the accession number, it was enough to convince us that he did in fact have the ring in his possession. The caller started to fill in some of the blanks in our story. He told us that he owned a jewelry store on Lexington Avenue not far from the museum. He believed the ring was worth $80,000, and he would return it to the museum for a reward equal to that value. Allen negotiated the reward down to $25,000.

Allen, Assistant Security Manager Ed Ryan, and I had already discussed the outlines of a plan in advance of the second conversation. Allen asked the caller to call again at 10:00 a.m. the following day.

This was still the era of rotary phones and something like caller ID was a long way off. We really didn't know who we were dealing with and whether the caller was a legitimate jeweler or a street thug or wise guy who wanted to rip us off and keep the gold ring. We wanted to facilitate an exchange, but we needed to do it in coordination with the NYPD. We had to pick a location we could control and one where we could station undercover police at the entrance as well as the perimeter. Anyone from museum security who participated would be armed. The goal was to recover the ring, arrest our caller, and ultimately arrest the thieves who took the ring in the first place.

That afternoon, we contacted the NYPD's Major Case Squad. Two of New York's finest, Detectives Benedetto Leotta and Ronald Moss, were assigned to our case. We felt that our caller was guilty of extortion and possession of stolen property, and the detectives concurred. After all, our caller acquired the ring knowing it was stolen and was demanding in effect a ransom to return it to its rightful owner—us. (And since you might be wondering, the Metropolitan Museum of Art is a private corporation and the art and antiquities in the Met are held in trust by the Board of Trustees. The buildings and the land in Central Park are owned by the City of New York and maintained by the Metropolitan Board of Trustees and Administration.) Together with the detectives, we took the rough outlines we had discussed internally and mapped out a plan for the ring's recovery.

In order to locate someplace nearby for the exchange, Christine called a colleague at the Acquavella Galleries on 79th Street and Madison Avenue. Her colleague was willing to let us use one of their offices. Detectives Leotta and Moss along with Ed Ryan

would pose as museum officials. I knew we could count on Ed to keep his cool in this somewhat unusual situation. And finally, once the exchange—ring for cash—was made, the detectives would arrest the caller. Before the meeting, we also needed the money for the exchange. I made a call to the museum's vice president for finance, filled him in on the case, and requested $25,000 cash to recover the Ramesses VI gold ring. Our VP went to the cashier's office and gave me 250 $100 bills. I stored the money in a canvas bag and waited. (Philippe de Montebello, the director of the Met at the time of the theft, is today the director of the Acquavella Galleries.)

Now we were ready for the next call and it came right on time. Allen set our meet for the gallery, and it was time for Ed and the detectives to walk over to Acquavella, canvas bag in hand. They executed our plan perfectly. It turned out the caller had an accomplice. The jeweler waited outside the gallery while his accomplice made the transaction inside. The accomplice was confronted and led us to our caller. Both men were arrested and charged on February 14, 1980, Valentine's Day, exactly one year after we recovered our herm. While the Greek head with its two hearts was probably someone's valentine, the date we recovered the Ramesses VI ring was pure coincidence.

Ultimately, our jeweler pleaded guilty and was given a light sentence. In exchange, he told us everything he knew about the two teenagers who sold him the ring. The detectives identified, located, arrested, and charged the teens for the actual theft. And we had our ring back, but in a memo summarizing the crime and recovery, Dr. Lilyquist observed that there was now a flattened area on the bezel of the ring. This "depression" can be seen on the ring today, back on display in Egyptian gallery 127. The depression was not incidental damage, but a part of the ring's journey out our front door.

With the teenagers apprehended, we were able to interview them and learn how two high school kids could pull off a major

The Acquavella Galleries located blocks from the Met on 79th Street where the ransom exchange was made by NYPD detectives and museum security personnel. The Ramesses VI ring was recovered and arrests were made.
AUTHOR'S COLLECTION

museum theft that went completely unnoticed. One of the great things about the museum is that it's always available to New Yorkers who are interested in adding some culture to their day, want to see something beautiful, or are just looking to get out of the February cold for a little while. These kids were wandering the Egyptian galleries when they noticed an overlooked flaw in the design of the protective barriers. In front of the ring, two of the locked panels could open out as a door so pieces could be easily added, changed, examined, etc. The case's designers had left a quarter-inch gap between door panels as well as a small opening at the bottom of the barrier. *Obviously*, no one could reach in and grab an antiquity without smashing the glass panel and drawing a guard's attention. But directly aligned with this crack was . . . the shiny gold ring of King Ramesses VI. As soon as they recognized this flaw, our young opportunists envisioned a way to exploit it for their economic benefit. Unlike our ballerinas, the ring's size magnified its allure as an opportunity to steal. As I'll discuss further in chapter 4, there's a direct correlation between the size of art objects and antiquities and their vulnerability.

On a return trip, they brought a wire hanger with them. As they made their way through the Main Hall, they picked up a museum floor plan at our information desk—but they already knew where they were going. If you were visiting our museum, it would just be a quick stop at the main information desk and a right-hand turn to the Egyptian galleries. These galleries can be relatively quiet on a weekday, and the theft predated the presence of video cameras in every gallery. So, while one of the teens acted as a lookout, the other fished the wire hanger through the quarter-inch crack and knocked the ring to the floor, where he had already placed the paper floor plan. As it hit the map, the ring's bezel depressed. Gold, of course, is "soft," even when combined with other metals. Our young thief simply pulled the floor plan out from beneath the glass and collected his prize. Talk about grabbing the brass ring.

Once he had the ring, the teen was afraid he might be searched on his way out of the museum, although he and his accomplice had attracted no attention. I don't know if this was part of a plan or a spontaneous act, but he popped the ring in his mouth. Thank God he didn't decide to swallow it. The teens walked out of the museum and soon to our jeweler on Lexington Avenue. The connection between thieves and jeweler was forged on the spot—there had been no prior relationship. A professional thief most likely steals gold for its commodity value—and ultimately finds a way to melt it down. The market for identifiable works of art and antiquity is extremely difficult to navigate successfully. While the theft was in its simplicity quite smart, the complexity of the market for stolen goods did our thieves in. I remember some discussion that if they enlisted in the Marines the charges would be dropped, but they were convicted as juveniles of grand larceny. This was their first offense and they, too, were given a light sentence with no jail time; and that's the last we heard.

The *Times* ran a story about the theft on February 16, 1980, which said, "The man who called the offices of the Metropolitan Museum of Art Feb 12th had a proposition. He knew that a gold Egyptian ring dating from the era of Ramesses VI, 3,100 years ago, had been stolen from the museum recently and said that he, acting as the museum's agent, would be glad to bring about its return for a fee of $80,000." Well, we know how that worked out.

Needless to say, the theft of King Ramesses VI's ring made us immediately aware of a fairly obvious blunder in the planning and construction of the Egyptian galleries. But like many things in life, the vulnerability that was built into the exhibit sprang from the noble intentions of the gallery's curator, Dr. Lilyquist. In planning the reinstallation of the museum's Egyptian collection, Dr. Lilyquist recently told me, "Making art more accessible was already in [our plan], but I took it further than any other department. It was a time of populism—people were saying that the museum was

elitist—and I, as a student, had often gone to museums to study objects, only to find that things were not on view, and there was no staff member available to ask. I also had the idea to display things chronologically, thereby emphasizing their ancient context, which in many instances were sites that the Met had dug when building its collection in the first place [Egypt gave objects to institutions that had excavated]. Egyptian collections normally display their objects by subject or type of object. Those two ideas meant that small objects could end up with large ones, gold could end up with baskets. And *that* meant that we needed large cases, without framing—where disparate objects could all live together. Brilliant concept, but the technology wasn't up to it, nor did we foresee the busy little hands." It was an error of omission because up until that time, security was what happened once the galleries were completed and the public was allowed in. These galleries were no exception, but from that point on, when our administration met with designers, contractors, and curators to create a new gallery or installation, you can be sure that the Security Department was also in the room. A few examples of this change in thinking include the construction of the Michael Rockefeller Wing in 1987, the 20th Century Wing in 1988, the Kravis Wing in 1991, hundreds of special exhibitions over the years, the Asian galleries in 1998, the Greek and Roman Courtyard in 2000, the Islamic galleries in 2012 (more on this later), and the New American Wing galleries in 2010. But in this instance, as with the *Saleria*, display cases (or vitrines) proved to be a weakness that was addressed by museums throughout the world in the following years. That said, the Met still strives to display the majority of its art and it does so to this day. That's why spaces like the one under the main stairs have been transformed from storage to public display.

Some months after the Finance Department handed me that $25,000, which I had promptly returned, I received a call from our treasurer. She asked for security's assistance to escort her to the bank

to make a cash deposit. I told her I would send my chief supervisor, who was armed, to escort her. She thanked me. About fifteen minutes later, my supervisor called and said, "Mr. Barelli, we have a little problem. You might want to come down here and take a look."

I went to the cashier's office and was amazed—and slightly horrified—by what I saw. My chief supervisor and a member of the Finance Department were standing in a secure area with two big museum store shopping bags stuffed with small bills. They were discussing walking over to our nearest branch and making a deposit. I took one look and said, "There is no way you are going to walk out of the museum with cash like this." I immediately changed the protocol around how money reached the bank. I can assure you that today this is done by armored truck, and no one from the museum handles cash deposits of any kind.

I mentioned the coins that you'll see in our fountains—and maybe you've made a wish yourself. Coins are thrown in the museum's fountains by visitors from all over the world. This includes fountains on the plaza, the American Wing, the Roman Courtyard, and the pool where the Temple of Dendur sits. This ritual was made famous in the wonderful young adult novel *From the Mixed-Up Files of Mrs. Basil E. Frankweiler*. In reality, every couple of months they are collected before the museum opens by the staff in the museum's Engineering Department. After they are collected and put in plastic containers, they are brought to the engineering shop where they are dried off, put back in the containers, and delivered to the museum's Cashier's Office. There they are separated by the cashier's staff into US and foreign coins. The US coins are deposited and counted as admissions income.

━ ⌁ ━

Protecting the integrity of the Met's collection was the most important day-to-day priority for the Security Department, but not the only one. As a cultural center for New York City—and

thus America—the Met hosts many special events attended by national and international dignitaries, celebrities, the press, and movers and shakers from just about every industry. Anyone who was in my house was my responsibility, and I worked with almost every branch of law enforcement to make sure our guests were safe. The museum, as a secure facility, boasts some advantages for sensitive events, and as a kind of neutral ground, it adapts to host any number of occasions.

Adjacent to the galleries where the ring was stolen was the Temple of Dendur, opened in 1978 and housed in the Sackler Wing. In the early 1960s, the Egyptian government was constructing the Aswan Dam—a massive engineering feat akin to our own Hoover Dam. The area that would be flooded housed many

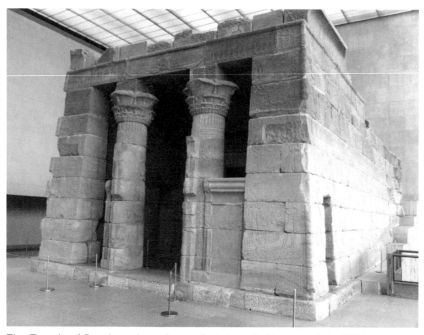

The Temple of Dendur, where Anwar Sadat made his speech in 1981 on his visit to New York City. THE METROPOLITAN MUSEUM OF ART

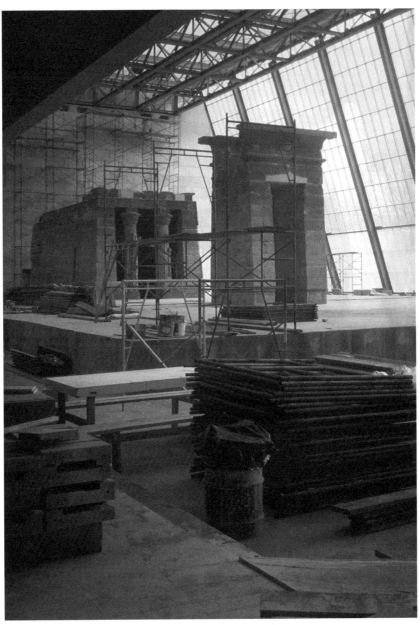

The Temple of Dendur before it was opened to the public in 1978. THE METRO-
POLITAN MUSEUM OF ART

ancient monuments, the Temple of Dendur being one of them. The Johnson administration struck a deal with Egypt's President Anwar Sadat to house the temple somewhere in the United States. A competition between American institutions—the Met and the Smithsonian among them—followed. Not unlike the jockeying that surrounded the Tut exhibits' American tour, the curatorial race to win the temple was dubbed the "Dendur Derby" by the press. On April 27, 1967, the temple was awarded to the Met. The Met's winning plan was to house the temple in a glass wing on the museum's north side. Designed by Kevin Roche and John Dinkeloo & Associates, the new space would protect the brittle sandstone from the elements: A water pool represented the Nile River and a glass curtain wall let daylight spill across the entire space. As the dam was being constructed and the valley began to flood, the temple was taken apart piece by piece, packed in 661 crates, and transported on the freighter *Concordia Star* to the United States.

In 1981, after the temple was permanently installed in the museum's new annex, Mayor Ed Koch invited President Sadat to a reception in his honor. Sadat would also speak to a large gathering of VIPs in the temple's memorable space. Sadat's visit marked my first involvement protecting a head of state, and the security concerns were considerable given the heightened tensions in the Middle East at the time. The third president of Egypt, Sadat served from October 1970 until his assassination by members of the Egyptian army and his security detail on October 6, 1981. He was awarded the Nobel Peace Prize in 1978 along with Israel's Prime Minister Menachem Begin for their efforts in bringing peace between the two countries. The 1979 Camp David Accord peace treaty was brokered by President Jimmy Carter at the presidential retreat in Maryland. The treaty outraged Islamic fundamentalists (among others) and led to Sadat's assassination at an annual military parade in Cairo.

The Secret Service considered President Sadat's visit to the Met in August a high-threat event. Both the Secret Service and State Department along with local and federal law enforcement were involved in overseeing his time in New York. We had to consider everything from demonstrations or protests of some kind all the way up to assassination. Security and advanced preparation were very serious, and we coordinated with American law enforcement as well as Egyptian security forces.

There were also background checks of personnel involved in the evening including maintenance and special-events staff. We held numerous walk-throughs. We established certain safe rooms for the evening should anything arise or we simply needed to get the president to a private place. There was even emergency medical staff on-site. All of this in advance of the approximately one hour President Sadat would spend in my museum.

As Sadat, his entourage, and personal security arrived through the main entrance, I noticed that his security detail was shockingly hostile towards other guests. After being greeted by Mayor Koch and President Macomber at the entrance, we proceeded along the pre-assigned route to the Temple of Dendur. As we led Sadat to the temple, I saw that his security detail became even more aggressive. If a guest got too close, they forcefully pushed them away. When President Erdogan's security forces recently made news for attacking protestors in Washington, DC, it was a vivid reminder of my first experience with a head of state. Sadat was introduced and made his speech. As we escorted the president out of the temple, any guest who blocked his path was physically moved or in some cases pushed to the ground to hasten his exit.

On the way out, the lead Secret Service agent turned to me and said, "We have to get to the safe room." We had designated an office on the route, and my thoughts immediately turned to some unseen danger in the crowd. To our surprise, the reason we rushed Sadat to a safe room was because he had a terrible toothache and

needed a dentist. As I looked at him sitting in the office, I could see that he was in some excruciating pain. After a few calls by the Secret Service, a dentist was located and the president and Nobel Peace Prize winner was escorted out of the museum by his security detail and the Secret Service. Lights and sirens—off to the dentist.

When I heard about Sadat's assassination two months later, I could only think about the irony of Sadat's security detail. When they were at the museum, they would do anything to protect him. Their aggressive manner is something I have never witnessed in all my four decades coordinating security operations for heads of state visits. And yet on that fateful day, that same security detail laid down and failed to protect him.

———

My first couple of years at the Met were not terribly good ones as far as valuable, irreplaceable missing objects go. First the herm, then the lost Degas ballerinas and the Egyptian ring. Believe it or not, it got worse at the end of the year. On December 20, 1980, at about 10:00 a.m. on a Saturday, a security supervisor discovered that a partisan, an ornamental spear-like object belonging in the Arms and Armor gallery, was missing. The partisan should have been attached to the top of a seven-foot pole. It had been carried centuries earlier by the Swiss Guard. This particular partisan belonged to an officer under Augustus the Strong, Elector of Saxony (1725). Designed with two outward-facing eagles on the sides of the spear tip, the partisan was one of only six designed specifically for the guard's six sergeants. Of these six partisans, one is in Dresden, one is in the Berlin Museum Fur Deutsche Geschichte, two are in the museum of the City of Bautzen, Germany, one is in a private collection, and one is the Met's (accession #36.78.2), which was stolen that December. I was the one who got the call from our supervisor, and I headed straightaway to Arms and Armor on the museum's first floor. This time, there was no doubt that a theft had

The partisan blade stolen from the Metropolitan Museum of Arts Arms and Armor galleries in December of 1980. One of only six in the world, it is still missing. THE METROPOLITAN MUSEUM OF ART

been committed. The partisan pole that held the blade of the partisan was off its wall mount and now leaned against it—the blade tip missing. The museum wasn't open yet, so we closed the room, and I began my investigation.

I mentioned that our partisan was one of six. I soon learned that—by the weirdest coincidence—one from this group had been sold at auction a month earlier for $5,500 to a member of the Arms and Armor Department. At the time of the theft, this individual was employed as a research assistant in our own Arms and Armor Department.

The night before the partisan was discovered missing, there was a staff Christmas party in the museum's Great Hall. Guests were allowed to wander farther into the museum if they wanted to see our beloved Christmas tree in the Medieval Art Hall adjacent to the Arms and Armor galleries. It was certainly possible for someone to leave the party and go unnoticed into the Arms and Armor galleries, remove the spear from the wall, unscrew the partisan from its pole, conceal it on their person, and eventually exit the museum. I realized that of the seven different partisans on the wall, the one that was stolen was the only one that could be unscrewed—the other six spearheads were riveted in place.

I made all the necessary internal notifications to inform the president and vice president of operations as well as the gallery's director, Helmut Nickel. My department filed reports with the FBI and NYPD. Unlike other thefts, no media was contacted at that point, because we felt there was a strong possibility that this was an inside job.

I reached the following conclusions: The stolen partisan was the only one that was screwed and not riveted in place; whoever stole the partisan knew this and attended the Met's staff Christmas party. These details made it feel a little bit like a game of Clue, only there weren't enough clues for me. We knew the weapon and the room of the crime. But it's knowing the guilty party that wins you

the game. The first person we interviewed, as you might imagine, was the research assistant—an assistant in the department and new owner of one of our partisan's sisters. One is an acquisition, *two* is a collection. But after talking with him, it became clear that our most obvious suspect had nothing to do with the theft. So it goes sometimes.

As we went forward with the investigation, we learned that there was a personnel problem in the Arms and Armor Department. A longtime employee had serious disagreements with both a colleague and his boss, Helmut Nickel, who subsequently reprimanded him. We interviewed this employee, and we felt we could not eliminate him as a suspect. Yet we did not have enough to prove anything. This person had the opportunity and knowledge. In this case, hypothetically, the motive was not financial but revenge. As Helmut wrote in a memo to the director: "The loss is deplorable not only from the point of rarity of this object (only six ever in existence), but it is also embarrassing, because I just finished an article about the arms of the Saxon Swiss Guard, which is scheduled for the Festschrift for Hugo Schneider, Director of the Swiss National Museum, Zurich, in November, 1981. Our two partisans (we also have the enlisted men's partisan) were prominently featured in this article." The stolen partisan originated in Dresden, Helmut Nickel's hometown. So, you can see why we thought that if the thief was a grudge holder who wanted to get back at his boss, he picked his object carefully. This is the kind of motivation for theft that's very hard to predict and guard against, although technology has come a long way in preventing similar crimes.

The partisan is still missing from the Met's collection. It will no doubt show up at an auction, estate sale, or flea market, or in someone's attic, in the United States or another country. There's even an outside chance it's still hidden in the museum's walls. It always surprises me how many objects lay unnoticed or hidden for years until the right circumstances fall into place and someone identifies

an object. After thirty-eight years, this has not happened with the Met's partisan, but someday it will.

In 2009, French investigators reached a dead end when a painting by Degas disappeared from a museum in Marseille where it was on loan from the Musee D'Orsay. Like our partisan, an inside job was suspected, and like our partisan, no arrest was made and the work was not recovered. That is until 2018, when authorities near Paris conducted a random search of the luggage compartment on a passenger bus. This is done to disrupt the flow of illegal drugs through the country. The painting *The Chorus of Singers*, valued at approximately a million dollars, was found in a suitcase. Not surprisingly, no one claimed the suitcase as their own and the work was returned to the Musee D'Orsay after a nine-year sojourn through France's black market. While a quick recovery is always best, the world of art and antiquities security has a long and institutional memory.

That winter, we were assisting the Costume Institute as they prepared for the exhibition *The Manchu Dragon: Costumes of China, The Ching Dynasty*, with special consultant Diana Vreeland. The Met's increasingly famous Costume Gala kicked off the exhibition and presented its own security challenges over the years, a few of which I'll discuss elsewhere. Although in security technology the use of alarms was still rudimentary, that year my department developed the first motion detector specifically to protect a work of art. While the Gala went off without a hitch, my lasting memory of the event was that I heard John Lennon had been assassinated right across Central Park in front of his home, the Dakota. The news settled over the Gala—and soon the rest of New York and the world—with a somber effect.

Celtic Gold Trail and the Road to Recovery

Of the three types of opportunist that a museum's security must defend against, the internal thief is the biggest problem, the most difficult to predict, and probably the most common in terms of the number of institutional art thefts.

The internal thief is an individual who works for or is contracted by the institution. A museum the size of the Met has thousands of people coming through its doors in addition to paying visitors. Internal opportunists have a much better and sometimes excellent knowledge of the organization and how it functions. They can wait for the right opportunity, sometimes even years, before making a move. In my experience, these individuals are driven by a personal financial problem such as divorce, gambling, or drugs, or even, sadly, medical bills. In a certain sense, they can be the polar opposite of the outside opportunist. For example, our teen thieves saw the vulnerability of Ramesses's ring and from there followed a path to monetize it; an internal thief might start with the premise "I need money" and work backwards from there. We'll see that this is not always the case, but it's the more likely scenario.

In October of 1981, the Met's Security Department was confronted with this kind of crime. An employee who had been with

the museum for twenty years and had a good work record betrayed the museum's confidence. He stole seven small objects from a case in the south medieval corridor containing works from the early Christian and Byzantine periods. These pieces were two gold Celtic coins from the second century BC, an Irish dress fastener and an Irish sleeve fastener both made of gold from the eighth century BC, two provincial Roman pins, one from the third to fourth century AD, the other from the second century AD, and a Roman brooch from the first to second century AD. In total, these objects were valued at close to $200,000. They had been donated to the museum by J. P. Morgan in 1917. These display cases were not far from where I recovered Degas's ballerinas.

This theft occurred about six months before my first trip to London, when I began to study how England's renowned Scotland Yard investigated art thefts. Most people think Scotland Yard is a special division of the British police, but it's the name of their domestic police force. The supervisors and detectives there were incredibly generous with their time. They shared their techniques and practices that were, frankly, more developed than what we had on our side of the Atlantic. Specifically, the Art and Antiques Squad allowed me to gather statistical data, talk with thieves, and accompany police on operations. I used what I learned both in my doctoral dissertation for Fordham ("On the Understanding of the Business of Art and Antique Theft: An Exploratory Study," 1985) and in the day-to-day operations of my department at the Met. If you eliminate opportunity, you eliminate theft. I'll share my experience with Scotland Yard in greater detail in chapter 4.

In England, the Art and Antiques Squad taught me a technique I call "the Chain of Events." My definition of the Chain of Events might not be what you'd think. It's what happens immediately *after* a theft, and it's the movement of stolen objects from person to person and/or market to market. The goal of this chain is relatively straightforward: dispose of stolen goods; acquire money.

4 Recovered

3 Not Recovered

Celtic coins and early Christian jewelry stolen from the Metropolitan Museum of Art by a longtime custodial employee in 1981. Four items, the Celtic coins and two gold dress fasteners, were recovered. The two gold pins were melted down to scrap gold, and the bronze brooch is still missing from the Met's collection. THE METROPOLITAN MUSEUM OF ART

Unlike, for example, the investigation of a violent crime where you might watch a small circle of suspects, when it comes to art theft, it's the object that is "fleeing" you. The farther and farther away the object gets, the smaller your chances of recovery. In fact, less than 10 percent of art crimes end with the successful reacquisition of the stolen art. Each link of the chain you establish increases the likelihood of recovery, as the pursuit of our two Celtic coins and five pieces of early Christian jewelry showed.

When this theft was first reported at 4:00 p.m. on the afternoon of October 14, we initially thought it was committed by an outside opportunist visiting the museum. That afternoon, a member of the custodial staff reported to security that the objects described above were missing from their display case. I came downstairs from my office, and I could see that there were descriptive panels in the vitrine without an accompanying object. The vitrine was ajar and some of the screws securing the Plexiglas cover were missing. Following protocol, I contacted the Medieval Department, and they confirmed both that the objects were missing and that no one in their department removed anything. One thing that bothered me right away was that this display case was in one of the museum's busiest corridors. At the Met, there's a corridor on each side of the main staircase that takes visitors to the Medieval Art and other major galleries including the American Wing and Modern and Contemporary Art. The thief would have had to unscrew and remove the Plexiglas cover, take the objects, and reinstall the vitrine, all while dozens of guests walked by. With that unlikelihood in mind, we changed the focus of our investigation to an internal opportunist.

Following our playbook, we reported the theft to the police and FBI. We also set up a telephone hotline that we sent out in a press release. Pictures of the objects along with detailed descriptions were distributed to the media. There was the concern that the gold antiquities would be quickly destroyed. Sometimes, the last link in the chain is a crucible.

WANTED
FIELD INFORMATION

THE ABOVE ARE PHOTOGRAPHS OF ITEMS TAKEN FROM THE METROPOLITAN
MUSEUM OF ART IN THE CONFINES OF THE CENTRAL PARK PRECINCT ON
OCTOBER 14, 1980.

#1 AND #2 CELTIC GOLD COINS OF THE SECOND CENTURY

#3 IRISH GOLD SLEEVE FASTNER

#4 AND #5 ROMAN GOLD PINS OF THE SECOND AND THIRD CENTURIES

#6 IRISH GOLD DRESS FASTNER

Celtic coins and early Christian jewelry information sent out by the museum to various media outlets, law enforcement agencies, auction houses, and art galleries, with a hotline number. This information was instrumental in the recovery of the art objects. THE METROPOLITAN MUSEUM OF ART

Three days after the discovery of the theft, I was at my desk in the late evening when our designated hotline rang. I answered with the hope that it might provide some genuine information related to our case. The call started off slowly. The caller wanted to know who I was, and he identified himself. He told me he had a friend who was a coin collector specializing in Celtic coins. His friend, according to the caller, knew where the Met's Celtic coins were. As we continued to talk for what turned out to be a two-hour conversation, the caller told me he wanted a monetary reward for the information he gave me. As you might imagine, the case of Ramesses VI came quickly to mind. This time, though, since the caller wasn't personally holding the stolen goods, I took the time to explain the case of our stolen ring, a little bit about possession of stolen goods, and what happened to our Lexington Avenue jeweler. There was silence on the other end. After much discussion, we made a deal. I agreed that if and when we got the coins back, the caller would get a commendation letter from the museum's director thanking him for his service to our institution. He finally gave me his friend's name and phone number. I hung up and immediately made my next call.

When this call was answered, I told the gentleman who I was and why I was calling. He sounded like he was expecting my call, and he was cooperative and congenial. Unlike his friend, all he wanted was to see the coins returned to the Met's collection. In turn, another link in the chain, he gave me the name and number of a coin wholesaler that he dealt with on Long Island. He said, simply, "He has the coins." This gentleman didn't know anything about the other objects; he just dealt with coins. Fortunately, the coins never had a chance to travel too far, because they represented the best chance for a solution. The other objects were harder to identify, less obviously of any great value, and there are few people who would have understood what they were even if they saw them firsthand. The coins, on the other hand, could be identified by collectors as was clearly the case.

The next day, Allen Gore, Associate Security Manager Joe Volpato, and I joined Detective Leotta and drove out to Nassau County, which borders New York City on Long Island. I already knew from our "ring sting" that we were in good hands with Leotta. He was a senior detective with the NYPD's Major Case Squad, and he had twenty-five years of experience as an investigator. After a short drive, we arrived at the coin wholesaler's office where we were joined by the Nassau County Police. The proprietor was waiting for us, and he turned the coins over without a question. He told us he bought them from a coin dealer in Deer Park, Long Island. Had we not found him, he told us his plan was to send them to a coin dealer in London, who would have probably auctioned them off in their next sale. Perhaps they would have been identified at the next link or perhaps they would have disappeared into a foreign, private collection and my chain would have been broken. But it wasn't. I had recovered our two gold coins and I was able to follow the chain further with the hope of recovering our early Christian artifacts.

The three of us headed straight to Deer Park, Long Island. This time, in a different jurisdiction, we would be met by Suffolk County Police. We arrived at the coin dealer's place of work and told the owner who we were. We explained that we just confiscated the Celtic coins that he had sold to the wholesaler. He understood the gravity of the situation right away. He searched among his inventory and produced a shoebox that contained our two gold dress fasteners. He told us that he didn't know what they were, and he had planned on melting them down. Unfortunately, the other two gold pins had already suffered that fate. He had no knowledge of the bronze brooch.

Even though we had reached this stage of our investigation within days, two of the museum's pieces would never be recovered. We set our sights on the last piece, but we also knew we were close to identifying our thief.

We asked the proprietor if he had a record of who sold him the coins and the jewelry, and he told us he did. He had followed a relatively new local law and documented the transaction. He even requested ID from the seller, who told him that the objects were from his grandmother's estate. The seller elaborated with details about how his grandmother found them in an Irish peat bog. Apparently, at least according to the dealer, he was believable. The dealer paid $1,800 for the irreplaceable art objects. Allen, Joe, Detective Leotta, and I stood in a small, expectant half circle as the dealer took his records out. He drew a finger across the column of purchases. Finally, it stopped on the museum's stolen antiquities. "Charles Kelly," he read and then looked up. What he saw in return was a look of surprise and disappointment.

Charlie Kelly was the custodial worker who reported the objects missing from the vitrine. At the time the coins were stolen, Charlie was a longstanding member of our staff. In fact, in the photo from chapter 1 that shows the *Mona Lisa* on exhibit, you can see Charlie guarding the exhibit as a security officer. He was promoted to a security supervisor in 1975, and in 1977 promoted again to supervisor in the Custodial Department. What had happened to Charlie that led him to commit this serious theft after so many years of good work? It was a somber return trip with both our coins, but only some of the jewelry.

The next morning, we called Charlie Kelly up to the security office. Detective Leotta was there, and he conducted the interview. At first, Charlie told us he had no idea who might have taken the objects. We explained to Charlie how we traced the objects to the coin dealer and how the dealer had given us Charlie's name. When he heard this, he broke down and confessed. He told us that he was getting divorced and needed the money.

"Charlie," I asked, because I needed to understand, "why did you give the dealer your real name and ID?"

"Mr. Barelli," he replied, "it's the law." Heartbreaking stuff.

Charlie was arrested and charged with grand larceny. He was put on probation and did not serve any time. The two Celtic coins and two gold dress fasteners are on display at the Met today in the east end of gallery 301. The two gold pins were lost forever. The bronze brooch is still missing. Charlie told us he didn't take the brooch because it wasn't gold, and at that point, we believed him. It could have fallen to the floor and been picked up by a visitor who may still have it today.

As for Detective Leotta, Benny, as I call him now, had been contemplating retirement from the NYPD when we recovered our Celtic pieces. After the investigation, we talked with him, and he accepted a position as an assistant manager of security. He started the day after his retirement and became part of the team.

As we followed this Chain of Events to our internal opportunist, we were helped along the way by local law enforcement—from New York City and Nassau and Suffolk Counties. Law enforcement at the local, state, and federal level has always been an incredible resource for the museum and helped us countless times.

But it's not always a one-way street. Sometimes law enforcement comes to the museum for assistance. The Met is encyclopedic and its staff of curators and experts unparalleled. Not infrequently, law enforcement might have an art theft case, found or confiscated art, and they need a professional to tell them exactly what they've got—and where in the world it might have come from. Two of these cases stand out from my time at the Met. One case was at the local level and involved the NYPD's property section; the other involved the FBI and artwork that was confiscated at John F. Kennedy Airport (JFK) in transit from Cuba.

By 1982, I had been promoted to associate manager of security, a position that put me second in command of the department. The assistant security manager, Ed Ryan, Eddie as he was called in the office, was a retired NYPD detective from the old school. Eddie was a short, classy guy who looked nothing like a cop, but more

like a banker. He had silver gray hair (he was sometimes called "the Gray Fox" by museum staff) and was always impeccably dressed in handmade Italian shirts and suits. He ate at the best restaurants and attended the opera regularly—usually in black tie. He had a storied detective career working out of the old Safe and Loft Squad with names like Jimmy Sullivan, a detective who went on to work for the Rockefeller family into his nineties. Eddie was a good reader of people and knew when to be nice or to turn up the heat on a suspect. He finished his police career in homicide in the Bronx at the 48th Precinct. After twenty years in the NYPD, he came to the Met in 1977, one year before me. Eddie was one of the lead detectives in the late 1970s who solved the case of the fire set at a Bronx social club by a jealous boyfriend that killed twenty-eight people. When I first arrived at the Met, Eddie and I worked as a team covering the night shifts.

One day, Eddie told me he had received a call from a former colleague and friend, an inspector who had just taken over the NYPD's property section. The property section is where evidence and confiscated property for crimes committed in New York is vouched for. The inspector was doing some house cleaning—or safe cleaning really—when he came across two pretty exquisite-looking antique, ivory pistols in a velvet case. These pistols had been confiscated in a drug bust in the Bronx in 1972. He called Eddie to ask if someone at the museum could take a look and tell him what he had. I told Eddie to refer the question to the Arms and Armor Department, knowing that Helmut Nickel and his team were the world's best when it came to antique weapons. Helmut started at the Met as a curator in Arms and Armor in 1963 and retired in 1988. He was a stern and no-nonsense colleague and exemplified a stoic German disposition. Above all, he was the foremost expert in his field. Today, the Arms and Armor galleries remain a much-visited favorite within the museum.

We called Helmut and explained the little we knew about the pistols. I asked him if it was okay for the inspector to bring the

Pistols confiscated in 1972 by the NYPD in a drug raid in the Bronx. For years, they lay in the NYPD property section, until they were brought to the Met and identified as Catherine the Great's pistols. THE METROPOLITAN MUSEUM OF ART

pistols in for possible identification (thinking we might get a general time range of manufacture, country of origin, and approximate value). Of course, it was. Along with the desire to help my department and in turn law enforcement when they are pursuing art and antiquities investigations, our curators are imbued with a natural curiosity. Every once in a while, that curiosity is well rewarded.

A couple of days later, I was in the Arms and Armor Department with Eddie, the NYPD inspector, and a case containing two pistols. The inspector put the case on the conference room table and opened it. Helmut looked at the pistols and without hesitation said, "These were Catherine the Great's pistols." His assertion, that no one doubted, that these pistols were the property of one of history's greatest and most important leaders, was astonishing.

Catherine II was empress of Russia from 1762 to 1796 and significantly expanded the empire during her reign.

Helmut then explained how he reached his conclusion. The word *Grecke* was engraved on the top rib of the pistols. And on the pistol grips there was an "E" for Ekaterine. Grecke was the gunsmith to the Empress Ekaterine. Helmut put on a pair of white gloves and picked up the pistols for a closer inspection. He told us they were made of ivory, had never been fired, a powder plunger was missing from one, and they were in excellent if not mint condition. After further inspection, Helmut said again, "There's no doubt about it, these were Catherine's pistols."

We were all elated by the revelation. It's rare that objects of such beauty, in excellent condition and of such historical importance, are brought to the museum under those circumstances. It's usually the other way around, where the object is revealed as a fake or reproduction. We thanked Helmut, who switched modes and inquired about what would happen to the pistols. He told the inspector that he'd be "delighted" to display them in his gallery. That's where you can find them today.

New York City was in possession of the pistols, and after an exhaustive search of the stolen property database, officials decided that the City of New York would anonymously donate Catherine's pistols to the Met. The Met would display the pistols for our visitors, but no one would know the story behind the recovery and how they entered the Met's collection. At the time, the Met's collection of armaments held nothing like these pistols, so they filled a void. Leonid Trassuck, a research associate at the Metropolitan who specialized in Russian arms and who assisted in the authentication process stated, "Their quality is so very high, I am almost certain they could have been used [held] by the empress herself." The craftsmanship and historical importance were at the "highest level of museum quality."

But the remarkable story of the Met's acquisition was not over yet. Before any object enters the Met's collection, the Acqui-

sition Committee has to approve it. At a formal meeting of record attended by the director, president, senior vice president of the Legal Department, and selected curators, conservators, and museum trustees, the committee will approve an acquisition on recommendations from specific curators.

When it was time to approve Catherine the Great's pistols for the Met's collection, David Schiff, a longtime museum trustee, informed the museum that the pistols had been stolen from his family, taken from the family's estate in 1972. The theft was reported to the local police at the time, but until he saw them again on the acquisition agenda, his family had considered them long lost. Mr. Schiff later told us that he remembered playing with the pistols as a young boy. Perhaps they had been quickly traded for drugs in the city—we'll never know exactly how they made their way to the Bronx. The chain was broken. After rectifying the proper ownership and provenance, the Schiff family generously donated the pistols to the Met.

These pistols had, remarkably, come full circle. Their twentieth-century history went like this: They belonged to a collector of European firearms by the name of Gustav Diderrich in the 1930s; he lent them to the Metropolitan Museum of Art from 1933 to 1935; sometime after 1935, the pistols were sold by Diderrich to the collector Clarence Mackey; from whose estate they were acquired in 1939 by David Schiff's father, John M. Schiff.

If you visit the Met's Arms and Armor galleries on the first floor adjacent to the American Wing, you can find the pistols. Their description reads "Gift of John M. Schiff, in Memory of Edith Baker Schiff, 1986."

—◦—

Soon after the United States entered World War I in 1917, the government realized the need for a modernized helmet for soldiers in the modernized field of warfare. The government looked

to Dr. Bashford Dean who was then the Met's curator of Arms and Armor. He was commissioned major of ordnance and among other responsibilities was charged with creating a new helmet for our doughboys. With other members of the museum's staff, Dean manufactured numerous prototypes and some were field tested during the Great War. Though none became the standard helmet for American soldiers, Dean's book on the subject, *Helmets and Body Armor in Modern Warfare*, was influential in the designs for helmets and body armor that followed.

In 1996, I was awarded a travel stipend funded by the *New York Times* for an exchange program between the Hermitage Museum and the Metropolitan Museum of Art. That November, I travelled to St. Petersburg, Russia, to offer my expertise to the Hermitage on the comprehensive subject of museum security. I spent a total of two weeks observing, surveying, and finally recommending security programs to the Hermitage's associate director and chief of security. On my last day, I attended a late afternoon meeting with the director, Mikhail Piotrovsky, his associate director, and the chief of security to give a briefing on my conclusions. I entered Dr. Piotrovsky's spacious office with a spectacular view of the Neva River. The three of us followed Dr. Piotrovsky to a cabinet that when opened revealed a bar with brandy and heavy crystal snifters. He poured each one of us a generous drink, and we proceeded to a small meeting table. I sat and looked out on the Neva, but what really caught my eye was what I saw on the wall behind his desk. It was a beautiful oval picture of Catherine the Great, who founded the Hermitage Museum in 1764. For one quick moment, I thought of her recovered pistols, and I felt like I had somehow provided a service to one of the world's great art collectors. The feeling was even sweeter after I'd had the privilege of spending two weeks in her palace.

But I certainly did not discuss Catherine's pistols with the director. I didn't want to cause any tension between our museums

or to open up a conversation about where he might think the pistols belonged. We did discuss various security topics, including internal opportunists and a museum's vulnerability when someone you entrust turns into a thief. Our meeting lasted an hour, and at the end, we toasted "Narzdrovia." The brandy was top shelf.

Fast forward ten years to 2005: Hermitage curator Larisa Zavadskaya, a specialist in enamels at the Hermitage and a model employee, changed from curator to internal thief. She had a great deal of opportunity. Larisa, who was in failing health, was able to stuff her pockets with jewelry, icons, silver, and (again) a golden salt cellar, though not of the quality and value of Cellini's. These items were supposedly in her care. She and her husband sold these objects to antiques dealers in St. Petersburg. The theft was uncovered after the museum conducted an audit of the antiquities in Larissa's stewardship. As the audit was being conducted, Larisa died suddenly of a heart attack while at her desk. It was ultimately found that the curator had stolen hundreds of valuable art objects. In part, she stole to pay bills for the illness that had precipitated her death.

Incidents like this force a museum to evaluate procedures and security protocols and to institute programs and checks and balances to stop future thefts. The internal opportunist is the most difficult because at some point there has to be an element of trust in your staff, especially the ones who have been trustworthy for years.

<div style="text-align:center">~~~</div>

My department pulled the Met's curatorial staff into another case in the mid-1990s. This time, it was the Federal Bureau of Investigation that called looking for assistance. FBI agents had confiscated four paintings at JFK Airport: three by Pablo Picasso and one by Camille Pissarro. The FBI had received a tip that these stolen paintings were making their way into the United States from Cuba. Now that they had them, they needed to have them authenticated.

And the hope was that this information would also reveal the location of the theft and perhaps other clues. Assistant Director James Kallstrom, who was in charge of the bureau's New York office, was our liaison on the case. Jim had been a great resource to the Security Department as we tackled issues like the threat of terrorism, which was already a concern before 9/11.

Now we had a chance to return the favor. Jim was astute when it came to investigations like this. Since he already had possession of the paintings, there was no rush to hold a press conference or announce their recovery. First, he wanted to make sure he knew what these works were; and to do that, he needed an expert in contemporary European painting. There was no one more qualified than William Lieberman, the Met's chairman of 20th Century Art (the department was renamed Modern Art in 1999). Bill was a giant in the field. He was a brilliant curator and a bit of a character who had arrived at the Met from our "neighbor" in the city, the Museum of Modern Art (MoMA), in 1979. He liked to be called Uncle Bill.

We arranged for a meeting and examination. For requests like this, Bill asked that the paintings be laid out on the table before he entered the room. Bill's entrance was priceless. He said nothing to acknowledge me or the roomful of special agents waiting eagerly for a determination. Bill looked at the first painting and said, "I don't know who painted this." He went on to the second and said, "I don't know who painted this." Then the third, "I don't know who painted this." Remarking on the first group of "Picassos," he said, "I have no idea who painted these paintings." When he got to the fourth painting, presumably a Pissarro, he declared, "And the person who painted this one should have his hand cut off." He then said, "I hope this was helpful. Nice meeting you all. Good bye." He turned and left the room as abruptly as he had entered.

Kallstrom turned to me and said, "I'm so glad we came here first. It would have been embarrassing if we held a news confer-

ence and then found out the paintings were worthless." He added, "We can't thank you enough. We really appreciate your help. And tell Mr. Lieberman we really appreciated his assistance." Just as Helmut had almost instantly validated the Russian pistols, Uncle Bill settled any question about the authenticity of these paintings. With that, Jim and his fellow agents left the museum with a bittersweet feeling. By having the paintings evaluated, they saved themselves a heap of embarrassment both from the press and presumably their superiors. On the other hand, the case of millions of dollars of smuggled artwork from a Communist country had just evaporated before their eyes. Discovering that a work of unknown provenance was not a lost masterpiece was, in my experience, the more likely outcome.

In art theft cases, the FBI gets involved if the object is worth more than $5,000. The rationale is that if these objects were transported over state lines, it becomes a federal offense and enters their jurisdiction. In 1994, "The Theft of Major Art Work" statute was signed into law. The statute made it a federal offense to steal from a museum or library. The requirements to meet this statute are the following:

The museum must be:

1. Situated in the United States;

2. Established for an essentially educational or aesthetic purpose;

3. Maintained by a professional staff; and

4. The owner, user, or custodian for tangible objects that are exhibited to the public on a regular schedule.

An object of cultural heritage means an object that is over one hundred years old and worth in excess of $5,000, or of any age and worth at least $100,000.

Now, the FBI has the National Stolen Art File (NSAF). It's a database of stolen art and cultural property. Stolen objects are reported to law enforcement agencies, and in return, these agencies submit them to the FBI's database. When an art object is recovered, the object is removed from the database.

In 2004, the FBI established an Art Crime Team (ACT). This team consists of sixteen special agents responsible for investigating art theft, in specific geographical areas, like the team of agents in New York City. My staff and I worked closely with the local ACT in art theft investigations. Today, if there is a theft of an art object, the first call would be to the ACT. This group has seasoned investigators who specialize in art theft.

So You Want to Be an Art Thief

THE LIFE OF A PROFESSIONAL ART THIEF IS NOT PLEASANT. IT'S A life that often includes incarceration, drugs, alcohol, failed marriages, and broken families. As a thief gets older, the lifestyle becomes more taxing. It becomes harder to recover from each incarceration or failed relationship. Despite what you might see in a Hollywood movie where a fit and attractive thief pulls off multiple thefts, there are just no positive outcomes to this lifestyle. As a security expert who has researched, studied, analyzed, and investigated art thefts my entire career, I've seen the reality time and again. Most importantly, I've *caught* many thieves and ushered them through the criminal justice system. Stealing art does not pay off. I'm sure the countless other thieves that have been caught and convicted would all agree—find another line of work.

By May of 1982, with my career at the Met advancing, I knew that to perform my job to the best of my ability I'd have to learn more—much more—about the criminals who threatened the integrity of the museum's collection. I was surrounded by some of the most highly educated individuals in their respective fields, and although I already held a master's degree in criminal justice, I needed to expand that knowledge specifically to the world of art and antiquities. In order to do that, I enrolled in the PhD program in criminology at Fordham University, writing my doctoral

dissertation on the subject of art theft. I had already learned a lot from my art theft investigations at the Met, but as a researcher and academic, I could step outside of my walls and learn from the people and organizations who had a much deeper knowledge base.

In 1978, I had read a paper presented the previous year in Paris by one of Scotland Yard's superintendents, Bernard Warren. Warren was in charge of the British police force's Art and Antiques Squad. In this paper, he outlined the squad's organization and functions, which seemed to hold many of the answers I was looking for. There was no group of law enforcement professionals like it in the United States. As I prepared for my postdoctoral studies, I wanted to get a professional introduction to Scotland Yard and the Art and Antiques Squad in order to meet with its members and learn what made the squad successful. I started with one of the professors who'd taught me Comparative Police Science at John Jay College. Before teaching at John Jay, Professor Philip John Stead had been the dean of academic studies at the Police College at Bramshill, England. I explained my research project to Professor Stead, and he told me to write an official at London's Home Office named Keith Jempson. The Home Office is a ministerial department of the British government that overseas immigration, security, and law and order including Scotland Yard. Mr. Jempson asked me to explain who I was and a little bit about the nature of my project. After I followed up with a formal request, I was referred to the top commissioners at Scotland Yard, who were graciously willing to accommodate my research.

I received approval from the Met's administration, and I was on my way to London. I would spend time with the Art and Antiques Squad in order to answer as scientifically as possible some fundamental questions about art and theft: Who was an art thief? Why did they steal? Where did they steal from? What did they steal? And how did they dispose of the stolen art? And what did the Art and Antiques Squad do at each step to thwart these efforts?

As I first walked across St. James Park from Pall Mall on my way to the Yard, I felt a sense of anticipation and excitement. Scotland Yard's headquarters were located on Broadway in Victoria (in 2016, Scotland Yard moved to the Curtis Green Building on the Victoria Embankment). I was anxious about how I would be received by officers there, and the members of the Art and Antiques Squad specifically. For a guy from the Bronx, it was an incredible opportunity to walk into a law enforcement institution with a world-renowned investigative history. Thankfully, the welcome couldn't have been warmer. My first meeting was with Deputy Commissioner David Powis, in charge of the Criminal Division of Scotland Yard. He was professional, friendly, and interested in my project. He said he hoped to "assist you and your great museum in your pursuit for answers about art theft." I was then introduced to members of the Art and Antiques Squad and I began my journey into the world of English art theft.

The Art and Antiques Squad, divided into two equal teams, consisted of eighteen detectives dedicated exclusively to crimes involving the theft of art and antiquities. The squad had developed intelligence on art thieves, incorporated a computerized system to track stolen art, and gathered years of statistics on art theft crimes. As I've mentioned, this was years ahead of the American approach to art theft. In addition to spending time on the job with the squad's members, I was able to access and extrapolate a great amount of information from that data.

There are entire shelves of books dedicated to the question "What is art?" But perhaps for the purposes of my field, it's worth a very brief note on the question of what defines art and antiquities. The definition of art for my purpose is applied to fine arts, which are man-made objects that incorporate beauty for the purpose of giving pleasure. Antiques, of course, derive value from their age, and frequently from the age of the fine arts that brought them to life. The tangle of arts—decorative, social and religious, commercial—is

complex and compelling. Law enforcement's focus is on protecting from and prosecuting the theft of man-made objects of value based on craft, materials, and market demands.

I'd be spending three weeks in the squad's company soaking up as much of their day-to-day work as I could. I sensed at the beginning that I'd need to win the confidence of the squad's members. In those first days, they were trying to get a sense of me and whether this outsider could be trusted. I'd seen the same thing with law enforcement back in the States, so I wasn't surprised or put off. I just had to find a way.

On my initial tour of operations, Detective Inspector Peter Taylor brought me into the art property room. Like its New York City counterpart where Catherine's pistols resided, this room was used to store art that had been confiscated as evidence or recovered on various art-related cases. The storage area was partitioned so each detective had his own space to store the valuables related to his investigations. As Detective Inspector Taylor walked me through the space and described how British detectives collected and stored evidence, I noticed a section that held far more art than the others. I asked, "Who's the detective responsible for all this art?" With a smile in his eyes, Detective Inspector Taylor replied, "That would be Detective Sergeant Peter Flaherty." I told him that I'd like to meet Detective Flaherty. I had a feeling that there was something special about him. I was able to meet him the next day, and after two weeks working together, I knew my instinct was right.

On my second day "embedded" within the squad, when I met Detective Flaherty things were collegial enough, but I could sense that I had a ways to go before I was accepted in a meaningful way. Detective Flaherty and I chatted about my research and felt each other out. He reminded me of a young Peter O'Toole—slim, tall, with piercing blue eyes and a great smile. By chance, I mentioned that I was a police officer for two years in Richmond, Virginia, from 1972 to 1974. It was like the wall came down between us.

All he wanted to do was talk about my experience as a cop. I told him I was a patrol officer in one of Richmond's worst neighborhoods, called Churchill. I had been involved in two shootouts: one with a robbery suspect, and the other with a drug dealer. Culturally, and this remains true today, the idea of police officers exchanging gunfire with suspects is unusual in Britain. It's as exotic as a Western film.

From that point on, I was introduced not as the Metropolitan Museum's security manager but as an ex–police officer. With Peter opening doors, my acceptance with the squad was solidified. I was able to ask for and receive all the information that the squad had at its disposal. He was probably the best detective I have ever worked with. Peter was witty, smart, and he had a great sense of humor. He knew how to interview victims, witnesses, and suspects. He had the true detective's capacity to read the facts of a case to solve it. He had a great deductive, investigative mind, and the personality to deal with the criminal element. His humor was pure British. When I brought up a point that did not meet his approval, he would shoot back, "John, surely you're joking." Our professional and social relationship lasted for over twenty years. We assisted each other on cases when possible whether they were in London, Europe, or at the Met. Peter retired from the Yard in about 2002, moved to the southern coast of England, and became a sea captain. The last time I spoke to him was in 2003 when he told me he was off to captain a private yacht in the Aegean Sea. He was a great guy, a friend, and fantastic investigator. And did we put away a few pints of ale in London's pubs.

As you might expect, the pub was a social hub for the squad as it remains in British cultural life. If that meant a pint (or two) at the pub with the guys, then I was willing to put in the effort to advance my research. By spending time in their circles, I let them know that I was one of them and could be trusted.

After a week, with my own identification badge that allowed me freedom of access to the Yard, I met squad members at the pub

to discuss the day's cases, began to interview thieves, and to dig through thousands of data points. I felt like I'd attained acceptance and could do a great job there.

At the top of my wish list was the chance to accompany my peers on an active investigation. I wanted to see how they handled a case that would culminate, hopefully, in the arrest of an art thief. That case turned out to be the recovery of a cache of eighteenth-century English silver, stolen from an estate in Wiltshire, England.

English silver has a centuries-long history as a fine art form and has always been attractive to the art thief. Of all countries, England produced the most fine silver objects over hundreds of years, and the craft flourished through many different eras. The first objects were fabricated for the church. As time passed and commerce developed in London, greater quantities of raw silver were brought to England from a wide range of trading partners and colonies. During the fourteenth and fifteenth centuries, silver plate adorned the homes of royalty. Prior to 1660, the English Civil Wars led to the destruction of a large amount of the country's silver plate. After the restoration of the throne under Charles II, a new generation of silversmiths began work anew on the country's fine arts. These craftsmen were influenced in design and style by the influx of foreign silversmiths who immigrated to England from Italy, France, and Germany. Also, three beverages made their appearance in England—coffee, tea, and chocolate. The popularity of these drinks necessitated new silver containers. Teapots, coffee pots, and chocolate pots became popular in England from the late 1660s well into the nineteenth century. The seventeenth and eighteenth centuries saw prosperity, which resulted in an era of luxury. English domestic silver during this time was a means of displaying individual wealth. Household wealth coupled with silver's domestic usefulness precipitated an enormous amount of production in an abundance of styles. Silver objects encompassed all aspects of the

home from table service to decorative arts. Common pieces were coffee pots, chocolate pots, tankards, goblets, mugs, drinking horns, candlesticks, salvers, tea services, cutlery services, wine coolers, ice pails, wine labels, condiment sets, and soup tureens.

Individual silversmiths became important as English silver bloomed from its utilitarian origins into one of the world's great fine arts. In 1327, the Guild of London Goldsmiths was incorporated by royal charter. The Guild required every silversmith to register and use a unique mark (hallmark) on the silver objects he created. The regulation of silversmiths, and the quality of silver they used, was also addressed through the hallmark system. In principle, the hallmark remains unchanged from its origins in the Middle Ages. Today, hallmarking laws are strictly enforced on all silver objects produced in England. English silver must go to an essay office and receive the hallmark on its way out of the silversmith's shop. The continued use of hallmarks and the records that support them is important to the collector and researcher interested in identifying the place and time of origin as well as the value—both of the underlying metal and the quality of craftsmanship. The seventeenth, eighteenth, and nineteenth centuries produced some of England's most famous silversmiths. Paul DeLamerie (1688–1751) is considered the greatest silversmith of his time. In today's market, DeLamerie's work commands a high price. Other English silversmiths of that era who have been singled out as legitimate artists are Hester Bateman, Paul Storr, Anthony Welme, Peter Platel, Simon Pantin, and Peter Archamho.

Silversmiths also worked outside of London and some of the most well-known producers across England include Peter Pemberton (early 1700s, Chester), Robert Makepeace (1730s and 1740s, Newcastle upon Tyne), and John March (early 1700s, Exeter), to name a few.

The hallmark system is explained by four marks (or in some instances five) on the finished object. These marks are embedded

directly on the object, and if you've ever owned or even examined a piece of English silver, then you've probably noticed these marks. Starting from the far left, the first and third marks identify the object as sterling silver. To earn the designation "sterling," the silver must be 92.5 percent pure, which is why you also sometimes see "925" on silver objects. The second mark identifies the date the object was made, and the fourth is the maker's mark. The maker's mark is an artisan's individual mark, which is registered at the guild. The fifth mark was introduced in 1784. This mark represents the sovereign's head duty mark, which is a mark that ensured the maker paid tax on the weight of the silver.

Obviously, hallmarks can be of enormous help for anyone trying to identify and recover stolen goods. At the same time, thieves are also willing to exploit the value of good hallmarks as they move objects through markets. They are a kind of inherent provenance for anything crafted from English silver.

On May 7, 1982, just about a week into my visit, I was able to ride along as the squad's detectives pursued a number of stolen silver objects. I accompanied Peter, Detective Sergeant Colin Bunnett, and Detective Inspector Mickey Banks to London's Bermondsey Market, which was also called the New Caledonian or sometimes "Thieves Market." The squad had obtained reliable information from an informant that a "Roger Smith" would be selling stolen silver at the Bermondsey Market that morning. As I experienced at the Met, specific information about a theft is essential to investigators. In this case, though, the detectives were not responsible for one institution, a museum, but for the entirety of the marketplace itself. Their information on stolen objects came from a wide range of sources where art and antiquities changed hands: auction houses, museum curators, antiques dealers, or just an ordinary citizen who knew something about an illicit transaction.

Roger Smith was supposed to be 6'0", 190 pounds, around thirty years old, blond, and driving a white Ford Cortina. Peter,

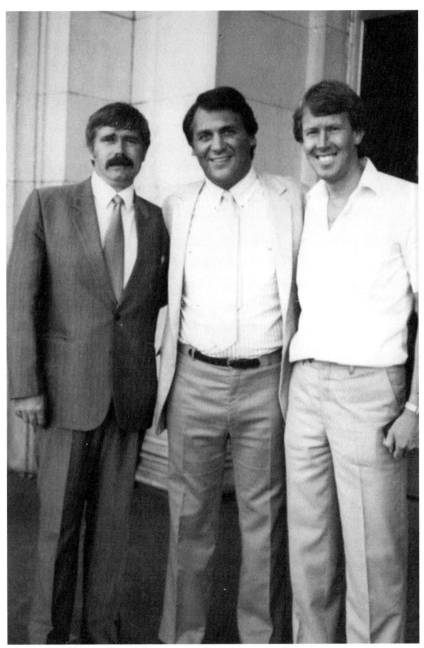

Scotland Yard detectives on the front steps of the Met, 1984, left to right: Mickey Banks, myself, and Peter Flaherty. AUTHOR'S COLLECTION

Colin, Mickey, and I set off over the Tower Bridge to the Bermondsey Market early in the morning. Like other English markets, Bermondsey opens only on certain days and at daybreak or 6:00 a.m. Much of the best business is done before the rest of the city has had its first cup of coffee. The Bermondsey Market earned the moniker the Thieves Market for a good reason. At that time, it was classified as a "Market Overt" based on English law dating back to the Middle Ages. A Market Overt designation meant that any goods sold within the confines of the market gained a good faith title between seller and buyer regardless of the history. In other words, dirty goods were cleaned in the sale, and the buyer could legally (and legitimately) claim ownership of a stolen object. As long as a sale was made between the specified hours, a buyer couldn't be prosecuted for handling stolen goods.

For obvious reasons then, the Art and Antiques Squad focused on this market. In the summer of 1994, to the delight of the art world and art squad detectives, the British Parliament overturned

Bermondsey Market sign, London, England, 1982. AUTHOR'S COLLECTION

the law that made Bermondsey a Market Overt. Though it is no longer a "Thieves Market," when we arrived early that morning, it was with the expectation that it would be exactly that. As we exited our cars, I had a Sherlock Holmes moment. Fires appeared sporadically across the market, burning in fifty-five-gallon drums in the crisp, early morning air. A mist covered the grounds with the smell of burnt wood and hundreds of stalls displayed goods of all kinds. While there can be fine arts, coins, collectibles or art of real value, there's also an endless display of bric-a-brac for sale: books, posters, household goods, pieces of small furniture, leather goods, and on and on. The market was populated by characters of all sizes, shapes, and personalities.

Within ten minutes, Peter and Detective Inspector Banks located an individual who fit Mr. Smith's description. Once he'd been identified, Peter and Mickey watched from a distance. Colin walked among the stalls and talked with dealers. Since he wasn't needed at that moment, he was already thinking about future cases. All my colleagues knew when we arrived was: Smith, stolen, eighteenth-century silver, sale at Bermondsey. They didn't know what kind of silver objects he might be fencing or where those objects came from.

The detectives saw Smith take a bag out of his car and carry it to a gentleman who stood nearby on Bermondsey Square. Smith reached into his bag and removed one silver teapot, two silver coffee pots, and two ornate silver tankards. The two men exchanged money for silver, and Smith returned to his car. We learned later that the man who bought the objects from Mr. Smith was a Parisian dealer. He would return to France that afternoon. He paid £670 for the six objects, which was well below their fair value. Without hesitation, the Scotland Yard detectives approached and confronted Mr. Smith. They identified themselves. I could see by the expression on Smith's face that he knew he had a problem. Peter did the questioning. Unfortunately for him, Mr. Smith also

had two large boxes full of silver in the trunk of his car. Peter asked simply, "Where did you get the silver?" Mr. Smith replied, "It's mine. I'm waiting for the market inspector before I sell any of it." Our suspect was unaware that he'd already been observed. When Peter asked him directly if he'd sold anything earlier, he said no. That lie was enough to arrest him for suspicion of handling stolen goods. We took Smith to the Tower Bridge police station along with his boxes of silver goods. Smith was questioned, the objects were checked against the central index of stolen art, but there were no reports on file that matched what we had. The detectives inventoried these objects for future identification. All the silver was hallmarked, so ultimately it was likely that the silver's source would be identified along with its history.

Colin Bunnett remained at the market and interviewed the French buyer. While Colin explained that he might have purchased stolen silver, this was probably not a great surprise to the buyer. Colin was a seasoned detective with years of experience in different squads within Scotland Yard. He dressed the part in tailored suits and a London Fog trench coat. When you saw Colin coming, you just knew he was a cop—a very bright one with a great investigative mind. And like most of the detectives at the Yard, he was hugely entertaining when I joined him at the pub. The dealer told Colin he bought the silver in good faith and had legal title, invoking his rights in a Market Overt. Colin took the man's name and information to be used as intelligence for future cases. There was nothing more Colin could do under those circumstances, but our French dealer couldn't make the same argument today.

Once we had returned to the Tower Bridge station house, Peter and Mickey continued their interview of Roger Smith. I was fortunate enough to be allowed to sit in for a short period of time. I watched these professionals at work. Mickey Banks was another seasoned detective at the Yard. As a detective inspector, Mickey was responsible for eight detectives under his supervision as well

Scotland Yard Detective Sergeant Colin Bunnett on the Metropolitan police launch in London, England, 1982. AUTHOR'S COLLECTION

as his team's administrative duties. He was a tough, no-nonsense detective with a dry sense of humor who would always get to the bottom of his cases. These detectives were professional and worked hard to enforce the law and recover stolen art.

For me to see these veteran law enforcement officers in action at that point in my fledgling career was an invaluable experience. It was exposure that I could not have had anywhere else in the world, and it helped me enormously in the decades to come as I worked to improve the Met's security.

After I left the interrogation room, I waited in another area of the station house. Peter and Mickey filled me in on what I'd missed. They told me they asked Smith where his silver came

from. Smith told them that he bought all the cutlery from "a bloke named Paul. I paid him £1,600 for it." Then the detectives asked where he acquired the three-piece tea service we'd seen him sell to the Frenchman. "I have a small shop in Brighton," Smith replied. "A man brought it in with other pieces of silver—thirteen in all. I gave him £1,200 for it." After two hours, Peter and Mickey were convinced that Mr. Smith was lying and that their original tip about stolen goods was correct. The problem the investigators had was that they still could not identify the silver's illicit origin. If they could not identify the silver as stolen, Mr. Smith would go free, and a judge would decide the fate of the confiscated objects.

Coincidentally, two detectives from the Wiltshire C.I.D. (Western England) had arrived at the Tower Bridge Station to ask directions to the New Caledonian Market. They were investigating the theft of a large number of silver objects from a country estate in their jurisdiction. They knew Bermondsey was a likely market for off-loading these pieces. The station's officers brought the Wiltshire investigators to Scotland Yard to meet Peter and Mickey. The detectives related that they were investigating the theft of over one hundred silver objects in their hometown. The crime had taken place three days earlier, on a Wednesday night, May 4, from a private estate.

The two teams went to work together to see if they could match the Wiltshire silver to the silver that was just confiscated. Fortunately, the Wiltshire detectives had a detailed description of the stolen goods that included information about the hallmarks. The hallmarks matched. It turned out these were pretty high-end pieces, many from eighteenth-century silversmiths including makers such as John March, William Darker, John Café, and Edward Wakelen. While it took a while for them to match the pieces that had made their way to France, most of the pieces were ultimately recovered thanks to the diligent work of English detectives and a little bit of luck.

The silver was stolen from a country estate at Winsley, near Bradford on Avon, Wiltshire. Mr. Smith had broken into the estate at night and cleaned it out. He pleaded guilty and was sentenced to three years in prison for handling stolen property. It's actually unusual in these kinds of cases for detectives to be able to tie the individual possessing stolen art to the theft itself. Usually, by the time an arrest is made, objects have moved a link or two down the chain. Mr. Smith did have an extensive record including convictions for handling of stolen property from country homes.

A year later, I attempted to contact Mr. Smith. He was still incarcerated at HR Prison, Coldingley, in Surrey, England. As I continued work on my thesis, he exemplified the kind of career art thief I was trying to understand. To my disappointment, my correspondence was returned unopened—return to sender with no explanation. This was not unusual and happened to me with the majority of thieves I wanted to interview. Out of the ten thieves I wrote about in my research project, I was able to interview a total of four. I was pleased with four interviews when you consider these individuals had nothing to gain, did not know who I was, came from a background of thievery, and were therefore probably given to suspicion. All four men were over forty years old and had been stealing art and antiques for years. They told me independently of each other that they agreed to talk with me because they were interested in my research project. They all believed that I was legitimate, would meet with them in confidence, and wanted to tell their story. All the men were tired of stealing.

The markets throughout England like London's Bermondsey and Portobello, as well as numerous markets in the seaside town of Brighton, are prime locations for thieves to dispose of stolen art objects. Foreign art dealers from the Continent (like our Parisian dealer) buy stolen art and easily carry it home. Once it's in France, Italy, Spain, etc., it becomes that much more difficult to trace or identify. A huge amount of art and antiques go through the Chunnel

or out England's port of Dover. From Dover, it's placed on ferries and hydrofoils that sail to ports like Calais and Bourgogne. Small objects can be concealed on person or carried in a bag with little worry of it being uncovered at the border. Larger objects can be moved in cars and trucks. The ease and speed at which stolen art can be transported works against the probability of its recovery.

This movement of the stolen art in an investigation is the Chain of Events. I mentioned this earlier, and it was on this trip that I learned its application in an investigation. After an object is recovered and identified as stolen from a specific venue, the investigator traces in reverse where the object was before the recovery in order to eventually identify the thief. The more time passes, the harder it will be to trace the recovery of a stolen object. Once the investigator comes to a dead end, the chain is broken and the investigation is compromised. Detectives must work quickly to notify dealers and auction houses to try to intercept a stolen item before it passes through on to the next link in the chain. The more detailed a description of the object, including photos, exact size, weight, identifying marks (such as hallmarks), accession number, and anything unique about the object, the greater the chance of following the chain to a successful recovery. The practical steps that I learned in England served me well in the decades that followed.

In addition to accompanying the detectives as they received a tip about stolen silver, intercepted the thief and the buyer at a Market Overt, and arrested the thief leading to a conviction, I spent a great amount of time in London examining the data that British police had collected over the years. Just as the Chain of Events taught me technique, this data gave me the knowledge to investigate theft and protect the museum from future intrusions. The records of the Art and Antiques Squad at Scotland Yard show that from 1981 to 1984 there were 4,055 art theft crimes reported in England. Of the more than four thousand thefts, 1,440 involved English silver, or 35 percent of all reported art thefts.

This significant percentage demonstrated that art thieves wanted to steal silver (they still do). There are specific reasons why: First, depending on the silversmith and date created, silver carries a high value; second, silver is relatively easy to fence or sell at the markets or to collectors; third, there is an abundance of English silver objects in unprotected country estates or residences.

There are other specific art objects that are attractive to the criminal element and are easy to sell at the markets. In addition to English domestic silver, there are clocks and watches, paintings, oriental rugs, porcelain objects, books, furniture, coins, icons, tapestries, stamps, drawings, prints, photographs, brass and bronze objects, ivory objects, jade objects, firearms, gold objects (jewelry), and collectibles. Of these, ivory might be more difficult today because of restrictions placed by certain countries.

Fifty-four percent of all paintings stolen in England during this period were under eighteen inches in size. A small painting is much easier for a thief to conceal (both during the commission of the theft and afterward). Regardless of the specific type of artwork or antique, smaller is better for the thieves. This information was, for example, statistical analysis that supported my "gut" about Degas's ballerinas.

Eighty-nine percent of stolen art objects in England are taken from private residences. Museums constitute only a small percentage. In the UK, there were only twenty-five museum art thefts in three years. Museums have better security systems than almost every private home. And importantly, the objects in a museum's collection are better documented, making it harder for thieves to dispose and sell them.

From 1978 to 1982, 7,511 paintings were reported stolen in the United Kingdom. Only 457 were recovered. This low recovery rate of 6 percent shows how difficult it is to recover artworks and why the focus following a crime is on the work more than the thief.

My interviews with the thieves supported the data and statistics that I had gathered at the Yard. Adam Page and John Randolph, independent of each other, both said they stole art because:

1. It was valuable.

2. There was an abundance of specific objects such as silver.

3. They detected the vulnerability of certain dwellings, especially private residences and country estates, as opposed to the well-protected museums that document, photograph, and publish their art objects. Art objects from museums are difficult to sell. There is more of a probability that someone in the art markets will notice a museum piece. These professionals were insistent that they stayed away from museums. (We'll see an example of this in the next chapter.)

4. They coveted small art objects that are easy to conceal during the commission of a theft and/or transporting them to the Continent.

5. Desirable objects were hard to identify due to lack of documentation.

6. There was an opportunity to steal without violence or weapons. Contrary to cinematic history, most art thefts are not violent crimes.

7. They had both acknowledged that prison is a hazard of the profession. You learn to do the time.

By comparison, the amateur thief, individuals like juveniles, employees, shoplifters, and opportunists, steal art objects but are not organized in their selection and disposal. The novice relationship to theft makes it easier for law enforcement and security when it comes to detection and recovery. It's ultimately hard to know

the percentage of crimes committed by professionals or amateurs. Most of the time, we have to analyze what was stolen and how—and of course the circumstances of any recovery. Of the thefts we've discussed thus far at the Met—the head of the herm (a prank?); the Ramesses VI ring (juvenile opportunism for money); the Celtic coins and early Christian jewelry (economic gain/inside job); and the Arms and Armor partisan blade (a spontaneous inside job or revenge?)—all were committed by amateur thieves.

I mentioned John Randolph above as one of the four professionals I was able to personally interview. The detectives at the Art and Antiques Squad gave me his contact information. I contacted John, and on my second trip to London in 1984, I was able to meet with and talk to him. He had agreed to meet me in Bristol, so I made arrangements to meet him at the Bristol Temple Mead railway train station. I wrote him before I left for England and gave him a date, time, location, and a description of myself and my attire. As I stood in front of the station, a car pulled up and a man rolled down the window and asked, "John Barelli?" I replied, "Yes," and opened his passenger side door. John was a good-looking man, in his late forties and in good physical condition. We shook hands, and John asked me where I'd like to talk. Drawing on my experience with the guys in the squad, I suggested we go to a nearby pub.

We settled on Ye Shakespeare, an establishment dating back to 1636 and not far from the train station. Each British pub has unique character, and this one could have been picked by a cinematic location scout.

It was the perfect place for John and me to get acquainted and to talk about his life as a thief. We hit it off pretty well, and after a few pints, the conversation flowed. I wasn't taking notes and I didn't have a recording device, because I didn't want to make John feel uncomfortable. At the end of our interview, I wrote down the key facts we discussed. John was well spoken, but unlike other thieves

I spoke with, he had little formal education. He was married three times and had three children in those marriages. John blamed his criminal career for the breakup of his marriages. As he repeated a few times over the course of our conversation, his incarceration, the act of going in and out of prison, was the biggest personal obstacle he faced. I came to view him as a lonely man who was trapped in a lifestyle that was formed in his late teens and early twenties. In the beginning, as a professional shoplifter, the attraction was easy money. The money fed a lifestyle of partying, drugs, and alcohol. The business of theft was his sole source of income. As we sat across from each other in the dark wooded barroom, he told me, "I came from a broken home where my stepfather resented me. He sent me to boarding school when I was twelve years old, and it was at this time in my life that I began stealing. On weekends, when school let us go home, I didn't. I hung around with my friends who started breaking into stores. This is when I learned how to steal and resell the goods to various markets." John spent four years in the army before being dishonorably discharged due to a smuggling conviction. After he completed his military sentence, he began to work as a thief full-time. His expertise continued mostly as a shoplifter. He mastered swiping goods, burglary—and where to sell the stolen goods. He put down his pint and said, "I wanted to get out of stealing and thievery, but the money was too good. I tried numerous times to work legitimately as a laborer but became discouraged when I would come home with £20 a day. I could make £100 or £200 per day stealing."

It was in conversations like these that I concluded the main reason for professional theft was straight up economics—not big-time money but day-to-day lifestyle. He had no legitimate skill, education, or talent to make the kind of money he wanted to finance this lifestyle. He found the path to making it through theft.

For more than twenty years, John made a living by stealing on a full-time basis. "I have committed hundreds and hundreds

of jobs that have kept me economically sound. I would make an average of £600 a week. The problem I had with the money was that the more I had the more I would spend and wanted. I liked to live good, dress well, and go to the best night spot. Over the years, some twenty-five, I was arrested and convicted numerous times and spent considerable time in prison. The majority of times I was caught was when I got too greedy. I remember stealing seven days a week for months on end. The probability was that I would get caught. If you can't handle prison, you can't last. I handle prison in three ways. One, plea bargain to a lesser charge to receive a lesser sentence. Two, once in prison try to get assigned to the kitchen, where one eats well, and also can make some money by selling food. And three, I stay away from drugs. Prison becomes a mental game, if you can handle it mentally you can do the time."

John didn't target art and antiques purposefully, but if they presented an opportunity along with other goods, he was more than willing to give it a go. Done right, it could present him with a quick profit. His professional disposition made him think about theft differently than, say, our young thieves of Ramesses's ring or our inside man and the Celtic coins. "I don't know the value of art objects, and I am not an art expert. What I do know is that I could make money by stealing and selling paintings, silver objects, gold objects, jewelry, clocks, oriental rugs, tapestries, and porcelains. I also make money by stealing and selling clothes and stereo equipment. I remember stealing a gold broach from a house that was worth a lot more than I got for it. I try to get a third of the value of the item that I am trying to sell. If I steal silver objects, I will not even bother trying to sell it for what it is worth. I usually sell it for the metal value. I don't necessarily concentrate on one type or types of objects, but instead look for the easiest opportunity. There is plenty of opportunity out there. Unprotected residences, especially large country homes and estates. They are full of valuables like paintings, silver, clocks, and jewelry. They are usually unprotected, and when

they are, the alarm systems pose no problem. The alarms are only as good as the response to them. And I usually have plenty of time to get what I want, and have enough time to get away before anyone sees me." One can also imagine that an heirloom rug, overlooked on the hallway floor, is rarely photographed or catalogued before it disappears.

John continued, "I have individual dealers who I have developed that I sell to with no questions asked. If questions are asked, it is very easy to make up a story, like we found them in our family's attic, or were in my family for years. It doesn't take much of a story." Perhaps, these items were found by an ancestor in an Irish peat bog? "I have also been very successful in taking small objects [like] silver, paintings, and jewelry to the Continent for sale to art and antique dealers. Customs is no problem. I am usually not checked, and if I am checked, the customs officer doesn't know what he is looking at. To do this, the object must've [been] small, and not unique. If you want to transport large objects to the Continent such as furniture, rugs, and tapestries all you need is an export license and a container for shipping. You can put anything in these containers. What makes me successful is that I have confidence, and I dress well. In my business, your image and demeanor is important; you must pass yourself off as respectable. The art and antique dealers I deal with are in it for the same thing I am in it for. To make money. I have had dealers ask me for specific objects such as rugs, furniture, silver, etc. What I will do is remember the specific request of the dealer and get it for him. This makes it much easier for me to sell an object. If I come across a specific object that has been requested by a dealer I am working with, I will get it. I do shop around for specific objects and wait for the right opportunity to take it. Auction houses and galleries are very easy because objects are accessible. I use my shoplifting skills. I don't go near museums; they are very well protected and the main reason is that the objects are well documented and published. There are too many other

opportunities around that are a lot easier. If you steal these objects from a museum, you are more likely to be arrested and convicted of a crime. Yes, and you know what that means, back in the slammer."

John had recently remarried and wanted to start a family. While the professional thief might avoid the traps that amateurs fall into as they move goods along the chain, the lifestyle itself is a kind of gilded trap. I couldn't help but feel that John was addicted to stealing for economic gain. Or as he said, "The money is just too good." I don't know whether John was ever able to break the cycle that led him perpetually back to prison, but I hope so. The odds, however, were not in his favor.

After my time with the detectives at Scotland Yard, I returned to New York. I brought back a fairly massive amount of notes and information I'd gathered.

In early June 1982, I returned to work and resumed my responsibilities at the Met. Our security operations were running smoothly until another theft occurred. This time, it was a theft at the New York University Fine Arts Institute at Fifth Avenue and 78th Street, a few blocks from the Met. Two of the Met's seventeenth-century tapestries, on loan to the institute, had been stolen. As academic as my work had been in London, and as much of a luxury as it was to ride along with the extremely professional Art and Antiques Squad, I was quickly thrust back into the reality of Met security and the challenges we faced.

With my newly acquired international approach, and thieves like John Randolph and his shipping containers in mind, my first reaction was to get all the information I could on the tapestries (including pictures) and send it to Scotland Yard: two large 11' x 8' twenty-three-pound armorial hanging tapestries designed by Charles Le Brun (1619–1690), woven in the Gobelins factory in Paris in the late seventeenth century. Once received, the officers there could include it in their index of stolen artwork. I began a lengthy investigation to try to determine who stole these tapestries.

I couldn't have guessed at the time, but it would take twelve years before we caught a break in the case. I'll tell the rest of this story in the next chapter.

Two years later, in May 1984, I made that return trip to London to reunite with the members of the Art and Antiques Squad. My first stop was the office at Scotland Yard: Commissioner Powis, Peter, Mickey, and Colin. Unlike my earlier visit, I was welcomed with open arms and a friendly reception.

This trip coincided with a pretty dramatic reorganization of the squad's place within the larger police force. I was surprised to learn that the squad would no longer function the way it had when I studied its techniques. The investigation of art and antiques theft would proceed at a police station level. The index of stolen art would be maintained, but would become the responsibility of the Criminal Records Office. The Art and Antiques Squad would keep an inspector and a detective in the criminal division to investigate national or—for lack of a better term—"big" art theft cases. Peter was reassigned to the CID at the Brixton Police Station. Mickey retired from the Metropolitan Police. And Colin was reassigned to the terrorist squad at the Yard. I was disappointed when I heard about these changes. As I looked back on the reorganization, I understood how lucky I was to have accessed the squad when I did. If I had tried to study the squad only on that second trip, my research would have been seriously limited. I couldn't have gathered statistics, worked on art theft cases, and interviewed art thieves. I have no doubt that I would not have been able to reach the conclusions I did, or complete my dissertation in a timely manner. Timing is everything.

Many years later, in 2013, I decided to refresh my research on art theft, this time as chief security officer at the Metropolitan Museum of Art. I contacted the Art and Antiques Squad at New Scotland Yard, such as it was then, and traveled to London. The squad was staffed by a detective sergeant and two detectives.

I met with the team to discuss art theft and verify the conclusions I'd reached in my thesis years earlier. Unfortunately, there were no statistics I could use to form a comparison because by that time art thefts were intermingled with all property crimes. That said, over the course of a week, as I spoke with the detectives in charge of what remained of the Art and Antiques Squad, the conclusions I'd drawn in 1985 about who was stealing art, what kind of art, and why, were determined to be sound.

Art thefts are as diverse as art itself. Art theft cases tend to take on a life of their own and follow their own story from the commission of the crime, to the fencing of the object, and finally the object's recovery. The one variable that is constant is that of opportunity. The thief, who is either an internal actor, an outsider, or professional, looks for that opportunity to steal without getting caught. If I was going to defend against art theft, I had to focus on presenting as limited an opportunity as possible—preferably none, of course. This was such an important part of my education on art theft, and a key factor in the building, development, and implementation of a security program to protect the Met's encyclopedic art collection. While not foolproof, as I'll show you, I was able to dramatically decrease the frequency of future crimes.

In 2015, I was invited back to London by the Scotland Yard Art and Antiques Squad to address the Museum Security Group as the keynote speaker. This group, which was organized by the squad, meets with all security directors in London three times a year to discuss varying aspects of art theft and security concerns. I was honored to address such a distinguished number of my peers on the topic of art theft and hardening a museum facility against terrorism. My address was well received at the British Museum's Hartwell Room before approximately one hundred museum professionals from the London area.

CHAPTER FIVE

The Magic Carpet Ride

MY EXPERIENCE IN LONDON GAVE ME A NEW PERSPECTIVE AS AN aspiring associate manager of the Met's Security Department. Within five years, I became the manager in charge of the department. In a nine-year span, I was promoted from an assistant security manager to the manager in charge at one of the world's largest museums. During this time—in 1985—my doctoral thesis was accepted at Fordham and I earned my PhD. Outside of academia, I used these experiences to advance a comprehensive and cutting-edge plan for the Met's Security Department. Along with the museum's administration and my security colleagues, I implemented these initiatives over many years. Key areas I developed to ensure that our Security Department was best in class were: an organizational structure with strong leadership and a professional management team that would develop, institute, and manage the security staff of six hundred; a state-of-the-art command center at the department's core to monitor technology, communicate, and coordinate emergencies; and liaisons with outside local, state, federal, and international law enforcement agencies. These were the building blocks to which we constantly added as technology improved, as we uncovered new problems and challenges, and as we worked to upgrade and educate staff. The goal was always the total protection of the Met, its collections, staff, the public, and physical plant.

Even with ongoing efforts, on June 23, 1982, art thieves struck again, although it was not within the walls of our institution. This time it was the loss of two seventeenth-century Gobelins tapestries. They were owned by the Met but had been on permanent loan to the Fine Arts Institute (a part of New York University) since 1978. They were displayed just blocks away from the Met at 78th Street and Fifth Avenue in the Duke Mansion, a handsome limestone structure completed in 1912. In 1922, art history became a dedicated field of study at New York University, and ten years later, the graduate program moved to the Upper East Side in order to teach using the Metropolitan Museum of Art's collections. In 1937, it was named the Institute of Fine Arts, and in 1958, Nanaline Duke and her daughter Doris Duke bequeathed the Duke Mansion to NYU. After a year of renovations by architect Robert Venturi, the Fine Arts Institute moved into the Duke Mansion. In addition to the masters and PhD programs, and in conjunction with the Met, the Fine Arts Institute also issued a certificate in curatorial studies. The Met has always had a close relationship with the institute and loaned many works of art that adorned the institute's interior spaces. Upon his retirement in 2008, Philippe de Montebello, a graduate of the institute, was appointed the institute's first Fiske Kimball Professor in the History and Culture of Museums.

On a slow summer morning, the administrator from the Fine Arts Institute called Met security. A short time later, Jack Maloney and I walked over to the institute and we met the administrator. After hearing her description of events, we started our investigation. Our first interview was with a Mr. William Byrne, the porter at the institute who discovered that the tapestries were missing. Jack conducted the interview with an ear towards figuring out whether we were dealing with an internal theft, an opportunistic outsider, or a professional.

The NYU Fine Arts Institute, 78th Street and Fifth Avenue, blocks from the Met, where the Met's two Gobelins tapestries were stolen, 1982. Notice the side alleyway where thieves broke into the institute. AUTHOR'S COLLECTION

Mr. Byrne told us the following, which I transcribed in my notes. "I arrived at the institute at around 5:30 a.m. and parked my car on Fifth Avenue, just south of the institute building. As I was approaching the main entrance of the institute, I was met by two uniformed Holmes security officers who said they were responding to an alarm at the institute that came in to their central alarm station at 5:00 a.m. The Holmes security officers waited outside the institute while I unlocked the door and entered the building. I went downstairs. Then I went upstairs at about 5:40 a.m., looked around, and saw that the window was broken in the Academics Reading Room and the tapestries that draped the walls

were missing. I then informed the Holmes officers and notified the 19th Precinct."

Detective Thomas Holves, of the 19th Precinct Detective Squad, and Detective James Sullivan, of the police department's Forensic Unit, responded to the institute. They conducted a search and Detective Sullivan lifted some prints off the glass window for analysis.

The two tapestries stolen:

1. Armorial hanging

 Silk and wool

 French (Paris; Gobelins), late seventeenth century

 H 9'4" W 7'1"

 Gift to the museum from Mrs. Lionel F. Strauss

 In memory of Lionel F. Strauss

 Entered the Metropolitan's collection in 1953, acc. #53.57

 Approximately 23 pounds in weight

 Value in 1982 was $100,000

2. Armorial hanging

 Silk and wool

 French (Paris; Gobelins), late seventeenth century

 H 11'2" W 8'9.5"

 Gift of Thomas Emery

 Entered the Metropolitan's collection in 1954, acc. #54.149

 Approximately twenty-three pounds in weight

 Value in 1982 was $100,000

Two Gobelins tapestries stolen from the NYU Fine Arts Institute in 1982, and recovered in London, England, some twelve years later in 1994. THE METROPOLITAN MUSEUM OF ART

After hearing about the morning's discovery, without the assistance of CCTV or any video-recording devices, Jack and I concluded we were looking at a professional job. The thieves broke through a large French door–type window that was hidden from view off of Fifth Avenue between the French Cultural Institute and the Fine Arts Institute. The location gave the thieves both the cover and the time to break the glass, enter the institute, tear the tapestries off the wall, and exit to (most likely) a van waiting on Fifth Avenue. At that time of the morning, there would have been no pedestrians and little vehicle traffic. There were no CCTV cameras outside on Fifth Avenue. We estimated that from start to finish it took the thieves at most five to ten minutes. The response from Holmes took thirty minutes, and it was a good forty minutes before the theft was discovered by the porter. Our thieves were long gone. There were at least two or as many as three thieves needed to get the job done, most likely two to break the window and take the tapestries off the wall. Each thief carried a tapestry out to a vehicle where a driver was waiting. Ten minutes and off our tapestries worth close to a quarter of a million dollars went down Fifth Avenue.

The tapestries were rare, but on the art market, they would be hard to identify as stolen if a buyer even bothered to research. If they left the country, they'd be that much harder to recover. They could have even been "ordered" by a collector just as our British thief described. If that was the case, then the location of the tapestries was most likely passed on to the thieves. They probably would have also wanted information about how the institute was alarmed and what kind of response they could expect.

Once we were back at the museum, I followed protocol and got word out to art dealers specializing in tapestries, auction houses, law enforcement, and the press. As I mentioned, I also let my professional colleagues across the pond know and provided all the details. Peter sent me the unique index number that the

tapestry case was filed under: #550/82. A small article appeared in local newspapers describing the theft of the Met's tapestries from the Fine Arts Institute. The coverage was minimal, one can only assume because they were not stolen from the museum itself. The story was not sensational enough to make the front page the way the herm and the Degas sculptures had.

I filed the British index number with all the information on the theft and waited for the next break in the case. But without any leads or incoming tips, the tapestry theft became a cold case. And it remained one for the next twelve years

On October 21, 1994, I was at my desk when a call came on my line from a woman named Gail in our Legal Department. "I believe I have a crank caller on the other line," Gail said. "It's a man with an English accent who says he's calling from London. He's saying he knows where a tapestry stolen from the Met is. That can't be from the Met, can it?" I interrupted her. "Just transfer the call to me and I'll handle it." As Gail transferred the call, I reached down and opened my desk drawer to retrieve the file on the tapestries. Could this be the break I'd waited twelve years for? I heard the transfer come through. "Hello, Mr. Barelli here. I'm chief of security at the Met. I was told you know where the Met's stolen tapestries are?" The caller replied, "Yes, I do."

He continued, "I work at the Franses Tapestry Archive, in the St. James section of London. We are devoted to the study of European tapestries. David Franses and I were offered two tapestries from a carpet dealer who deals mostly in postwar Iranian carpets in the West End. This is not unusual. We are offered hundreds of works each year. These were special and of very high quality, with distinct markings. As I did my due diligence, I examined the photos supplied by the dealer. I was able to identify that these tapestries belonged to the Met because I studied the work of Edith Standen, who was a curator of textiles there. She wrote a definitive work on all the European tapestries in the United States.

Edith Standen was a captain in the US Army during World War II. She was assigned as one of the 'Monuments Men' and was an expert in tapestries. I remembered seeing the Met's tapestries in her volume and was able to match them up with the photos. Believe me, Mr. Barelli, these are the Met's tapestries."

I wrote down the caller's number. I told him to hold tight and that I would call him right back. I hung up and immediately called Inspector Charles Hill, my current contact at London's Art and Antiques Squad. I was lucky to catch him at his desk. "Look, I just got a call from someone at the Franses Tapestry Archive," I told Inspector Hill. "Are you familiar with it? He's identified two tapestries from a photo, and he seems fairly certain that these are tapestries that were stolen here in New York twelve years ago. I can give you the index number that Scotland Yard gave me when I alerted you guys to the theft. If you could help me by running down these tapestries as soon as possible and seeing if they are in fact ours, I'd be enormously grateful."

Inspector Hill and I agreed that my caller would meet him ASAP in the lobby of Scotland Yard and take him to the location where the tapestries were being stored.

About two hours later, Inspector Hill called back. "John," he said. "Your caller, Dr. Campbell, really knows his fine arts. Very impressive. Great news. I have your tapestries in our property recovery room." The carpet dealer was an Iranian whose family had been involved in weaving and selling very fine carpets in Iran, but left during the 1979 revolution. The family settled in London and opened a carpet shop in Mayfair on South Audley Street. He was completely innocent and had bought the tapestries in good faith. He was fully cooperative with Inspector Hill and the recovery process.

My mind went back to my first visit and the tour of the squad's property room. Now, the Met's tapestries were secured there. The caller, Dr. Thomas Campbell, did indeed know his stuff. Six months

later, he became the Met's assistant curator in European Sculpture and Decorative Arts (ESDA). In 2009, Dr. Campbell became the ninth director of the Metropolitan Museum of Art. It never failed to amaze me that a call our Legal Department thought was perhaps a hoax ended up coming from the museum's future director.

My original plan was to get on a plane, fly to London, and return with the tapestries. I could also spend time with Inspector Hill, and we would try to follow the links of the chain backwards from recovery to theft. But Ashton Hawkins, the Met's vice president and legal counsel, told me that it wasn't that simple. Since the museum had settled the loss of the tapestries with our insurance company over a decade earlier, the tapestries were actually the property of the insurer now that they were recovered. First, we had to buy back our tapestries, which we did for $225,000. Then we had them shipped back to us in New York City.

Today, the tapestries are still in Textile Conservation, and hopefully will be put on view in the Met's galleries. As far as the follow-up investigation, Inspector Hill notified me that the tapestries entered England and the City of London from a dealer in Rome with ties to New York City. I sent that case information to the FBI Art Squad in Queens, New York. After some preliminary investigation by the FBI, the case hit a dead end and the file went into cold storage. I was thrilled with the recovery of the tapestries—as was the administration and the curators in ESDA. Recovery of the tapestries was paramount in the investigation. While it would have been good to catch our thieves and hear from them how they executed the crime, having our artwork recovered was a great reward. In art theft investigations, the recovery of the stolen object is paramount and the identification of the thief secondary.

As for the Institute of Fine Arts, it continues to thrive as an educational foundation. If you are interested, they have a rich lecture schedule available to the public and offer many of these lectures through online streaming.

On March 18, 1990, a major art theft was successfully executed at the Isabella Stewart Gardner Museum in Boston, Massachusetts. The work of a group of professionals, the Gardner theft is the kind of heist most people think about when they imagine a museum being robbed. It has also captured the popular imagination because of the artwork involved and the fact that the case was never solved. I'm certain it was a professional job, because when you analyze the facts, certain elements stand out. In the early morning hours at approximately 1:10 a.m., two thieves disguised as police officers tricked the museum's security guards into opening the door. The "cops" told the guards they were answering a disturbance call. They were allowed into the museum. Once inside, they restrained the guards with duct tape and then handcuffed them to a pipe in the museum's basement. There was no violence, which is also a professional trademark. It's almost a certainty that the thieves received some kind of help from the inside. After they gained access to the museum and neutralized the security guards, they were free to roam the museum for approximately eighty minutes. The alarm system was strictly monitored from within; the only alarm going to outside help was a panic alarm located in the security-monitoring office, which was never activated. They collected whatever they wanted. The videotapes were also taken by the thieves as they left the museum, which was of course a major blow to the following investigation.

In all, thirteen art objects were stolen. After twenty-eight years, all thirteen are still missing. One thing that always bothered me about the Gardner theft was the selection of the objects that were taken. The thieves had ample time to remove anything they wanted. But they bypassed incredibly valuable artwork by Titian and Raphael in order to take a Chinese bronze beaker and a gilt gold finial in the form of an eagle. The thieves also cut paintings

from the frames, which would have caused significant damage to the canvasses and diminished their value.

The most valuable works they took were the five oil paintings: one by Johannes Vermeer, *The Concert*; two by Rembrandt van Rijn, *The Storm on the Sea of Galilee* and *A Lady and Gentleman in Black*; one by Govert Flinck, *Landscape with Obelisk*; and a small painting by Impressionist painter Edouard Manet. The other eight items taken included five drawings by Degas, a tiny etching by Rembrandt, and the two decorative arts objects mentioned above. In total, it amounted to a truly bizarre selection. Since there was little physical evidence and no video recording, the FBI took a good look at the stolen inventory in trying to determine who was behind the crime. A true thief might have only stolen the Vermeer, one of only thirty-four in the world. As we've seen, it can be tricky to ransom works, but the Vermeer is so valuable that focusing on one work would have made much more sense than spending an hour and a half stealing prints and decorative arts. The breaking and entering was well done, but artwork was damaged and the selection of works made no sense. While it came to be known as "The Art Theft of the Century," it was likely committed by professional thieves who knew absolutely nothing about art. I ended up agreeing with the FBI's eventual assessment that it was the handiwork of a bumbling confederation of Boston gangsters and out-of-state Mafia middlemen, many of them now long dead.

The statute of limitations for the crime has passed. Various rewards were offered from $5 million to the present-day reward of $10 million. There have been no takers. Whether the thieves might ever be identified and prosecuted remains unanswered, but the focus never strayed from recovering the artworks.

In 1997, a reporter for the *Boston Globe* was given paint chips (supposedly from a Rembrandt painting) by an individual who said he knew where the stolen art from the Gardner heist was located. In 2003, working with the FBI and a private investigator, I set up a

meeting with Hubert von Sonnenburg, the Met's chairman of the Sherman Fairchild Paintings Conservation Department. Hubert was one of the world's leading conservators and an expert on seventeenth-century Dutch painters who had published numerous studies on the painting technique of Johannes Vermeer. He agreed to examine the paint chips that were then in the FBI's custody. On October 8, 2003, Special Agent Geoffrey J. Kelly, retired FBI Associate Director Larry Potts, who was hired as a private investigator by the Gardner Museum, and I brought the chips to Hubert's office. Hubert said he would examine the chips by electron magnification to determine the makeup of the paint composition. Through this process, he could see if it matched paint layers found in a seventeenth-century Rembrandt or a Vermeer. A week or so later, Hubert had his results. He positively identified the chips. He told me, "John these chips came from a Vermeer painting, and I

A magnified picture of the paint chip in the Isabella Stewart Gardner Museum theft. PERSONAL PHOTO

believe it was *The Concert*." He handed me a technical photo of the chips and explained how what I saw authenticated the paint. There was one cross-section that specifically matched the profile he was looking for. When someone of Hubert von Sonnenberg's stature gives you his opinion, as with Uncle Bill, you can take it as gospel.

The fact that a paint chip had been handed over to a *Globe* reporter eight years after the theft meant, to me at least, that someone was holding the Vermeer and it had not been destroyed. I think the paintings and other objects are still out there somewhere—in a storage unit, an attic, a basement, or at a flea market or waiting to be offered at an auction house or by an art dealer. Someday, whether it is thirty, forty, or fifty years from now, the right person will bring them forward, or notice them as the stolen paintings or objects from the greatest art theft of the twentieth century. The real concern is the fragility of seventeenth-century paintings by Vermeer and Rembrandt as well as the works on paper by Degas. These works need ideal environments—temperature, humidity, and exposure to light—to ensure that they will not deteriorate. The key to the recovery of these paintings and drawings may actually be the Chinese bronze beaker and the gilded eagle finial. They will hold up better over time and are less known. They just might be out in the marketplace today waiting to be noticed by the right individual who puts them together with the Gardner. Fingers crossed.

———

After the theft of the Met's tapestries, even though they were not stolen from the museum's grounds, there was a nice stretch of time without any theft-related issues. This allowed us to spend as much time as possible looking ahead as well as addressing my department's day-to-day responsibilities. I continued to work on the master plan, especially in the area of recruiting and training programs.

In 1985, for the first time in my professional career, I became aware of the need to be concerned about the possibility of terror-

ism. The primary threat was specifically some kind of domestic terrorism. My boss, Joe Volpato, put me in touch with Kevin Hallinan, who was the executive lieutenant of the NYPD's 19th Precinct (Joe and Kevin had worked together in the robbery squad). Lieutenant Hallinan had worked with us on the investigation of the tapestry theft. But Hallinan and I found ourselves working together again when he was promoted to become co-commander of the Joint Terrorist Task Force (referred to today as the JTTF).

The development of the task force went back to 1980 when the number and frequency of bank robberies in New York was going through the roof. To combat this, the NYPD and the FBI joined forces. The combination of federal and local enforcement resources worked, and within a year, the crime rate in this area was declining. This approach was soon adapted into a joint task force to fight terrorism. Before 9/11, there were thirty-five Joint Terrorist Task Forces in the United States. Today, there are over one hundred JTTFs nationwide.

A short time after Kevin took over command of New York's JTTF, he called me. He wanted to discuss a case he was working on. During the 1970s and 1980s, groups like the FALN, Weather Underground, the SDS, and the Symbionese Liberation Army were a serious issue for the city's safety. The MO for these groups was unpredictable pipe bomb attacks on high-profile but soft targets. By contrast, international terrorism wasn't on the radar in the city until 1993 with the first World Trade Center bombing, and the weapon of choice for these international groups was more likely something like a truck.

Kevin told me his task force had a suspect who was working in our restaurant. He believed this individual was involved in a bombing. You can imagine how unsettling that possibility was, and of course, my department would do everything it could to help. Kevin needed a set of fingerprints to see if they matched prints lifted at the crime scene. I told Kevin that all of the Met's employees are

fingerprinted and we had those prints on file. Kevin was then able to secure the prints through appropriate channels. The prints we provided and those found at his crime scene matched. This person was arrested, indicted, and ultimately convicted. Kevin retired from the JTTF and the NYPD in 1986 to become the senior vice president for security and facilities for Major League Baseball. Everyone in New York and those of us at the Metropolitan Museum owe him a debt of gratitude for his work.

I was always concerned with a threat or attack by a terrorist group or individual. I mentioned the first World Trade Center bombing, and not everyone is familiar with, or even aware that, there had been an earlier attempt to bring a tower down prior to September 11, 2001. On February 26, 1993, at 12:17 p.m., a truck bomb was detonated in the garage of the World Trade Center's North Tower. The plan failed, but six people were killed and 1,042 were injured. Islamic fundamentalists were responsible for the attack. This attack fundamentally changed the way I looked at our security defenses. A principal concern was the Met's vulnerability to vehicles, especially vans and trucks. The museum had constant shipments in and out that came through our loading docks and parking garages. We were advised to have sentry booth checkpoint searches around the clock as well as hydraulic bollards to control vehicle traffic. The security checkpoints were instituted then, but the bollards to harden the museum and make it less vulnerable to a vehicular attack weren't added until after 9/11. As was seen in New York City as recently as the Halloween truck attack on bicyclists in 2017 that killed eight, protecting people and institutions from vehicles that are used as weapons is an ongoing issue. But we did everything we could at the Met to address the problem in 1993 and again in 2001.

My relationship with the JTTF continued throughout my years in charge of security and was invaluable in keeping our institution, its patrons, and employees safe. I developed a close work-

ing relationship with John P. O'Neill, the FBI agent in charge of counterterrorism. John was very helpful in 1999 when our director, Philippe de Montebello, and associate director, Mahrukh Tarapor, traveled to Iran. They went there to meet with the Iranian cultural minister and to explore future collaborations and exhibitions. John directed me to the US State Department and specifically Christopher Stevens, who was in charge of the Iranian Desk there. Chris Stevens worked with me for months. He introduced me to the Swiss ambassador to Iran, the Honorable Rudolf Weiersmuller, who met with Philippe and Mahrukh in Iran. The ambassador made sure the trip went smoothly and my colleagues had a successful trip. Stevens went on to become ambassador to Libya, and on September 11, 2012, he was assassinated by terrorists in Benghazi, Libya, at the age of fifty-two.

As I've mentioned elsewhere, the Met's relationship with law enforcement was give and take, so when John asked me for a favor, I was happy to help. The FBI and specifically the JTTF needed some technical assistance with their surveillance systems. What we had developed at the Met through our research-and-development section was exactly what they needed. I put John's technical team together with mine to give them the technology they needed. With our help, John's counterterrorism mission was carried out across various locations around New York City. They gained valuable information on terrorist activities. I was glad we could help the bureau as it sought to keep Americans safe in New York and around the world.

John called me in June 2001. He said that he would be retiring from the FBI. John being John, he wanted to know if he could hold his retirement party at the Met. Maybe at the Temple of Dendur? I said, "John, do you have $50,000? Because that's what it will cost." There was silence on the other end. I said, "John, did you hear me?" "Yeah," he said. "Well I guess I won't have my party at the Met." And he chuckled. "Sorry, John. I really wish I could

do something." He understood. I asked him what he would be doing after he retired. He told me he had two offers to head up security departments: one at the Sony Corporation and the other at the World Trade Center. I suggested John stay away from the Trade Center, mentioning that it's a real headache to secure, not to mention the politics (it's controlled by the Port Authority, which is a two-state agency between New York and New Jersey). John took the job at the Trade Center.

On September 11, 2001, I arrived at the Met as usual at 7:00 a.m. It happened to be a beautiful late summer day with clear skies and temperatures in the seventies. I always looked forward to arriving at work. Every day at the Met was different: exciting, challenging, and sometimes stressful and difficult. This turned out to be one of the most stressful, difficult, and challenging days of my career.

"Mr. Barelli, you really have to come in here and see this," my loyal and longtime assistant security manager Amy Vasquez called to me. Amy was in our conference room watching the live broadcast that so many of us saw that morning. As we watched the TV, we saw that a plane had struck the North Tower of the World Trade Center. It was a sight of unimaginable destruction. As I sat at the conference room table with my management team, our first impression was that it was a terrible accident. Decades earlier, a plane had inadvertently crashed into the Empire State Building. But that opinion changed the moment we saw a second plane hit the South Tower. Everyone around the table realized that it was no accident. America was under attack. I immediately called the president and director to inform them of what happened. I told them that I believed it was a deliberate attack, most likely from an Islamic fundamentalist terrorist group. I thought of John's concern with Islamic fundamentalism and the 1993 bombing, and I wondered if he was at the towers and how he was. I didn't learn until a week later that he perished in the North Tower when it collapsed. It was his first week as security director. John O'Neill was a great

colleague, mentor, and most of all a great friend. It was a sad day when we lost John.

As I got off the phone, all I could think of was my family: my wife, Anna, and sons, Peter and Andrew. We lived down on the Lower East Side not too far from the Trade Center. My sons were in school, and Anna was at home. I knew I had to get in touch with Anna ASAP. I called, but the line was busy. No one knew what was coming next. There were incoming reports then of the attack on the Pentagon and a plane crash in Pennsylvania. I knew what responsibilities I had in front of me. We had to make some critical decisions to make sure the museum and art collections were secure. However, the overwhelming feeling of insecurity only got worse as the morning proceeded.

A meeting was immediately convened in the director's office. As I left my office, I went onto the adjacent roof garden. I looked south and saw a large plume of black smoke rising over the city-scape. What I had seen on TV was real. That plume of smoke was where the Trade Center stood and it stayed there for days to serve as a reminder of what had occurred.

After I entered the director's office, we were soon joined by Director de Montebello, the chairman of the board, Jamie Houghton (who just happened to be at the museum for a meeting with the director and president), President David McKinney, Senior Vice President Emily Rafferty, who became president of the Met some years later, and other museum officials.

Our discussion about what steps we needed to take took place as we all had our eyes glued to the TV screen. To our utter shock, we watched as the South Tower collapsed at one minute to ten. A terrible quiet permeated the room. Twenty-nine minutes later, the North Tower collapsed. Decisions had to be made. I recommended that we immediately close the museum and shut down all garage operations. Everyone present agreed. I executed the order, and the museum's visitors were evacuated in an orderly manner.

All employees were dismissed except for essential staff in security and maintenance. The museum was on lockdown and our night-time security protocol was instituted.

I tried Anna again. It took some time to get through. Finally, the phone rang. Anna said she was fine, but she was really upset. She had picked up the boys from school, and they were all safe and at home. I knew Anna could handle the situation there. I stayed overnight at the museum for the next two days to oversee security and maintenance operations. The decision not to go home and be with my family was difficult. In my position, I was the one, along with my incredibly brave security staff, who had to make sure the museum was protected. The city was at a standstill.

On Wednesday, the day after the attacks, we had a better understanding of what had happened and who was responsible. Four hijacked planes were used as weapons against the United States of America. Two planes were crashed into the World Trade Center towers, one into the Pentagon, and the fourth was brought down in a field in Pennsylvania by brave American heroes preventing what probably would have been an attack on the White House. Mayor Giuliani did a lot in the days following the attack to help bring the city back to its feet. The Met's administration and leadership followed the mayor's lead as we all tried to return normalcy to the city as quickly as reasonable. We opened the museum to the public on Thursday, just two days after the attacks. The museum became a refuge for both New Yorkers and tourists as they sought an escape from the horrors of what had occurred. The day we re-opened, we welcomed over seven thousand visitors. I think our ability to share our resources with the city was a testament to the Met's entire staff. I finally made it home on Thursday evening after we closed the museum. I walked down Fifth Avenue all the way to the Lower East Side. The city was like a ghost town. Almost all the shops on Fifth were closed. I wondered if the city would ever rebound from this devastating attack. As I walked and looked

into the faces of the few people on the streets, I knew exactly what they were thinking. It was the same thing that was going through my mind. This had been the worst attack in history on the United States of America homeland. It was the only thing any New Yorker could think about—all the innocent lives taken and the utter devastation. It was a great relief to finally get home and see my wife and boys.

The attacks on September 11 changed the way security professionals looked at buildings, facilities, and their security. New methods had to be incorporated into a security program to defend against the possibility of a terrorist attack. Security professionals were again using terms we had addressed in 1993 like *soft target*, *hardening a facility*, *bomb blast protection*, *bag checks*, *electronic wedges or bollards*, *vehicle inspections*, *network video systems*, *command center*, *perimeter security*, *ID card access*.

Working with the JTTF, the NYPD, Intelligence and Counter Terrorism, and the Central Intelligence Agency, I developed contacts to support the museum with intelligence and information on terrorism. Specifically, I turned to the NYPD Intelligence Division and Counter Terrorism Unit, headed by Deputy Commissioner John Miller. This unit supported the Met with manpower and intelligence to harden the museum against a terrorist attack.

I originally met John Miller in October of 1981, which happened to be the same month the Celtic coins were stolen. We met while John, who was a young investigative reporter, covered the story of our recovery of the coins and early Christian jewelry for local station WNEW. I remember John as a terrific investigative crime reporter. He did some of his best work covering the Mafia—specifically John Gotti, the Teflon Don. John moved on to WABC and co-hosted *20/20* with Barbara Walters. In 1998, working for WABC news, he interviewed Osama bin Laden in Afghanistan. He left journalism and took various positions in law enforcement. He was in charge of counterterrorism with the

L.A. Police Department, an assistant director of information with the FBI, and his present position is deputy commissioner of intelligence and counterterrorism with the NYPD. John set up a number of conferences on combating terrorism for cultural institutions that were hosted at the Met. I moderated these panels and I'd like to think they were helpful to a large number of institutions that share our goals.

—~—

As I've discussed, terrorism was just one of the serious problems I had to think about on a daily basis. There was art theft and recovery, vandalism, fire, accidents, medical emergencies, extreme weather conditions (hurricanes and snowstorms), crowd control, active shooter and workplace violence programs, evacuation drills, and the protection of the public, staff, collections, and facility. My staff and I had to be prepared to act and to solve all of these problems. This is where our security programs, procedures, communications, training, and liaisons with outside agencies (law enforcement, fire departments, and emergency medical departments) would shine in response to any and all emergencies and difficult situations. The Met is what I call a horizontal structure, spread out on twelve acres with the majority of the building only three stories tall. Because of this, I was able to isolate emergencies to specific areas not affecting the whole museum. By contrast, in a vertical structure like an office tower, no matter where the emergency is located, it will affect the entire building. An emergency, accident, or flood in the Temple of Dendur or American Wing could be isolated while the rest of the museum stayed open.

As unlikely as it might first seem, extreme weather such as hurricanes and snowstorms has always been a concern. Two memorable hurricanes come to mind: Hurricane Irene on August 28, 2011, and Hurricane Sandy on October 28, 2012. The threat during these two hurricanes was the extreme rain and wind against which the

museum is not invulnerable. Rain causes leaks that might over-whelm the drainage systems and lead to interior flooding. And wind could damage our roof and expose the interior to water and debris. The strongest resource in any emergency response program is the staff, and there is no staff more dedicated and professional than the staff at the Metropolitan Museum of Art. The Director's Office, President's Office, curators, conservators, security personnel, and maintenance staff all work together as a team to prevent and respond to leaks, floods, and structural damage, thus protecting the art collections. In 2007, to reinforce the team concept, the Director's and President's Offices created the Curatorial Response Teams (CRT). These teams consisted of curators and conservators who were responsible for specific art areas and would mobilize when art was in danger. The CRTs coordinated with security, main-tenance personnel, and outside agencies if necessary to respond to emergencies involving works of art, and their response was critical during Hurricanes Irene and Sandy. The teams were mobilized and stayed overnight at the museum. During a twenty-four-hour period, they covered and moved numerous art objects away from leaks caused by the driving wind and rains.

CHAPTER SIX

Opportunity Strikes

THE MOST VULNERABLE INSTITUTIONS FOR OPPORTUNISTIC THIEVES are libraries, especially rare book and document archives, historical society archives, university and museum libraries, and museum print study rooms. Esteemed institutions that have experienced opportunistic thefts at the hands of the outsider, the professional, and the inside man are the Library of Congress, the National Archives, Columbia University Library, the New York Public Library, New York's Museum of Modern Art, and the Metropolitan Museum of Art's print study room. Even as I write this in the fall of 2018, a years-long, major theft targeting the Carnegie Library in Pittsburgh has made international news.

In 1992, ten years after the theft of the Met's tapestries from the NYU Fine Arts Institute, and two years before their recovery, four objects disappeared from the Jefferson R. Burdick Collection in the Met's print study room, a part of the Prints and Drawings Department. These stolen objects are hardly what you'd expect to find at the Met. They were baseball cards.

In 1947, Jefferson R. Burdick, a Syracuse electrician, donated his collection to the Metropolitan Museum of Art's Prints and Drawings Department. The collection he had amassed over a lifetime included approximately 330,000 postcards, advertising inserts, posters, and some thirty thousand baseball cards. The collection

included the holy grail of baseball cards: the Honus Wagner 1910 pristine White Border series (T206) for the American Tobacco Company. These baseball cards were stored in albums that contained full sets. It was one of these albums that was compromised by an outside opportunist in the prints department study room. Three of the missing baseball cards featured Mickey Mantle and one the "Say Hey Kid," Willie Mays.

Out of the blue, on November 5, 1992, at approximately 1:30 p.m., a call came into the security office. The caller told Jack he had a young Asian teenager in his collectibles store trying to sell him baseball cards that he believed belonged to the Metropolitan Museum of Art. Jack's reaction was one of both skepticism and interest. Our office received a number of calls every year from individuals who claimed they had found or bought art objects that belonged to the Met. After questioning these individuals about what they (thought they) had, it was usually determined that these objects were reproductions. It was not unlikely that they were from the Met's merchandising department with an MMA stamp on them. Every call had to be taken seriously, though, to make sure that the object wasn't a real piece of art from the Met's collection like our Ramesses ring and French tapestries.

This call was different. Jack knew that the Met did not reproduce baseball cards. And he also knew that we had an old cold case involving a rare card. In 1982, a missing 1933 Babe Ruth card from the Burdick Collection was most likely stolen. The caller also stated "that on the back of each card one Willie Mays and two Mickey Mantles was a stamp identifying 'The Metropolitan Museum of Art, New York.'" Jack knew he had to act quickly if he was to recover the baseball cards. He convinced the shop's owner to stall the teenager so he could have the police respond. After he hung up, Jack contacted the 6th Precinct on 10th Street in the West Village. The shop was located not far from there on Sullivan Street, and Jack explained the situation

to the desk sergeant. The sergeant dispatched a patrol car to the collectibles shop.

Jack filled me in on his call. After he explained the case and mentioned Mickey Mantle, I had a flashback to my own childhood in the city. I went to Yankee Stadium with my friends at least once a week during the 1960 and 1961 seasons to see Mantle, Maris, and of course Yogi Berra. We took the 6 train to 125th Street, then switched to the 4 to 161st Street: Yankee Stadium. We paid fifty cents and sat in the right-field bleachers next to the Yankee bullpen. What memories—it was a golden age for baseball in New York.

In a follow-up conversation shortly thereafter, Jack told me, "John, I just got a call from the sergeant at the 6th. He said they arrived at the store on Sullivan Street and confronted the teen who was trying to sell the Met's cards. He admitted stealing them from us last week. They've arrested him for grand larceny and possession of stolen property. We recovered the three baseball cards, a Willie Mays and two Mickey Mantles." I replied, "Jack, great job. Call Colta Ives and fill her in on the recovery." When Jack called Colta to tell her that we recovered the baseball cards, she gave us some disturbing news. She said, "My departmental technician, while checking the albums, found a fourth card missing from the same pilfered one. It was another Mickey Mantle card, 1954 Bowman number 65." Well, Jack got back on the phone and called the sergeant and assistant district attorney and told them that we were missing another Mickey Mantle baseball card. The teen had to be the culprit. For whatever reason, though, when questioned by the assistant DA, the kid said he didn't take that 1954 Mickey Mantle. He was adamant that he did not take the card, and to this day, the 1954 Mickey Mantle Bowman #65 is still missing from the Burdick Collection along with the 1933 Babe Ruth card. The teen pleaded guilty to grand larceny in the third degree and was sentenced on April 13, 1993. Because he was a juvenile first offender, he was sentenced to five years' probation.

Our investigation continued so we could analyze how this young opportunist was able to steal the baseball cards in the first place. For years, the Met has given scholars and select visitors access to the print study room to view the collection. In order to view these baseball cards, an individual would contact the prints department and make an appointment. According to the department sign-in sheets, our young opportunistic thief signed in on two different dates a week before his arrest. He produced false ID with a bogus name and address. His motive was simply to steal the baseball cards and sell them for ill-gotten gains. When the thief accessed the album, he waited for the right time and slipped the cards out of the album sleeves. As discussed, the small size of these cards presents an attractive target. You don't see them as much today, but there used to be many small shops throughout the city that bought and sold comics, baseball cards, and other kids' collectibles. Our thief easily concealed the cards in his pocket, returned the album to the prints department technician, and walked out of the museum. Opportunity strikes.

The baseball cards:

1. Mickey Mantle 1951 Bowman Baseball Card #253, recovered

2. Mickey Mantle 1952 Bowman Baseball Card #101, recovered

3. Willie Mays 1951 Bowman Baseball Card #305, recovered

4. Mickey Mantle 1954 Bowman Baseball Card #65, still missing

The collectibles market is an area that has always attracted opportunistic thieves. This market includes items such as sports memorabilia, historical autographed items, historical documents, maps, and known artist prints and drawings. Given the opportunity, these items are abundant, valuable, easy to conceal, and sell

on both the legal and suspect markets. The important element that aided in the recovery of the Met's baseball cards was that the cards were marked on the back "The Metropolitan Museum of Art, New York." If the stamp was not there, the cards would never have been recovered. Most collectibles, however, are not marked and are easy to sell in the secondary markets. The value of these baseball cards has increased tremendously from 1992, when they were valued at approximately $2,000 apiece. A similar 1951 Bowman Baseball Card #253 that was stolen from the Met and recovered was auctioned off in 2018 for $700,000. The only other cards with more value were the Honus Wagner T206, sold in 2016 for $3.3 million, and the 1952 Topps Mickey Mantle, sold in 2018 for $2.88 million. These collectibles have attracted all three kinds of opportunists.

Along with recovery of the baseball cards, my job was to learn from this theft and do what I could to make sure it didn't happen again. There was some negative history with allowing visitors to view works in the prints department, whether they were priceless Rembrandt prints or baseball cards. In 1972, an individual by the name of Theodore Donson was given access to the Met's prints collection. He waited for the opportunity to steal numerous prints, exactly as our young thief did. After reviewing specific prints, he slipped them in his portfolio and left. Donson was a practicing attorney who saw an opportunity to steal prints from the Met in order to sell them. He placed ads in various newspapers to advertise Rembrandt and Degas prints for sale. The break in the case came when a staff member at the Met's information desk received a telephone call from an anonymous tipster. The caller stated that there were prints that belonged to the Met in a locker in Grand Central Station, locker #6281. Sound familiar? When police opened the locker, they found two envelopes. There were seventeen of the Met's prints including works by Degas, Duvet, Toulouse-Lautrec, Brueghel, Hopper, Cassatt, Rembrandt, and Holbein. They also recovered prints and a rare book from the New York Public Library

and prints from the MoMA. The New York City police detectives quickly zeroed in on Mr. Donson and the frequency of his visits to the Met. He was confronted by the police and confessed. He was arrested and charged with criminal possession of stolen property. He pleaded guilty and was sentenced to five years probation with the stipulation that he submit to psychiatric treatment. He also lost his license to practice law.

University rare book rooms, museum libraries, and museum prints and drawings departments, with collections of prints, maps, historical documents, and rare books, are vulnerable to opportunistic thieves. To foster scholarship and studies, private scholars, students, and visitors are given access to these rare materials—as was our teenage thief at the Met. This vulnerability was beautifully chronicled in Michael Blanding's book *The Map Thief*. In the book, Blanding tells the story of an individual named Forbes Smiley III, an expert on historical maps dating back to the 1500s. He was a map collector and dealer who assisted in building the collections of both private clients and public institutions. The only problem was that he did a lot of his "building" by stealing historical maps from libraries and then selling them. This opportunistic thief targeted libraries for over twenty years from the 1990s to 2005. Institutions included the New York Public Library Rare Book Division and Map Division; Yale University's Beinecke Rare Book and Manuscript Library, and Sterling Memorial Map Collection libraries; the Newberry Library; Harvard University, Houghton Library; the British Library, Map Library; and the Boston Public Library, Rare Books, and Norman Leventhal Map Center. He would visit these institutions, locate what he wanted, and then wait for the right moment to slip mostly rare and valuable maps into his pocket or portfolio. As a dealer, he was able to easily sell his recently pilfered maps. This was a classic professional opportunist who knew well where he could sell his works. In the end, his luck ran out when he was observed by staff at Yale University's Beinecke Rare Book

and Manuscript Library concealing maps. He was subsequently arrested, prosecuted, and sentenced to four years in prison, of which he only served three and a half years. He also had to make restitution of almost $2 million. His light prison sentence was due in part to his cooperation in the recovery of the maps he had stolen. Of the ninety-seven maps that Smiley said he stole, eighty-nine were recovered and eight are still missing. This case forced library institutions including the Met to bolster their security programs in these areas.

From the 1970s through 1999, the CCTV recording systems used by libraries and museums were not what they are today. In all of the investigations prior to the late 1990s, the CCTV systems were of no help because the recording systems were inadequate or nonexistent. This is not the case today at most museums and libraries. Presently, the Met has an extensive, advanced, state-of-the-art CCTV recording system. These systems serve a dual purpose. First, they act as a deterrent; and second, they can be an incredibly effective investigative tool should a theft occur. In 2005, I recommended that the museum establish a five-year plan to install the latest state-of-the-art CCTV network recording system in all the museum's galleries. With the endorsement of the museum trustees, Director Thomas Campbell, President Emily Rafferty, and Senior Vice President for Legal Sharon Cott, the program was approved and completed in 2010.

To specifically address how to protect our baseball cards, the museum set aside a special gallery within the museum's American Wing. The baseball card exhibition gallery would rotate cards every six months to give the public the opportunity to view the cards without giving them the opportunity to steal them. We were able to take away opportunity from the outsider and professional by eliminating hands-on visits to the prints room.

In the late 1990s, the Met invited Yogi Berra to a luncheon to kick off an exhibition in the new baseball card gallery.

They even had "Pasta alla Yogi" on the luncheon menu in his honor. Harold Holzer, the Met's senior vice president for public information, knowing that I was a big baseball fan and Yogi's acquaintance, invited me to greet Yogi and his wife, Carmen, at the main entrance. When Yogi arrived, he spotted me and came right over. "John it's great seeing you. How are you doing." "Great Yogi. It's really a pleasure to have you and Carmen here at the Met." We proceeded back to the American Wing to the baseball card gallery and viewed the cards on exhibition. There of course was the Honus Wagner card and a few from Yogi's illustrious career. There were some photo ops before we proceeded to the Trustees Dining Room (presently named the Members Dining Room) for their lunch. I met Yogi and Carmen after lunch and escorted them out of the museum to their car, which was waiting on the plaza. A photographer traveling with Yogi offered to take a picture of the

Signed picture of me with my friend Yogi Berra on the plaza of the Met. PERSONAL PHOTO

two of us. We took the picture, and later in the year, he signed it. Yogi was one of those truly genuine, great people I was fortunate to meet during my career.

I met Yogi in the early 1990s when I volunteered for special events as a security consultant for Major League Baseball. As I previously mentioned, my friend and colleague Kevin Hallinan was the senior vice president of security for Major League Baseball. Kevin knew how much I loved baseball, so he would ask me to help him out on various projects and events. When I could and my schedule at the Met allowed, I jumped at the chance. One of the many memorable events I was involved in was the 1989 Hall of Fame induction ceremony at Cooperstown, New York. The inductees were Johnny Bench, Carl Yastrzemski, Red Schoendienst, and Al Barlick. MLB's commissioner, Bart Giamatti, and Kevin were concerned about the possibility of demonstrations related to Pete Rose. Commissioner Giamatti had recently banned Pete Rose from the sport for life because Rose was caught gambling on baseball. I went up to Cooperstown to assist Kevin and his team with security on crowd control issues. There were some small protests and large crowds, but the ceremony and festivities went on without any major problems. At the end of the Hall of Fame weekend, all the old-time baseball players were getting ready to leave the Otesaga Hotel. As the VIPs were departing, I stood on the front steps with Kevin and the sports commentator Bob Costas. Commissioner Giamatti walked down the steps and got into his limousine, rolled down the window, and gave us a wave. As I waved back, I noticed the commissioner open the car door, get out, and start walking up the hotel's steps. He was walking right to me. As he extended his hand to shake mine, he said, "John, I just wanted to thank you for all your help with the Hall of Fame ceremonies. It was a real success. Thanks again." "It was my pleasure," was my response. That was the kind of person Commissioner Giamatti was. He was another great individual I had the pleasure and honor

to be associated with during my career. Approximately one month after that handshake with the commissioner and ex-president of Yale University, the unthinkable happened. On September 1, 1989, Giamatti had a massive heart attack and died. On November 15, 1989, I was invited to his memorial service at Carnegie Hall.

In 1994 and 1996, the Met had important visits from an emperor, an empress, and a princess.

On June 15, 1994, a reception and dinner were hosted by David Rockefeller and Arthur "Punch" Sulzberger, publisher of the *New York Times* and chairman of the Met. The dinner was intended to foster and encourage good relationships between the United States and Japan. The guests of honor were Japan's Emperor Akihito and Empress Michiko. The Japanese royal couple were in New York City for a three-day visit, which was part of a two-week tour that included a State Dinner at the White House hosted by President Bill Clinton and First Lady Hillary Clinton. Guests at the Met dinner included Governor Mario Cuomo; Mayor Giuliani; former mayor David Dinkins; former leaders of European countries, Edward Heath of Great Britain, Helmut Schmidt of Germany, and Jacques Chirac of France; and members of the Metropolitan's Board of Trustees. The reception was held in the American Wing Engelhard Courtyard and the dinner in the iconic Temple of Dendur.

It was my job to ensure the security and safety of the emperor and empress, government officials, and guests that evening. There is a lot of advance preparation and planning that goes into an event like this to make it a success. The most important aspect is coordination between all the players involved: outside agencies such as the Secret Service, the US State Department, the New York City Police and Fire Departments, and Japanese security services. On the operational side of the Met, there are the press, special events

office, and maintenance and engineering departments. The overall planning of the event fell under the Development Office headed by a vice president at the time, Emily Rafferty, Vice President for Public Information Harold Holzer (press), Dick Morsches, Chris Giftos (catering, flower arranger extraordinaire), and myself for security and safety.

When you are planning security and safety for an event like this, you must be involved in every detail, from the catering and seating of guests and dignitaries, guest arrivals and check-in, press locations and access, and background checks of staff working the event (usually done by the Secret Service and/or State Department) to advance security sweeps with canine(s), motorcade arrival and departure points, safe room for dignitaries, emergency medical response plan, backup plan if something goes awry, and, as always, the safety of the museum's collections. Coordination and planning come with numerous meetings and walk-throughs with all involved parties. We wanted to make sure everyone was on the same page and knew exactly what their part was as well as the parts of the other players. As the evening drew closer, the plan solidified.

Everything was in place and all the guests were in the American Wing Engelhard Courtyard awaiting the arrival of the emperor and empress. The motorcade arrived in the North Garage. The doors to their limousine opened and the emperor and empress were greeted by President William Luers, Chairman Arthur Sulzberger, and Mr. Rockefeller. The group that included the royal entourage, security staff, Emily Rafferty, Chris Giftos, and myself proceeded to the large elevator. The elevator was waiting for the royals and the accompanying group. We all entered the elevator. I instructed the handpicked operator to go up to the first floor. The elevator didn't move. What seemed like an eternity was just a few minutes. The next voice I heard was Emily Rafferty. "John, we are not moving." Without really thinking about it, I said, "Come with me." As I led, we proceeded down the corridor, through the area where the caterers and waiters

were staging the dinner. We went up the stairs to the first floor of the American Wing. Minutes later, the emperor and empress exited the old bank building into the Engelhard Courtyard to the applause of the invited guests. It was like nothing out of the ordinary happened. Now I know why the Secret Service uses stairs instead of elevators when they can. In our critique of the visit, we established the elevator was overloaded, causing it to shut down. Believe me, this would not happen again. I did learn that whenever we could, we would use the stairs instead of the elevator for heads of state or VIP visits. The reception and dinner went on as planned. When it came time for the royal entourage to exit the museum, we made sure we used the stairs to get to the garage where the limousines waited. After the visit, President Luers received a beautiful letter dated June 16, 1994, a day after the event, from David Rockefeller commending him for his efforts for a very successful evening. David Rockefeller believed it was a positive event that improved Japanese-American relations. A quote from his letter:

> *As one who has been involved in a good many rather large events involving foreign personalities over the years, I believe I am well qualified to judge the exceptional professionalism and skill with which last night's event was handled by you and your staff. A thousand thanks to you and your very wonderful staff.*
>
> *Sincerely, David Rockefeller*

A quote from his response to David Rockefeller:

> *Dear David,*
>
> *I am most thankful for your thoughtful and immediate letter on the dinner at the Met for the Emperor and Empress.*
> *I am pleased that it worked out. Ninety percent of the work in the museum was done by a dedicated staff of people, most*

particularly those headed by Emily Rafferty, Chris Giftos, our Security Chief John Barelli, and Harold Holzer, who managed the not insignificant press contingent. It was, as we say, an all hands effort and one that I am pleased to say demonstrates the depth of talent and energy of our staff.

No institution does receptions and dinners better than the Met. The key is, as President Luers said, "the depth of talent and energy of our staff."

The princess who visited the Met in 1996 was no ordinary princess; she was in fact one of the world's most popular figures at the time. The princess was the honorary chairperson for the Costume Institute Gala as well as the accompanying Christian Dior exhibition: Diana, Princess of Wales. I didn't know it right away, but Princess Diana's visit was going to test all my abilities and security experience. Diana was a good friend of Liz Tilberis, the editor of *Harper's Bazaar*. Liz, who was organizer and chair of the gala, had invited Diana to attend the gala as the guest of honor. Diana had already rewritten the rules of royal attire and was an international trendsetter who brought a more up-to-date, frequently haute couture, and youthful look to the British monarchy. She was to wear a midnight blue dress designed by creative director John Galliano in his first collection with the House of Dior. At this point in her public life, Lady Di was attracting Beatles-level hysteria in her public appearances. I had to design a security program for the gala around Diana's visit, which entailed coordinating a security program that would both meet the needs of the gala and ensure Diana's safety and privacy.

Liz and Emily Rafferty decided that the simplest and best solution would be to make me Diana's sole security bodyguard for her time in New York. I met with them and I told them it was difficult for one person to provide security for such a high-profile figure, but they insisted, and I accepted the challenge. After that

meeting, I called Scotland Yard and Diana's protection detail leader, Graham Crocker. Crocker informed me that Scotland Yard was not involved in protecting Princess Diana when she was on "her private visits." I told him I found that surprising, and let him know I would be responsible for her security while she was in New York City.

The challenge of protecting the Princess of Wales appeared a lot harder once I knew that I would not have the assistance of British law enforcement. I had to depend on myself, my security staff, and the NYPD. The first hurdle to overcome was transportation. Diana was flying from London on the Concorde and arriving at New York's JFK Airport at 3:30 p.m. on the afternoon of the gala. No longer flown by Air France or British Airways, the Concorde was the ultra-luxurious supersonic jet whose profile was iconic in the 1970s and 1980s. From JFK, Diana, her sister, Sarah, and Liz would board a helicopter and fly to the East River 60th Street heliport (which is no longer in use today). I would meet them at the heliport with Liz's limo driver, Jim, and we would proceed to the Carlyle Hotel at 76th Street and Madison Avenue. In preparing for the visit, I interviewed Jim in my office to make sure he was an acceptable driver. He was very professional with an outstanding driving record. He'd been Liz's driver for over eighteen years, knew the city, and understood the importance of who he was driving. I was adamant that I did not want any replacement driver, and if he did not show that day, I would have driven us myself. Security protocol dictates that you never let an unknown driver behind the wheel when you have an individual like Diana in the car. Safety comes first and knowing the driver of the vehicle is paramount.

The plan was for Jim to pick me up at the Met and together we would drive over to the 60th Street heliport. I also met with the management of the Carlyle Hotel to discuss security arrangements. The hotel's management wanted Diana to arrive on 77th Street and go through a residential building connected to the

Carlyle to avoid the press and crowds that would have gathered at the main entrance on 76th Street. I objected and insisted that we enter through the main entrance. I asked the 19th Precinct to supply barricades and police officers to control the entrance alongside hotel security personnel. Diana would exit the limo, pose for pictures, and shake hands with admirers. This would all unfold in a controlled, secure, barricaded area with police and Carlyle Hotel security. I have learned over the years that it is better to let the press and excited public get pictures and see a celebrity or world leader than to try to sneak them in. If you sneak in, you just create more problems because then the press or public will do anything to get that picture or see the celebrity or dignitary.

With an unmarked NYPD Intelligence vehicle following us, I joined Jim at the Met and we drove over to the heliport. We picked up Diana, Sarah, and Liz and proceeded to the Carlyle. We all soon arrived at the Carlyle, and Diana exited the limo and walked through the secure, barricaded area. The press got their pictures and the public got to see Lady Di.

When we arrived at room 2701, Diana and Sarah settled in. Liz formally introduced me to Diana. She was striking, beautiful, extremely nice, and down to earth. I went over some ground rules for the visit. I told Diana that I would be at her side the whole evening, and if she needed anything or had any questions, she could ask me. I also said I would be in the adjoining room anytime we were in the hotel. She understood, and said, "John, can you please keep an eye on my dress during the evening. The strap tends to turn and become uneven. When you see that happening, just adjust it for me. Thanks for all your help."

At 6:30 p.m. sharp, we stepped into the elevator on our way to the gala. Diana was stunning in her blue Dior dress. We exited the hotel the same way we entered and again all the press and spectators got their pictures and a view of Diana. We proceeded in the limo to the Met's main entrance at 82nd Street and Fifth Avenue. I knew

as we exited the limo that our security programs were in place. The NYPD and my staff were in position to ensure not only Diana's safety and security but the safety and security of all the celebrities and VIPs attending the gala. We walked up the main steps and Diana posed for pictures as we entered the Main Hall. Once in the Main Hall, Diana graciously met with the invited guests and posed for more pictures by selected and screened press. We then went to the Dior exhibition through a crowd of guests who were respectful of Diana's space. She met the director and Emily Rafferty and they escorted her through the exhibition. After the exhibition, we made our way through the Main Hall to the south side of the museum where the dinner was being held. In 1996, the museum restaurant, called the Fountain Restaurant, was located on the first floor where the Roman Courtyard is today.

For the gala, the museum restaurant was transformed into a private dining room for six hundred celebrities and guests. I proceeded to take Diana to her table, where she sat with Liz, Sarah, and John Galliano. In the days prior to 2010, the gala's format was different. It was in December not May. At approximately 10:00 p.m., the public could purchase a ticket to the after-dinner party, which would end at approximately 2:00 a.m. The guests would be able to view the costume exhibition, then dance in the Temple of Dendur or American Wing Courtyard, where there was a buffet and drinks. The evening of the Dior exhibition, there were approximately two thousand guests who attended the after-dinner party. As Diana's entourage—which included Director Philippe de Montebello, Emily Rafferty, Chris Giftos, Liz, Sarah, and myself—exited the dinner, we made our way up to the second floor, and across the Main Hall balcony to avoid the throngs of guests below. We stopped and Diana peered over the balcony. She turned and looked at me. I said to her, "we would never have been able to navigate through that crowd. It would be complete bedlam." She just nodded her head in an affirmative yes. We proceeded through

Princess Diana and I entering the 1996 Costume Institute Gala and Dior exhibition at the Met. DON POLLARD, MET FREELANCE PHOTOGRAPHER

the Asian galleries and made our way to the North Garage to depart for the hotel. As we got down to the Egyptian galleries on the first floor, Diana was able to peer into the Temple of Dendur. Diana saw hundreds of people dancing. She turned to me: "John, I would really like to dance, what do you think." My answer was "Absolutely not. I really couldn't ensure your safety because of the crowded conditions." She looked disappointed, but there really was nothing I could do about the situation. We proceeded to the garage, where Jim and the limo waited for our short trip back to the hotel. Diana said good night to Emily, Liz, and Chris and posed for a picture with them. I opened the rear doors for Diana and Sarah to get into the limo. I got in the front passenger seat and said, "Jim, let's go to the Carlyle." I thought how sad it was that this beautiful young lady wasn't able to really enjoy herself. All she wanted to do was dance at the gala, and because she was so famous, she couldn't. I saw a person who was really trapped in a situation that made the simple things hard to do. As both Diana and Sarah sat in the back seat, I tried to lighten up the evening by saying, "Now ladies, where would you like to go for a nightcap." I heard them say in unison "Really where?" "Well, we can't go to a public bar," I said. Diana suggested "the hotel, where we could have some champagne and I can play the piano." We got to the hotel and the waiting crowds and press behind the police barricades. Diana and Sarah exited the limo, waved to the crowds, and posed for the press. We proceeded to room 2701, where I said good night and told them I would be in the adjoining room if they needed anything. I didn't stay for any champagne but I did hear Diana playing the piano in her room.

Diana and Sarah were scheduled to leave for the airport the next day. This time, I suggested we take the limo to the airport with our NYPD Intelligence vehicle following. At about 9:00 a.m., I received a phone call from the Carlyle's manager. He said that John Kennedy Jr. was coming to the hotel to visit Diana. I met John at the Madison Avenue entrance and escorted him up to the suite via

the freight elevator. I rang the bell to the suite, Diana answered, and John walked into the room. No sooner had I returned to my room when Diana's suite door opened. I heard John say good-bye and exit into the hallway. "John, that was awfully quick," I said. "Yes. I asked her if I could interview her for my magazine and she said no." The magazine was *George*. I escorted him down to the Madison Avenue exit and said good-bye.

At 10:00 a.m., Sarah called and told me she and Diana wanted to go shopping. I went over to their room to ask them what they wanted to shop for. Diana told me she wanted to buy Game Boy video games for her young sons, William and Harry. I told her there was a store right across the street and it was probably better if Sarah and I went while Diana stayed in the room. Again, she was disappointed but she graciously agreed. Sarah and I went down to the store and I believe she bought every Game Boy video game they had. It really cast Diana in a human light to see her wanting to return to her sons with gifts as so many parents do.

An hour later, Diana, Sarah, Liz, and I left the Carlyle—again to crowds and the press. Jim and the limo were waiting for us. We proceeded to the airport with our police escort. On the way, Diana thanked me for being at her side and asked for my business card. I thanked her as she exited the limo at a private entrance at the British Airways terminal. When Diana got on a commercial flight, she would be the last person to enter the plane and she would sit in the first front seat. She then would be the first person to exit the plane to lessen her exposure. I said, "Hope to see you again and safe travels." Little did I know that about eight months later Diana would die in a tragic accident. As difficult as it is to conclude, I think the accident could have been prevented if some basic security protocols were followed such as knowledge of the driver and relationship to the press. Although in England and Europe at the time, the paparazzo were worse than the press on steroids.

KENSINGTON PALACE

11th December, 1996

Dear John,

Thank you very much for looking after me during my all too brief visit to New York.

✳ I did want you to know how enormously I appreciated being under your secure wing!

With my best wishes,
Yours sincerely,

Diana.

Mr. John Barelli

Letter from Princess Diana thanking me for "being under your secure wing," 1996. AUTHOR'S COLLECTION

The one memento I have of Diana's visit is a beautiful letter she sent me, and that one sentence from the letter: "I do want you to know how enormously I appreciated being under your secure wing!" I wish I could have been there that night in Paris to protect Diana as I did in New York City months earlier, and that I could have had her under my secure wing.

⁓

Every one of the thirty-seven costume exhibitions and galas that I was involved in had unique challenges. As I look back on all the costume exhibitions, there is one that stands out above the rest. That was *Alexander McQueen: Savage Beauty* in 2011. The attendance was a staggering 661,509, making it among the top ten most popular in Met history for a special exhibition. I am proud to say I was involved with all the top ten special exhibitions except the aforementioned *Mona Lisa* exhibition in 1963 when I was a visitor. The number one exhibit will probably always remain *The Treasures of Tutankhamen* at 1.3 million visitors. The challenge with the McQueen exhibition was really the exuberant crowds. The expression is "build it and they will come." Well, the Met built it, and did they come. They came in droves. Day after day, the lines snaked through the galleries. A number of visitors were let in, while others waited in line until it was their turn to enter. This went on for the run of the exhibition, day in and day out. The exhibition was so popular that our director, Thomas Campbell, decided to extend it for one week. The added twist was that the hours for the exhibition were also extended until midnight for that additional week. This extension, along with its amplification in social media, created a buzz that only increased the popularity of an already popular exhibition. The crowds were getting larger and larger.

The challenge for the museum, security, and visitor services was to make sure the visiting public had an enjoyable, safe experience. We also had to make sure that the permanent collections were not

disturbed by the enormous crowds. To give you an idea of the size of the crowds, we had some fifteen thousand to eighteen thousand visitors a day just to the McQueen exhibition. The lines extended from the exhibition through the galleries back down to the Main Hall and out the front doors. It was there that we split the lines going north and south up and down Fifth Avenue around into Central Park towards Cleopatra's Needle. The lines were over a quarter mile long. And if you were at the end of that line, it would take you at least three to four hours before you entered the exhibition. The amazing thing was that people didn't mind or complain about the long wait. In fact, as people left the exhibition, they were talking about how great it was and how it was well worth the time.

I remember one late summer evening on the last week of the exhibition. I was standing outside on the main steps looking at the lines extending up and down Fifth Avenue. I was joined by President Rafferty. I said, "Emily, we just got a weather report that a major thunderstorm is coming our way. It may help disperse the crowds." Relief came across Emily's face. About five minutes later, the storm hit and the rain came down in buckets. I stood there expecting the crowd to run for cover. To my amazement, I saw what looked like thousands of umbrellas open up. I turned to Emily, "Oh shit, we really have our work cut out for us now. Nobody is leaving." The rain only made matters worse: slippery floors, wet visitors, etc. But through all this, we had no unhappy visitors. The lines went on and our visitors enjoyed the exhibition. There was a real happening in the museum on the Main Hall balcony. You could see the line extending all around the whole balcony. What happened next was a museum first and probably a museum last. A wave was started by the visitors waiting in line, just like you would see at a football game. The museum setting is not used to something like that and it made me and my staff nervous, but eventually it stopped as unexpectedly as it started.

We had advertised that the museum would keep the exhibition open until midnight. Operationally, that meant we had to strategi-

cally cut off the line at midnight. As the last visitor entered the main door, we had an additional three hours before the last person exited the exhibition. This meant my staff would not close the museum until 3:00 a.m. Since my first day at the Met, one thing I always observed about the museum staff was they always responded to the challenges that were put before them. This exhibition was one of those times. The museum and security staff responded beautifully, and without their efforts and professionalism, we couldn't have pulled off this challenging exhibition.

As I look back and compare what the Security Department was like when I arrived in 1978 to when we guarded the McQueen exhibition in 2011, I see a dramatic transformation. By 2011, the

Alexander McQueen exhibition lines outside and inside the Met, 2011. DON POLLARD, FREELANCE MET PHOTOGRAPHER

Security Department was running on all cylinders: strong leadership, management team, security personnel, and supervision (including recruiting and training programs); advanced technology and security systems (including the latest state-of-the-art command center); specific security programs to address concerns like terrorism and art theft; liaison with outside agencies to support our security staff and programs; and last but not least an understanding of art thieves, what motivates them, and how they tend to operate.

I believe the current security team is one of the most skilled, professional, innovative, and tested in the museum world. The majority of the management team consists of homegrown professionals who began their careers at the Met as security officers and worked their way up the ladder. Each individual manager was handpicked for their expertise in specific areas: personnel management and training, technology services, physical security, and investigations. The backbone of any security department are the security officers. In 1989, the Met extended its hours to remain open on Friday and Saturday evenings until 9:00 p.m. To staff the new hours, we created another platoon that would work on a four-day-a-week schedule. This new schedule was key in attracting college graduates for the security officer position. In fact, from 1989 up until my retirement, and I believe presently, a college degree is required to join the Met's security team, providing a talent pool of skilled, educated individuals to fill managerial, supervisory, and technical positions. The museum has also benefited in filling a broad spectrum of positions other than security throughout the institution—positions in maintenance, finance, development, human resources, assistants and technicians in curatorial offices, and curators in the musical instruments and American paintings departments. Over the last twenty-five years, the Security Department at the Met has developed into a diverse, well-trained group of over six hundred professionals from over ninety countries, speaking more than forty languages.

With my security management team pictured in the Irving galleries, 2013.
AUTHOR'S COLLECTION

Technology has developed to a high level of sophistication and application for a museum setting. The single most important development in this area has been the video network recording systems of the closed-circuit camera, or CCTV. This comprehensive network of cameras not only records events but is also integrated into alarms and monitored by our command center. The Met has come a long way from the days of no cameras. These technology programs and advances will continue to develop with the strong research and development program that is in place.

And I've already discussed the strong relationship and communication between the museum's security staff and law enforcement officials at the local, national, and international levels.

The Art of Protecting Heads of State

As I touched on in earlier chapters, the Met is a place where the most powerful and influential world leaders come to talk, celebrate, and represent their nations, projects, artists, and institutions. Presidents, dictators, prime ministers, kings, queens, emperors, empresses, princes, princesses, first ladies, foreign ministers, cultural ministers, religious leaders, US senators, members of Congress, US cabinet members, Supreme Court justices, and local officials such as the mayor of New York City all come, sometimes as visitors, but most of the time they visit for a special reception or dinner, or when the Met is a venue for an independent event.

In addition to the Temple of Dendur, the museum also uses locations such as the American Wing Engelhard Courtyard, the Astor Court, and the Main Hall for special events. These amazing spaces contain beautiful works of art from throughout human history. When it comes to security, the museum has a built-in security and safety infrastructure to complement additional security programs that come with visits of heads of state and dignitaries.

I was a couple of years into my tenure as head of security at the Met when, in 1988, it was announced that Mikhail Gorbachev, the general secretary of the Soviet Union, was coming in December to New York City. The main reason for his three-day visit was to address the United Nations General Assembly and meet with

President Ronald Reagan and Vice President George H. W. Bush. He and his wife were also scheduled to meet and have dinner with (of all people) Donald Trump and his first wife, Ivana, and tour Trump Towers. But before the Gorbachevs' arrival, the Trump meeting and dinner was canceled due to scheduling conflicts. More importantly to me, Gorbachev was going to visit the Met.

I had the most interesting meeting of my career just a few weeks after the announcement that the Gorbachevs were going to visit the museum. This meeting was with Gorbachev's advance security detail and the head of the KGB, Vladimir Alexandroich Kryuchov. I received a call in my office from my security supervisor at the main entrance. "Mr. Barelli, the Russian security team has just arrived." I walked down to the Main Hall to meet the detail. When I got there, a group of approximately ten men dressed in dark business suits was waiting at the information desk with one US Secret Service agent and one US State Department representative. The first person I was introduced to by an interpreter was Vladimir Kryuchov. He extended his hand and I reached out to shake it. As I shook his hand, I could feel his grip tighten like a vise. I came back at him and tried to crush his hand. He looked at me in approval, grunted, and patted me on the back as if to say, *ok, you are as strong as me*. He turned to his men and nodded an approval as if to say I was acceptable.

From that initial handshake and introduction, I felt I was trusted by the leader and thus the entire Russian security team. We communicated through an interpreter as I led the group on a walk-through of the route and locations that Mr. and Mrs. Gorbachev would take. As we went, I explained various security protocols, all of which would be coordinated and approved by the Secret Service. We then proceeded to meet with my administrators including Dick Morsches and William Luers, then the Met's president. We reviewed the details including the arrival point, which was to be the Central Park entrance into the Engelhard Courtyard of the American Wing.

Touring the American Wing and the Impressionist galleries, Vladimir asked through his interpreter if we would close the galleries to the public before the Gorbachevs' visit. Everyone looked at each other. Vladimir said something in Russian to the interpreter. The interpreter turned to me and said, "Vladimir said whatever John says, we will do." Well, I guess he really did trust me. I turned to President Luers and said that I thought we should close those specific galleries to the public. Before President Luers could say anything, Vladimir said *OK John* in a nod of approval.

After our meeting was over, I told the members of the Russian security team that they were free to roam the museum on their own. They all had this perplexed look on their faces that I would let them do such a thing. Well, they did go on their own and enjoyed every minute of their unescorted tour in the closed museum. The decision to give them that freedom was not something they usually experienced. It solidified a trust and willingness to work with us as a team.

I remember being a little nervous the night before the Gorbachevs' visit. It was a cold morning as I left our apartment and walked to the subway to take the 6 train to work. I was thinking through all the plans and details to make sure the visit would run smoothly. I arrived at the museum at around 7:00 a.m. and turned on the TV in the conference room. To my amazement, there was a breaking news story. A serious earthquake had occurred overnight in Armenia. Gorbachev had canceled the rest of his New York City trip and would immediately return to the Soviet Union. A bittersweet feeling came over me. The excitement of the visit became a letdown, but a sense of relief came as well that the responsibility of being an integral part of the protection of a powerful world leader was off my shoulders.

Like clockwork, the pressure of protecting world leaders came up every year during the month of September. September is the month that the General Assembly of the United Nations meets

at the UN headquarters in New York City. During this month every year, heads of state, first ladies, and dignitaries from countries all over the world descend on New York City with their entourages. The island of Manhattan becomes a traffic gridlock nightmare. Traffic is stopped for the movement of heads of state. The best way to maneuver in the city is to go underground and use the New York City subway system. There were always numerous visits from heads of state, first ladies, and dignitaries to the Met to enjoy the permanent collections and special exhibitions and attend various receptions.

There were two memorable visits about a decade apart. The responsibility of protecting not one but hundreds of world leaders occurred in 2000 and again in 2009. In 2000, President Bill Clinton selected the Met to host a reception for 167 of the world's leaders and their spouses who were attending the United Nations Millennium General Assembly in New York City. Then in 2009, President Barack Obama followed and hosted a reception at the Met for 172 world leaders and their spouses attending the UN General Assembly that year.

The Clinton reception on September 7, 2000, was probably the largest, most important, and logistically challenging non-art-related event ever to take place at the Met. Just think of the security and safety responsibility involved in the planning and logistics for 167 heads of state arriving in a coordinated way. Ninety-eight of the world leadership, including all of the most powerful leaders on the face of the earth, would gather around the Temple of Dendur. All but seven of these world leaders would enter the Met through the main entrance. An exception would be President Clinton, who entered through a private, covered entrance in the North Garage. There were six countries that were considered high risk—it was determined that there was a higher chance of demonstrations or attack against them—thus these leaders received a higher level of security. The heads of state from Russia, Israel, England, France,

Palestine, and Germany would enter through the covered South Garage. All the heads of state with their spouses and security detail would proceed through the Main Hall, Medieval galleries, and enter the Engelhard Courtyard of the American Wing. President Clinton was to receive each one of the 162 heads of state, say hello, and have a picture taken. The couples would then proceed to the Temple of Dendur for a reception and speeches. In addition to the museum's staff, more than eight hundred security personnel from federal, state, and local agencies assisted in the event.

On one of our walk-throughs with representatives from the Secret Service, the US State Department, the NYPD Intelligence and Counter Terrorism Division, the FBI, CIA, and the Joint Terrorist Task Force (JTTF), we discussed various aspects of the visit including protection of the perimeter, drop-off and pickup, emergency response teams, counter-snipers on rooftops of buildings on Fifth Avenue and the museum, canine sweeps of the museum, and most importantly the protection of the gathering at Temple of Dendur. As the advance security teams from the different agencies conducted a perimeter survey, we stopped at the grassy knoll outside the temple's southern facade. If you've visited, you know the curtain wall of the temple consists of glass. To obstruct the vision of outsiders, the NYPD Emergency Services Unit (ESU) provided portable spotlights mounted on trucks to shine outward from the glass curtain wall. This was very effective and was utilized on future presidential visits and receptions. Concrete barriers (also known as Jersey barriers) were also installed to stop vehicles from driving from the East Drive in Central Park onto the grassy knoll and through the glass wall. A detective with the NYPD brought up an interesting point of concern. He asked, "What if someone rented or hijacked a plane and crashed it into the Temple?" The response from the Secret Service was that there would be a no-fly zone instituted in the surrounding area, and local airports like Teterboro would be closed for the evening event. At the time, it seemed to

Entrance of the Met for the United Nations Millennium General Assembly reception hosted by President William Clinton, 2000. AUTHOR'S COLLECTION

be the right answer to this question. But as we now know, that is exactly what happened approximately a year later at the World Trade Center and the Pentagon.

President Clinton was not accompanied by his wife, Hillary. I could only assume it was related to the Monica Lewinsky affair that was going on at the time. Instead, he arrived with his daughter, Chelsea. Chelsea did not stand with the president in the receiving line but off to the side, or sometimes next to me and the lead Secret Service agent. One of my many responsibilities that evening was to accompany the lead Secret Service agent who was responsible for President Clinton. If something serious occurred or if there was a medical emergency, I would assist the president's detail leader and his detail in either exiting the museum or taking the president to a secure room. After a head of state was announced to the president and had their photo op, they passed by me and the Secret Service agent and proceeded to the reception, which was adjacent to the

UN Millennium General Assembly reception, 2000. Left to right: Met Security Manager Jose Rivero, Chelsea Clinton, President Clinton, myself, and Met Assistant Security Manager Dane Dodd. WHITE HOUSE PHOTO

Engelhard Courtyard. It was a surreal scene. I was able to stand in my place of work and witness world leaders waiting in line to meet the president of the United States, then pass right by me on their way to the Temple of Dendur. I was standing across from the receiving line when Chelsea Clinton came up and stood by me. I said hello and introduced myself as the chief security officer. She was very nice and personable. She told me how much she liked the museum and how beautiful it was. As we talked, I looked up and saw Yasser Arafat walk up to President Clinton, shake his hand, and turn to have their picture taken. He then proceeded to walk by the lead Secret Service agent. When he got to Chelsea, he stopped and said, "Ah Chelsea," in a very surprised, happy way. He gave her a big hug and said, "I am so happy to see you." He then looked at me, said, "Hello," and gave me a big hug. I have no idea why he would give me that type of greeting. As Arafat moved on, the lead agent bent over and whispered in my ear. "If anyone got a picture of him hugging you, don't even think about going into politics." I was stunned and nodded in the affirmative.

As the night proceeded and the last head of state took his picture with the president, I was approached by a staff person from the White House. She instructed me and two of my security managers to stand with the president and Chelsea for our photo op. On one of President Clinton's many return visits to the Met, I was able to have him sign the photo for me. He remembered the evening and thanked me and my staff for our effort. The event was a huge success, both for me personally and professionally, for the president, and for the peaceful gathering of world leaders.

On September 23, 2009, we had to do it all over again, this time for the UN General Assembly reception hosted by Michelle and President Barack Obama. The drill was the same and the second go-round was not as stressful as the first, but the responsibility was just as great. The agencies involved were the same: the Secret Service, US State Department, NYPD Intelligence and Counter Terrorism

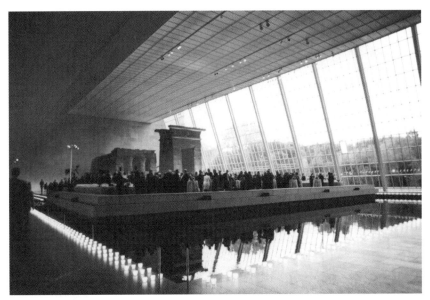

2000 UN Millennium General Assembly reception in the Temple of Dendur with 162 heads of state present. AUTHOR'S COLLECTION

Division, the FBI, CIA, and the Joint Terrorist Task Force (JTTF). Ten years later, the players within these agencies were largely different. But with all the changes in personnel, new relationships were made and a team effort was established. The photo op with President Obama and First Lady Michelle Obama was in the Vélez Blanco Patio and the reception was again in the Temple of Dendur. All went as planned with our second global event.

During huge events like these, it was always my responsibility to protect the museum's art collection. The protection of the Met's collection was always my department's highest priority and core mission.

With that protection of the museum's collection came an odd phenomenon that no one ever expected. It was not fear of someone stealing paintings off the wall. Quite the opposite; it was the hanging of paintings *on* the walls of the Met. Over the years, we had a handful

et matters

A BIWEEKLY NEWSLETTER FOR THE STAFF AND VOLUNTEERS OF THE METROPOLITAN MUSEUM OF ART

Met Welcomes President, First Lady, and World Leaders

Among the many photos that were taken of President Barack Obama and First Lady Michelle Obama at the Met last September 23, when the Museum was the site of a major event in connection with the opening of the United Nations General Assembly, was this one below with H.E. Dmitry Medvedev, President of the Russian Federation, and his wife, Mrs. Medvedeva. The photos of the President and heads of state were taken in Vélez Blanco, and like this one, most are available for downloading from the State Department website.

A reception attended by almost 400, including 135 heads of state, as well as Governor David Paterson, Attorney General Andrew Cuomo, State Comptroller Thomas DiNapoli, and Assembly Speaker Sheldon Silver, was held in The Temple of Dendur in the Sackler Wing. In his remarks there, the

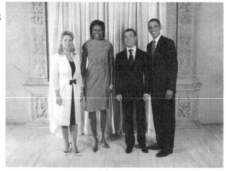

President Barack Obama and Russian Federation President H.E. Dimitry Medvedev with Mrs. Medvedeva and First Lady Michelle Obama. Official White House Photo by Lawrence Jackson.

President commented on how wonderful the space was and thanked Director Thomas Campbell and the entire Museum for allowing the event to take place.

Many staff were involved in making the event such a noteworthy success. The Museum is particularly grateful to Whitney Donhauser, Ashley Potter Bruynes and the Special Events staff, Phil Venturino and Tom Scally and their team in Facilities and Buildings, and John Barelli and the Security Staff.

2009 United Nations General Assembly reception at the Metropolitan Museum of Art hosted by President Barack Obama and First Lady Michelle Obama, shown in the Vélez Blanco Patio with President and Mrs. Medvedev of Russia.
THE METROPOLITAN MUSEUM OF ART

of artists come into the Met and leave their works. They left works at the information desk, outside the museum on the steps, or just in the Main Hall with a note. Artists left their works for all different reasons with the idea of maybe being discovered by a curator. The majority of these works were paintings. From time to time, artwork was mailed unsolicited to individual departments like Contemporary Art and Arts of Africa, Oceania and the Americas (AAOA).

On the afternoon of Thursday March 7, 2007, curator Alisa LaGamma in the AAOA Department called the Security Department to inform us that she received a package containing what appeared to be two shrunken human heads. The package was accompanied by a note that stated that the sender's family wanted to donate the heads to the Metropolitan's AAOA Department. The note went on to say that they received the heads from friends in Ecuador in the 1980s. Alisa stated emphatically "that the AAOA Department would not accept them into their collection." Assistant Security Manager Mario Piccolino responded to the AAOA Department, where he inspected the heads and removed them to the security office. Alisa determined that the heads were indeed authentic shrunken heads most likely from Ecuador. The Jivaroan tribes of Ecuador and Peru perfected the process for shrinking heads. This was done for religious as well as economic reasons to fill the demand of foreign tourists. The question we had was what exactly to do with them. I guess I could have displayed them in my office. The only problem was they had a pungent smell of rotten meat. We could have thrown them out in the trash, but this idea was rejected. My assistant Ed Devlin said, "John let's call the Central Park Precinct, explain to them that we would like to turn over some lost property." "Ed, are you for real. Tell the captain we have two shrunken heads. I don't think so. Let's call the precinct and see if they can help us." Ed spoke to Lieutenant Richie Messimer at the precinct. Richie was always a big help to us. He asked Ed, "What do you have? Shrunken heads? That's a first." Another day

in the life of New York's Finest. He said, "Why don't you call the New York City Morgue, on 30th Street and First Avenue. See if they want them." Ed called the morgue and talked to the administrator. Ed reported back to me. "John, the people at the morgue said they would come over to pick up the heads. They said they would go nicely with their collection." And so it went. We found a resting place for the unsolicited shrunken heads.

There were times when artists would try to leave a painting in a specific gallery or even display it on a gallery wall. These usually were small paintings, which were easily concealed on one person to be brought into the museum. The artwork would be hung usually with tape at an opportune time in a gallery so as not to be observed. These paintings were always soon discovered by a security team. Each one was removed, reported, confiscated, and investigated. Most of the time, that was the end of it. The painting would end up in the security office, and at some point, it would be discarded.

Two shrunken heads mailed to the Arts of Africa, Oceania and the Americas (AAOA) Department as a donation to the collection, 2007. AUTHOR'S COLLECTION

There was a different twist to one such case that occurred in 2005. At approximately 11:25 a.m. on Sunday March 13, a call was received in the Met's command center that a small painting had been taped to the wall in the American Wing mezzanine painting galleries. It had been discovered by a security officer on patrol. The response by security management staff was immediate. They removed the painting and an accompanying descriptive plaque from the wall. An investigation was conducted. The painting was of a woman wearing a gas mask. The work was oil painted on a board approximately 10" x 13" in a decorative frame that you would purchase at an art supply or department store. The Plexiglas-encased plaque described the painting and named the artist. It read:

Banksy, 1975
Last breath
Oil on board
Donated by the artist

Last breath was painted shortly before Banksy became recognized as one of the most important artists of his generation. The work addresses how the fear of terror has taken hold and is slowly suffocating society.

The graffiti artist Banksy came on the scene in England in the 1990s. He was unknown to any of us in security when he left his painting there. As we conducted our investigation on this latest illicit art instillation, we discovered that the Met was not the only cultural institution he had targeted. During a visit to New York City in 2005, Banksy also illicitly left his artwork at the Museum of Modern Art, the Brooklyn Museum, and the Museum of Natural History. At MoMA, he hung a painting of a can of cream of tomato soup in the third-floor elevator lobby. At the Brooklyn Museum, he hung a painting of a redcoat colonial-era military officer holding a spray paint can with anti-war graffiti in the background between

Banksy oil painting on board illicitly displayed in the mezzanine painting galleries of the American Wing at the Met, *Last Breath*, 2005. AUTHOR'S COLLECTION

Individual in a trench coat displaying a picture on the wall of the Met's galleries. Banksy took credit for the prank, 2005. PRESS CLIPPING, PUBLIC ACCESS

two paintings on the fifth floor in the American Identities galleries. And in the Museum of Natural History, he hung a glass-encased beetle equipped with fighter jet wings, missiles, and a satellite dish.

Elyse Topalian, a spokeswoman for the Metropolitan Museum of Art, said "that museum officials believed that a painting found there, a small, gold framed portrait of a woman wearing a gas mask, was hung surreptitiously on March 13." Guards noticed it and removed it from a wall near other paintings in the American Wing. Ms. Topalian added "that no damage had been done to the wall or to other artworks. The museum does not look kindly on such unauthorized additions to its walls. I think it's fair to say that it would take more than a piece of scotch tape to get a work of art into the Met." After the investigation and interviews of the witnesses and security officers, we concluded there were three individuals involved in the hanging of the painting. Two individuals were

observed arguing shortly before the galleries opened to the public. The security officers responded. We feel that this deliberate distraction gave an individual in a trench coat the opportunity to hang the painting on the wall using an adhesive. There is no evidence that Banksy was present.

Banksy's satirical art has been displayed in cities all over the world. His modus operandi is to pick a site usually in a public setting. He then secretly installs his illicit artwork as he did at the Met. As people discovered it, an excitement would develop and crowds gathered to view the work. He is very popular now, has a huge following, and has carved out a niche in the art world.

The problem Banksy ran into at the various New York City museums where he illicitly displayed his art was twofold. First, at the Met his painting was discovered by Met security within minutes and removed. No crowds a had chance to develop, or cause a commotion that would attract publicity, as was wrongly portrayed in the recent movie *Ocean's 8*. Second, the Met and other museums did not look on this prank favorably. It was not until Banksy took his show to the streets of cities around the world that he achieved success and fame.

A Piece of the Met

ON FRIDAY MARCH 29, 2013, AN ISLAMIC ART TECHNICIAN WAS making his daily rounds. He was responsible for cleaning and inspecting the art objects throughout the fifteen galleries containing Islamic art. The galleries are located on the second floor in the museum's far southeast corner with a footprint of nineteen thousand square feet. These galleries opened to the public on November 1, 2011, after eight years of planning and construction, and they highlighted the arts of the Arab lands, Turkey, Iran, Central Asia, and later South Asia. The Islamic Art Department was founded in 1963 and holds a present-day collection of fourteen thousand objects ranging from the seventh to the nineteenth century. The works are decorative arts, paintings, rugs, jewelry, pottery, illustrated texts, metalwork, religious articles like the Koran, and architectural rooms like the Damascus Room.

It was in the Damascus Room where the technician noticed something unusual. As he entered the room, he glanced to his right over the Plexiglas barrier and noticed that an object—a perfume sprinkler on a shelf—had been moved. The sprinkler was held with a specifically designed mount that engaged the base of the object and secured a wire at the top to hold its stopper. Upon further inspection, he noticed the mount was bent and no doubt tampered with. The political and religious concerns of displaying Islamic art

had always been a concern for the Security Department. My staff, the Islamic Department curators, staff, and the museum's administration were then and are today sensitive to visitor reaction to the display of Islamic art. A good example of this concern was whether to display a rare sixteenth-century illuminated manuscript showing Muhammad on his winged steed Buraq. Museum officials knew that displaying Muhammad on a steed might disturb Islamic fundamentalists. In a 2015 terrorist attack in Paris, twelve journalists were murdered after the magazine *Charlie Hebdo* printed cartoons showing Muhammad. Director Thomas Campbell said, "We hope that it does not become a lightning-rod issue. These are not twentieth-century cartoons setting out to be confrontational. They're representative of a great tradition of art." The Met went on to display the manuscript with no dispute or reaction.

When this object was discovered disturbed in the Damascus Room, my first reaction was that it was a political or religious demonstration or objection to the art object by a visitor. The object reported vandalized:

Rosewater/perfume sprinkler
Nineteenth century
11" in height
Silver and silver filigree, partially gilded, inlaid with enamel and colored glass cabochon

But the perfume sprinkler had no political or religious connotations. What remained was removed from the gallery and transported to the Objects Conservation Department and studio for inspection to make sure there was no damage. As the inspection took place, I instructed my management staff and command center operators to review the video from the camera that covered the Damascus Room. This was now 2013—not 1979 with our Greek head or 1980 with our Egyptian ring, when we had no video.

Islamic rosewater/perfume sprinkler with lid. In 2013, the lid was stolen from the Damascus Room by a visitor who seized an opportunity. The lid was recovered and the individual was later arrested and convicted of a federal crime.
THE METROPOLITAN MUSEUM OF ART

As my team was reviewing the video, something unexpected occurred. I received a call from the conservator, who told me the lid was missing from the top of the perfume sprinkler. It was a screw lid that had been snapped off. Looking at photos on file, I saw the lid, which was a carved piece of red coral and silver stopper about three inches in height. To make sure it was not still in the gallery, another inspection of the Damascus Room was conducted, but there was no sign of the lid. I notified my management team and command center staff that our vandalism case had become a theft investigation. The security management and command center staffs are experts in the use of the sophisticated, custom-designed video system to track, identify, and document the theft and thief by viewing multiple camera recordings throughout the museum. These technologically savvy investigators were the fruits of our recruiting program.

What followed was a textbook art theft investigation. After two weeks of reviewing video, my staff was able to track our thief from the scene of the theft (with exact times in the museum) back to when he and his party of three entered the museum at the 82nd Street entrance. Now the trick was to identify the thief by name and location so he could be arrested, held accountable for his actions, and we could recover the perfume sprinkler's lid. It was at this point that I took over the coordination of the investigation. In reviewing the video, I observed a man reach over the protective barrier in the gallery. He then tried to take the perfume sprinkler off the shelf where it was displayed. This outside opportunist was given a chance to steal and he was taking it. The only thing that stopped him was the security fastener attached to the base of the shelf and the sprinkler. It worked to save the whole object from this thief. Our suspect left the room but reappeared some twenty minutes later. This time, our opportunistic thief grabbed the lid and snapped it off of the sprinkler. As he turned and proceeded to walk out of the gallery, you could see him look at his prize and put it

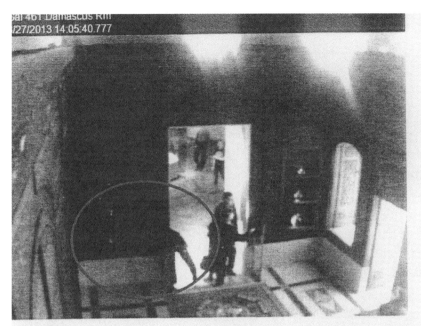

Image 1

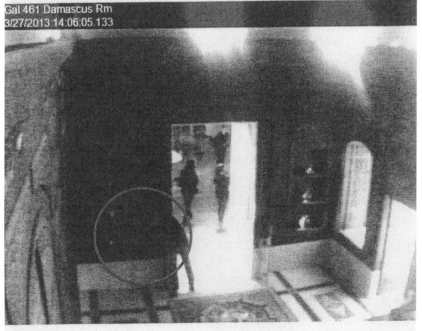

Image 2

The thief reaching over the barrier in the Damascus Room, stealing the lid from the perfume sprinkler, 2013. THE METROPOLITAN MUSEUM OF ART

in his pocket. He didn't take the entire sprinkler, but he did get a piece of the Met. The next time we were able to observe our thief was in the museum sales shop where he met a young woman (who we later found out was his daughter). She was shopping for small reproduction prints of artists exhibited in the museum. She finally decided on a Van Gogh print. Bingo. If she paid with a credit card, we could come up with a name and maybe a link in the chain that would lead us to our thief. We did. It was the only Van Gogh print sold that day, and she paid with a credit card. Now, we had a name and bank card. All we had to do was to contact the bank and get the information on this individual. The credit card search told us that the credit card was a prepaid card issued by Citicorp, Mexico City. Since it was not a typical credit card, no address or name was found on file. All we had was the name of the woman who signed the credit card receipt. We also had good facial pictures of the party of four as they entered the museum at the 82nd Street entrance. At that point, my internal investigation hit a wall. It was time to call the FBI Art Crime Team (ACT). The FBI had the resources to carry this investigation to the next level. That level was the international stage.

As explained previously, stealing artwork from a museum is a federal crime under Title 18, United States Code, Section 668. The perfume sprinkler was over one hundred years old and worth more than $5,000, which satisfied the statute's legal threshold. I picked up the phone and called the FBI's supervising special agent, Timothy J. Rembijas. I already knew Tim and explained our case. Tim told me he would be right over to sit down and discuss strategy. Tim and Special Agent Adam S. Roeser, who was assigned the case, met with me in my office. Tim retired from the FBI a month later and Adam took over our case. The important fact that kept coming up in our discussions was the connection with the Mexico City bank card. Tim recommended that they take the picture of our suspect and run the name of the woman through

the immigration system to see if they were foreign visitors who traveled together into the United States around the time of the theft. When the young woman's name was put into the system, a group of four foreign visitors from Mexico came up along with pictures of each: three females and, yes, one male. The man perfectly matched the picture that Agent Roeser had taken from the Met's video. And now we had a name, an identity, to put with the suspect's picture.

Agent Roeser called me and said, "John, we have enough probable cause to present our case to the US Attorney's Office in the Southern District of New York." Then Agent Roeser and an assistant US attorney went before a US magistrate judge of the Southern District of New York with the complaint against our suspected thief. After the hearing, the court issued an arrest warrant for the thief who stole the Met's perfume lid. On August 9, I got another call from Agent Roeser. "John, our suspect was entering the United States from Mexico into Miami. He was detained by Homeland Security and Immigration and subsequently arrested. He will be transported to New York City where he will be formally charged with an art theft." "Wow," I replied. "Thanks for your great work on our case." "Oh, John, you may want to look this guy up. You'll be surprised when you see who he is. I'll keep you updated on the progress of the case."

I got off the phone with Adam and proceeded to do some research. What I learned was unexpected. Here was an individual who traveled with his family to New York City and visited the Met. He was a high-level business executive in an important Mexican corporation. He was well educated with advanced degrees. He had also held various high-level positions in the Mexican government. One could conclude he did not steal the art object for monetary gain. What made him step over that line from museum visitor to thief? We may never really know the answer to that question, but I do know that opportunity was there and he took it.

A year after the theft, in May of 2014, he pleaded guilty to theft from a major US museum. The lid of the sprinkler that he stole and brought to Mexico was returned to the US government and then the Met. The court calculated sentencing guidelines to be in the range of twelve to eighteen months imprisonment. At his sentencing, our convicted thief gave his version of why he reached over that barrier and first tried to steal the entire perfume sprinkler and then returned to steal the lid. In support for his actions, the defendant submitted a doctor's psychiatric evaluation. This report explained the defendant's mental and emotional condition and his motivation for committing the offense. The report concluded the defendant had a depressive disorder. He coped through an all-consuming drive to make exhaustive searches to acquire and collect cultural artifacts, objects of art, and antiquities. The defendant acted impulsively because he was worn to a frazzle by the stresses at work. In response, the prosecutors argued that a substantial sentence was necessary to reflect the seriousness of the offense, to protect respect for the law, and to provide just punishment. While security is of paramount concern to the museum, it allows visitors to experience its collections without hiding them behind unnecessary intrusive barriers. The defendant abused that trust. The only reason the defendant did not get away with the entire vessel—and instead just got away with the lid—was because the vessel itself was secured to the shelf. The fact that the vessel was one of the least valuable pieces on display did not mean this was not a serious crime. It was lucky that the defendant targeted the vessel and not an object of art worth millions of dollars. The defendant, an educated and successful businessman, was plainly not deterred from stealing from one of the world's great institutions. Due to the defendant's conduct, the museum has expended substantial sums to further tighten security in the Damascus Room. A substantial sentence would send a message to him and the general public that such conduct would not be tolerated.

The federal judge did not agree with the defendant's psychiatric argument. The judge followed the recommendation of the US attorney, Preet Bharara, with some adjustment. Our thief would be confined to house arrest (wearing a monitoring device) for one year at his Miami residence. It was the house where he spent the year prior to his plea. He was also fined $50,000 and an additional $1,200 restitution to repair the lid. His immigration status and ability to re-enter the United States after he left was left up to Homeland Security and the Immigration Service. The federal crime of art theft from a museum could affect the defendant's visa status and re-entry to the United States. For this businessman, it was a huge price to pay for his actions. My knowledge of the case ends there, but one can imagine the level of difficulty a federal conviction would create as I write this.

In 1764, an Italian criminologist and jurist named Cesare Beccaria wrote a treatise entitled "Dei Delitti e Delle Pene," which is translated "On Crime and Punishment." Beccaria is considered the father of modern criminal law, the classical school of criminology and criminal justice. His work in the Age of Enlightenment changed the thinking on subjects such as torture, the death penalty, penology, and punishment. His treatise condemned torture and the death penalty and concluded that punishment should fit the crime. For Beccaria, the purpose of punishment was to create a better society, not inflict revenge. Punishment serves both to deter others from committing crimes and to prevent the criminal from repeating his crime. Beccaria also believed the connection between a crime and its punishment is stronger if the punishment is somehow related to the crime. He argued that crimes against property, including theft, should be punished by fines (so, a financial and not a physical penalty). Beccaria's treatise soon caught on, and within one year after publication (anonymously for the original 1764 Italian edition), it was published in French and English in six different editions. The treatise had a profound influence on the founding

fathers of the United States including Thomas Jefferson and John Adams. Catherine the Great of Russia and many European emperors vowed to follow his recommendations, and legal scholars of the time hailed Beccaria. This is exactly what I believe went through the judge's mind during sentencing. I believe the judge ordered a just punishment that fit the crime, better served society, and deterred others as well as the criminal. The criminal justice system worked from the beginning to the end of the case thanks to the dedicated men and women in the federal system with strong support from my security staff. We owe Cesare Beccaria, the father of modern criminal law and criminology, for taking us out of the era of torture and revenge. I have great respect for the present system (though it is not perfect) of criminal law and our humane judicial guidelines to deter crime and the criminal.

When we first observed the condition of the perfume sprinkler, we suspected it was an act of vandalism. We later found out through our investigation that it was in fact a theft. Throughout my years at the Met, most intentional vandalism has been minor: a pencil mark on a sculpture, gum put on a pedestal, or small scratches on a painting. These kinds of incidents have been easily repaired by the great work of the unsung heroes of the Met. These essential employees are the conservators in the conservation departments of paintings, objects, paper, and textiles. The conservators in these departments bring art objects back to life after they are damaged accidentally or intentionally. The primary concern with major damage was accidental damage caused by a visitor tripping into a work or, as we have seen, from weather like hurricanes. The most important security system that has been developed and put in place to prevent and deter not only theft but also intentional vandalism has been the Met's sophisticated CCTV recording video systems. This system has been invaluable in distinguishing between intentional or accidental vandalism. In the area of internal accidents, we have used the system to piece

together the cause and time an event took place to help determine exactly what might have happened.

There were two memorable accidental incidents involving artwork that I investigated. Both of these investigations demonstrate the dedication of museum professionals in responding, understanding, repairing the damage, and recommending programs to correct the underlying problem. Make no mistake about it. All art museums have experienced accidental damage to artwork in their custodianship. Mistakes are made and it is the museum's job from the director on down to identify the reason for the accident and correct it.

In 1983, after years of negotiations with the Vatican and the Vatican Museum, an exhibition of artwork from the Vatican Museum collection would tour the United States. Entitled *The Vatican Collections: The Papacy and Art*, the exhibition of 237 objects was to travel to the States to be displayed in three museums, the Met and two other museums chosen by the Met because of their locations: one in the Midwest, the Art Institute of Chicago, and one on the West Coast, the De Young Museum in San Francisco. The Met organized, coordinated, oversaw, and negotiated with the Vatican which art objects would be included. The Met was basically the Vatican's agent with respect to the exhibition. In 1979, Philippe and his staff traveled to Rome with his wish list to begin the tough negotiations with the Vatican Museum. Every object in the exhibition had to answer two questions: Which Pope collected it? And why? Many objects were not coming to the United States because they could not pass the two-question test. Other objects like Raphael's altar piece *Madonna of Foligno* were deemed too fragile to travel. A major object, a headless Greek sculpture from the first century BC known as the Chiaramonti Niobid, failed to satisfy the criteria of the exhibition. "We didn't know what it meant to the popes," remarked Dr. Georg Daltrop, the Vatican curator of classical antiquities. Masterpieces in the exhibition included paintings

such as Leonardo da Vinci's *St. Jerome*, Caravaggio's *Entombment*, and Veronese's *St. Helen*.

All those involved in the selection process felt that an object like the Apollo Belvedere was so celebrated, so symbolic of the Vatican collections, that an exhibition that did not have it would be incomplete. This was a must-have piece. At first, the Vatican said no. After some serious back and forth and a clause in the contract that the Met would fund the restoration facilities of the Vatican conservation studio, the Vatican agreed to lend the Greek god Apollo to the exhibition. It became a signature piece of the show. The ultimate praise was expressed by Johann Joachim Winckelmann (1717–1768). The famous German art historian and archaeologist said, "The statue of Apollo is the highest ideal of art among all the works of antiquity to have survived destruction."

The Apollo Belvedere is a 7'3" white marble sculpture of a second-century copy of a famous bronze by the Greek artist Leochares. It was considered the Vatican Museum's first acquisition. The statue was brought to the Belvedere Courtyard in 1503 by Pope Julius II. It remained at the Vatican until 1789. That is when Napoleon on his Italian campaign confiscated artworks from the Vatican and brought them back to the Louvre. After the fall of Napoleon in 1815, the Apollo was repatriated to the Vatican, where it has remained ever since. In 1983, it was on its way to the United States and the Met.

The Apollo Belvedere had a long history of restoration that dated back centuries. In 1981, the Apollo Belvedere lay in thirteen different pieces on the workshop floor of the Vatican's chief marble restorer, Ulderico Grispigni. He was a master marble restorer who brought back to life Michelangelo Buonarroti's *Pieta* after the face of the Madonna was attacked in 1972 by a deranged individual wielding a hammer. Grispigni had his work cut out for him with the Apollo's restoration. He removed old rusted iron dowels holding the sculpture together and replaced them with stainless

steel screw dowels. He was also able to remove it from the wall where it was fastened for hundreds of years. Now it could stand upright on its own feet, so to say. His work was reviewed with one word, "Spectacular."

Two years later, it was traveling to New York City on a Pan Am 747 for 896,000 visitors to see. Another showstopper that was traveling to New York City on another 747 was the Augustus of Prima Porta, a magnificent marble sculpture slightly larger than life (86¼" in height), among the most important sculptures of the Roman Period of the first emperor, Augustus Caesar. Sculptured in the first century AD, it was discovered on April 20, 1863, in the Villa of Livia at Prima Porta, near Rome. It was in superb condition and only needed minimal restoration to the left forefinger and the fingers of the right hand. The carrying crate for the Augustus Prima Porta sculpture measured some 13'H x 7'W x 6'D. The crate was specially constructed to protect the sculpture from sudden impact. It was designed like a Russian nesting doll, a crate within a crate within a crate, with foam material between each crate to lessen any potential damage. The crate was taken to the airport in Italy on a flatbed truck under police escort and loaded on the Pan Am 747 cargo plane. When the crate arrived at JFK, it was unloaded on the tarmac and transported to a flatbed trailer for its forty-five-minute trip under police escort to the Met. Jack Maloney was in the cab of the flatbed and riding shotgun on this trip.

Jack called me to say they were leaving the airport. The plan was to have the crate carrying Augustus arrive at the museum's service garage where we would take possession of it on our loading dock. Museum staff would then remove the sculpture from the crate and transport it up to the gallery on the second floor. We called this gallery space "the airplane hangar" because of its twenty-two-foot ceilings. It was ideal for displaying large sculptures like Augustus. Ninety-nine percent of the art that comes into and out of the Met comes through the North Garage loading docks. A few exceptions

Augustus Prima Porta sculpture, Vatican exhibition at the Met, 1983. THE MET-
ROPOLITAN MUSEUM OF ART

are made because the objects are oversized and are unable to navigate through the labyrinth of passageways on the ground floor. Over the years, for example, oversized tapestries had to be carried up the main stairs and through the main entrance. Some large art objects exhibited on the roof garden were so big they had to be lifted onto the roof by a crane positioned in Central Park. In 1982, one of the most memorable and greatest works of art that was brought to the Met had to enter up the main steps without its crate because of its size (14.5' x 13.5'). This was the only and easiest way to get Cimabue's Crucifix into the Met and the Medieval Sculpture Hall, where it was exhibited for approximately two months from September 6 to November 11. The Cimabue Crucifix (c. 1265) took its name from the Florentine artist. The work is important in the history of art because it is one of the first Italian works of art to break from the medieval Byzantium style and it led the way to the birth of the Italian Renaissance.

So, who had the responsibility to decide where, when, and how to move large priceless art objects in and out of the Met? His name was Franz Schmidt. I say *was* because Franz retired some years ago after a Met career that spanned over forty years. Franz was a master rigger who headed up a famous team of riggers who were together responsible for the movement of large and oversized works to their final gallery destination. Franz immigrated to the United States from Germany in the early 1960s, and within a few years was a member of the museum's maintenance team. He was a licensed electrician who held the Met's electrical license. Later in his career, he was promoted to building manager in charge of all aspects of building maintenance. But the one of his many talents that was most important to the Met was his ability to size up a work of art no matter how big and move it to its display point.

After the Monsignor's call from the airport, I made my way down to the North Garage to ensure that all our security protocols were in place and that the loading dock was clear to accept the

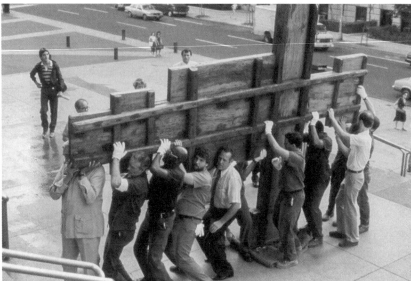

The Cimabue Crucifix being carried into Met up the front steps, 1982. THE
METROPOLITAN MUSEUM OF ART

flatbed trailer carrying Augustus. As I arrived at the North Garage, I received a thumbs up from the armed special officers who were manning the sentry booth that controlled the garage entrance. The loading dock bays were clear. I proceeded to walk up the ramp to Fifth Avenue to meet the truck at the entrance. About fifteen minutes later, I saw the flatbed coming down Fifth Avenue with the NYPD police escort in front of and behind the truck. The crate was in the middle of the flatbed covered with canvas. All traffic was stopped as the truck made a right turn off of Fifth Avenue. I proceeded to walk down the ramp ahead of the truck so I could be at the loading dock when it pulled in. Registrar personnel who were in the convoy left their vehicles and proceeded to walk behind me. About halfway down the ramp, I turned and saw that the truck had picked up speed and was going much too fast. I turned to Herb from the Registrar's Office and said, "What is he doing??" We both put our hands up to slow him down but it was too late. Seconds later, we heard a loud crash. I ran into the garage and what I saw gave me that sick feeling like I got punched in the stomach. *Holy shit.* The top of the crate had hit a concrete support beam and had splintered into pieces as the truck came to a halt. There were pieces of wood board all over the garage floor. As I looked at the crate, I could see that its top had been flattened. I had no doubt that Augustus sustained some serious damage. I turned and looked up on the loading dock, and standing there with a look of horror on their faces were a who's who of the museum world. There were officials and curators from the Vatican, curators from the Met, and my immediate concern, the vice president of operations, Dick Morsches, my boss. I focused on Dick's face, and he was visibly stunned and shaken.

I turned my attention back to the truck. The passenger's side door opened and Jack jumped out. The Monsignor was possessed. Jack ran over to the driver's side, opened the door, and pulled the

driver out. He went for his gun and said, "I am going to shoot you, you son of a bitch." I grabbed Jack and told him to calm down. It was really a dramatic and terrible moment. After that, my first call was to Franz Schmidt. We needed Franz to get his team to figure out the best and safest way to take this puzzle apart without causing further damage to the sculpture. The other key person we needed on the scene was Ulderico Grispigni, the Vatican's master marble conservator. He was key because he knew the precise locations of the restorations, and he also helped oversee the original packing of the sculpture in Italy. Fortunately, if you will, he was one of the Vatican staff members who was on the loading dock and he witnessed the horrible accident. Franz and the riggers were there in what seemed like minutes. Franz and Grispigni assessed the situation. The rigging team powered up a forklift and brought equipment, straps, crowbars, moving blankets, pulleys, and all available maintenance manpower. The garage was closed down as the tedious work began.

The first challenge was to take the crate apart piece by piece without disturbing the sculpture. It was important to uncover the sculpture to assess the damage. Grispigni was concerned with Augustus's legs. It was standing upright in the crate. He felt that if there was any damage, it would be at the legs. After some three to four hours taking the wooden case apart, the sculpture was almost totally uncovered. Remember, there were three cases constructed one within another. I watched Grispigni, flashlight in hand, start his inspection. Everyone waited in suspense for his verdict. After what seemed like an hour, Grispigni gave a thumbs up and said, "*Molto bene.*" Very good. No damage. The legs and the rest of Augustus were in perfect condition. The unbelievable had just occurred before my eyes. After seeing what happened to that crate and the condition it was in after it hit the garage ceiling, if anyone told me that there was no damage, I would have told them they

were nuts. I believe the popes past had intervened to protect the Augustus. This was a case of divine intervention. The exhibition went on with one of the stars of the show and no one the wiser.

On the evening of October 6, 2002, there was another accident involving a marble sculpture. But this time, it was devastating and it wasn't anyone's fault. The "victim," if you will, was an Italian Renaissance marble sculpture that was part of the Met's permanent collection. The sculpture:

> *"Adam" Italian, Venice*
> *Date: 1490–1495*
> *Sculptor: Tullio Lombardo (Italian, 1455–1532)*
> *Medium: Marble*
> *Dimensions: 6'3½", 770 lbs.*
> *The Metropolitan Museum of Art, New York, Fletcher Fund, 1936*
> *Accession #36.163*

The renaissance sculptor Tullio Lombardo carved the museum's "Adam" for the tomb of Andrea Vendramin, Doge of Venice, in the early 1490s. In 1821, "Adam" was taken from the tomb and brought to Vendramin's Calergi palace. In 1844, the duchess of Berry bought the palace and its contents. Around 1931, the Parisian banker Henry Pereire acquired it. His widow sold the sculpture to an art dealer in 1935. A year later, the Met purchased it for its permanent collection, where it was exhibited until the accident.

At 9:20 p.m., after the museum was closed and cleared of public visitors, a night division security officer was making his scheduled rounds. He entered the Vélez Blanco Patio (gallery 534) off the Main Hall and observed an almost unbelievable scene. The Renaissance sculpture of "Adam" was scattered across the floor in

Sculpture of "Adam." Badly damaged in 2002, and magnificently restored twelve years later by the Met's Objects Conservation Department. THE METRO-POLITAN MUSEUM OF ART

numerous large and small fragments. The security officer immediately notified the command center. He was instructed to secure the gallery and make sure no one had access. Notifications were made to Assistant Security Manager Louis Vallejo, the manager on duty that evening. He immediately responded and secured the scene. The next notification was to the Curatorial Response Team (CRT). Curators from European Sculpture and Decorative Arts (ESDA) and conservators specializing in stone sculpture responded to the scene. I was told as well, and I started the chain of notifications to the Met's administration, specifically the director and president. Jack Soultanian, the Met's conservator and expert on stone sculptures, took charge of the accident scene. He treated it as if it was a crime scene, meticulously documenting every fragment and mapping them on a diagram grid. What Jack began that night was the beginning of a twelve-year restoration project to bring "Adam" back to life.

My job was to determine the cause of the accident to ensure something like that could be avoided in the future. After an extensive investigation that included numerous interviews, review of video recordings, and the examination of the construction of the pedestal on top of which "Adam" was displayed, the conclusion was that the sculpture fell onto the marble floor in the Vélez Blanco Patio at 5:59 p.m. after the museum was closed to the visiting public. We determined this by our review of the video recording of the adjacent areas. No one entered the patio area between 5:17 p.m. and 9:20 p.m. when the security officer discovered the damage, thus eliminating the theory that it was accidentally or purposely pushed over. We concluded that the damage to "Adam" was completely accidental and did not involve any human interaction. Eventually, over a period of time, the pedestal most likely fatigued and gave out under the sculpture's weight. The cause established, the museum formed a task force of curators, conservators, museum maintenance

professionals, and engineers to review all artwork on pedestals to ensure the integrity and proper construction of their pedestals.

The much bigger challenge was to restore the sculpture so it could be displayed again. This monumental challenge (no pun intended) was put before those unsung men and women in the Objects Conservation Department. If you could only imagine a marble sculpture in twenty-eight large pieces and numerous little pieces spread all over the floor, you might have concluded that this was not a challenge but an impossibility. No way could this Renaissance masterpiece be brought back to life. I have worked with conservators in objects, paintings, paper, and textile over the years, and I've been astounded with each and every conservator's ability, talent, and dedication to restoring works of art. They are all truly amazing individuals and dedicated professionals.

The Metropolitan is known to have the top curatorial, conservation, and scientific staffs in the museum world. To perform the daunting task of restoring "Adam," the museum, and specifically the Objects Conservation Department, brought together an elite team from within and outside the museum. This team consisted of skilled and dedicated conservators, scientists, engineers, and imaging experts who together would perform a miracle in restoration that took over a dozen years. The work of all these professionals— their analysis, testing, and treatment—have yielded a beautifully restored statue. And their work has transformed and developed new methods to be utilized for future restorations.

On November 11, 2014, "Adam" was returned to a gallery on the first floor (#504). At the time of the installation, Director Campbell said, "We are proud to return this great Tullio sculpture to the public in a beautiful new gallery. Our extraordinary conservators collaborated with a team of experts over twelve years to pursue this challenging work. The result of their care and innovation are stunning."

What will the future bring? I have learned that the future will bring some type of crisis—it is just a fact of life. These events will be major and minor: major in the form of art theft, accidental damage to works of art, medical emergencies, or weather-related problems. Crises are typically unpredictable. Just look at what happened to the National Museum in Brazil on Sunday September 2, 2018. The two-hundred-year-old museum, the oldest in Brazil, was destroyed by fire. In this instance, you could say it was predictable. It housed the country's most important natural history artifacts. The fire destroyed 90 percent of the collection, which included twenty million artifacts from Egyptian, ethnological, archaeological, paleontological, geological, and zoological departments. The museum suffered from years of neglect and lacked an overall fire program including a suppression system.

Fire programs must include three elements: prevention, detection, and suppression. These elements should be of the highest priorities at all museums, libraries, and historical landmarks. Prevention must include inspections by local fire department officials to identify vulnerabilities, such as storage, laboratory, and high-risk areas (workshops), and training programs for staff and security personnel in fire-prevention programs including fire extinguisher training and housekeeping. Detection involves early-warning devices such as smoke detectors monitored by a command center and/or the fire department. Suppression requires the installation of a well-maintained wet pipe sprinkler system throughout the facility. These systems are the last line of defense and will put fires out. For years, museum officials were reluctant to install sprinkler systems because of fears of water damage. In 1987, I started a campaign with my colleagues in the fire science arena to change the thinking of museum officials by explaining that sprinkler systems were reliable and water damage was less serious than a devastating fire. It took years of convincing and devastating fires at institutions

without fire-suppression (sprinkler) systems. Specifically, museum officials could not ignore the 1988 destruction of the National Academy of Science Library founded by Peter the Great in 1714 in St. Petersburg, Russia, and the fire that destroyed the Los Angeles Central Library in 1986. Beginning in 2000, the Met took the lead in the museum world and began a program of installing wet pipe sprinkler systems throughout the facility.

The first key is to prevent incidences from occurring and learn from uncontrollable incidents and mistakes. The second key is to be prepared, react, and respond to crises with all the resources and programs that have been put in place. As I have outlined, the Met over the years has learned from its mistakes, used its resources, and developed, instituted, and maintained its security and safety programs. The Met is in a good position to prevent and respond to major and minor crises. There is always work to be done. Institutions like the Met have to continue to use research and development to keep up with advances in the security and safety fields. We can always improve in areas such as security technology systems and the increased use of CCTV recording systems, cybersecurity, investigative techniques, training programs, recruiting personnel, fire prevention/detection/suppression, and forming security programs to prevent and respond to the ever-changing criminal elements, art theft, terrorism, and workplace violence.

EPILOGUE

IT WAS AN EDUCATION IN THE ART WORLD, A PLEASURE, AND AN honor to have had a long career at one of the world's finest institutions. I was not only a member of a great staff of professionals, but it was also an awesome responsibility to be in charge of the protection and safety of an art collection that spanned all the fine art produced in mankind's history. I often had comments conveyed to me by visitors, friends, dignitaries, and professional colleagues that I held one of the most important positions in New York City.

The position of chief security officer at the Metropolitan Museum of Art is all encompassing, challenging, stressful, and at times downright rewarding. At an art museum like the Met, security is included in all aspects of the institution: art exhibitions, special events, budget and strategic planning, security and safety programs to protect the permanent art collection, staff, visitors, and the facilities. It was always challenging to develop, implement, and sustain various security and safety programs such as recruiting and training, the latest state-of-the-art technological advances, investigative techniques, liaison with outside law enforcement agencies both domestic and international, and preventive and innovative programs adapting to problems that arise (such as crowd control at the McQueen exhibition). It was stressful being at the center of all types of investigations including the recovery of stolen art, personnel and workplace problems, union issues (close to one thousand employees at the Met including security, building maintenance, and art technicians are members

of the city municipal union DC 37 local 1503), medical emergencies that occur involving staff and visitors to the museum, serious weather conditions like Hurricanes Irene and Sandy, and heads of state, dignitary, and celebrity visits. And it was rewarding to develop lasting programs that carry out the mission of the Security Department, that of the protection and safety of the art collections, staff, visitors, and facilities. I have been honored to serve under two directors, five presidents, and three vice presidents.

Directors:

Philippe de Montebello (1977–2008)

Thomas P. Campbell (2008–2017)

Presidents:

William B. Macomber Jr. (1978–1986)

William Luers (1986–1999)

David E. McKinney (1999–2005)

Emily K. Rafferty (2005–2015)

Daniel Weiss (2015–Present)

Vice Presidents of Facilities and Construction:

Richard Morsches (1964–2001)

Philip Venturino (2001–2009)

Thomas Javits (2009–Present)

I am most proud of the professional and diverse security staff that was developed under my leadership. This includes security

training programs, technological advances, strategic planning, and investigative techniques that were instituted by me and my management team. The success of these programs was initiated, developed, implemented, and maintained by hard work, dedication, professionalism, teamwork, and leadership. Without the support of the administration and trustees of the museum, none of these programs would have been possible. Museum resources were budgeted to ensure that the Security Department of the 1970s, 1980s, and 1990s was transformed in the new millennium into a professional department that was well managed and equipped to protect its art collection.

In the area of art theft and art theft investigations, I conducted field research to observe and study art thieves and art theft cases. This study, experience, and understanding has assisted the Security Department at the Met in developing security programs to prevent theft by lessening the opportunity. The key word is *lessen*, not *eliminate*. You can never totally eliminate opportunity. When an opportunist sees an opening and takes it, an art theft can occur. That is when that empty feeling will go through your body down into your stomach. It's the time to regroup and go from defense to offense. Using all your knowledge, read the crime scene, view the video, interview witnesses, determine what type and size of art was stolen, identify and notify the art markets where objects could be sold, if necessary utilize the press and media to advertise the theft, identify the thief as an insider, outsider, or professional opportunist, and most importantly utilize the liaisons that have been developed with the FBI Art Crime Team (Act), NYPD, and Scotland Yard Art and Antiques Squad.

In my studies, I have tried to develop a profile that can define an art thief. Individuals who steal art are unlike your typical burglar, for example, and have different reasons to steal art. As we have seen, the majority steal art for monetary gains (Egyptian ring, tapestries, Celtic coins and early Christian jewelry, and baseball cards),

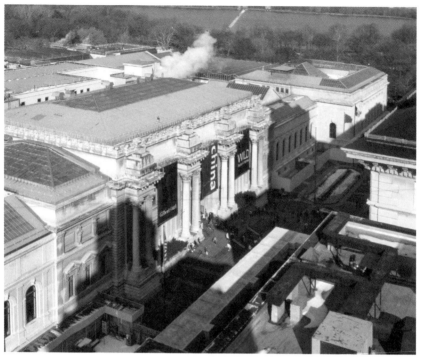

Façade of the Met. THE METROPOLITAN MUSEUM OF ART

but some steal as a prank (Greek head), some steal as a reason to get back or spite (the Arms and Armor partisan), and some steal for reasons we just cannot explain (the Islamic perfume sprinkler lid). What we can conclude is that not only is art theft as diverse as art itself, but the art thief is equally diverse. The common thread in all art thefts is that the thief has been given the opportunity.

Now when I return to the Met as a guest at a reception or just a visitor, I feel a sense of longing for the days when many challenges were directed at me and I had to lead the charge; that will not change. It is hard, but I can at times separate myself from my previous life as a member of the Met's staff so I can enjoy and appreciate the wonderful art objects and the grand architectural settings. I do miss being able to walk through the galleries when no visitors are

present, as I did as a night security manager walking through the Tut exhibition or the American Wing Courtyard at 2:00 a.m. As I walk through the galleries as a visitor today, I am often stopped by a security officer on post who acknowledges me and says very rewarding words, "Hi, sir, great to see you and we really miss you."

Where the security and safety of the museum goes from here and into the future is in other hands. I can say with great confidence it was left in great hands. As the Security Department goes forward, continued recruiting and training of a professional staff and advances in technology will ensure the future of a jewel of New York City, and one of the greatest art museums in the world.

Acknowledgments

First and foremost, I would like to thank my wife, Anna, and sons, Peter and Andrew.

My literary agent Zach Schisgal for his professionalism and writing talents that made my career a story.

The Metropolitan Museum of Art, administration, and all the Met's trustees, Chairmen Arthur Sulzberger, Jamie Houghton, and Dan Brodsky. Trustee Mrs. Florence Irving, who supported the mission of the Met's Security Department and encouraged the writing of this book. Especially Director Philippe de Montebello and President Emily Rafferty. A special thanks to Senior Vice President Harold Holzer, who has assisted and directed me in the writing of this book. Also Director Thomas Campbell. Presidents William Luers, David McKinney, and the current President, Daniel Weiss. Associate Directors Doralynn Pines, Mahrukh Tarapor, and Carrie Rebora Barrett. In the Met's Legal Department Vice Presidents Sharon Cott, Ashton Hawkins, Penelope Bardel, Linden Havemeyer Wise, and Becky Murray. In the President's Office Whitney Donhauser and Missy McHugh. My colleague and friend Chris Giftos, who for years beautified the Met's Main Hall with his flower arrangements. In the Construction and Facilities Department, Richard Morsches, Dan O'Leary, Nancy Staub, Lita Semerad, Linda Syllings, Nicholas Cameron, Franz Schmidt, Thomas Scally, Philip Venturino, and Thomas Javits.

My colleagues in the curatorial departments who I worked with over the years. In AAOA, Alisa LaGamma, Julie Jones, and

197

Douglas Newton. In American Art, Morrison Heckscher, Sylvia Yount, Alice Cooney Frelinghuysen, Thayer Tolles, and Peter Kenny. In Arms and Armor, Stuart Pyhrr, Pierre Terjanian, Donald LaRocca, Helmut Nickel, and Hermes Knauer. In Asian Art, Maxwell Hern, James Watt, and Judith Smith. In the Costume Institute, Andrew Bolton and Harold Koda. In Egyptian Art, Diana Craig Patch, Dorothea Arnold, Christine Lilyquist, Marsha Hill, and Catherine Roehrig.In Prints and Drawings, George Goldner, Carmen Bambach, and David del Gaizo. In European Paintings, Keith Christiansen, Everett Fahy, Charles Moffett, Katherine Baetjer, Andre Bayer, Susan Stein, and Dorothy Kellet. In ESDA, Ian Wardropper, James Draper, Clare Vincent, and Wolfram Koeppe. In Greek and Roman Art, Joan Mertens and Maxwell Anderson.In Islamic Art, Sheila Canby, Navina Haidar, and Marilyn Jenkins. In the Robert Lehman Collection, Laurence Kanter and Dita Amory. In Medieval Art and the Cloisters, Griffith Mann, Peter Barnet, Barbara Boehm, Helen Evans, Chuck Little, and Thomas Vinton. In Modern Art, William Lieberman and Kay Bearman.In Musical Instruments, Kenneth Moore. In Photographs, Jeff Rosenheim. In the Thomas Watson Library, Kenneth Soehner.

Special thanks to Barbara Bridges in the Met's photo studio.

The unsung heroes in the conservation departments who bring back the life in art objects. In Objects Conservation, James Franz, Lisa Pilosi, Jack Soultanian, Carolyn Riccardelli, Pete Dandridge, and George Wheeler. In Painting Conservation, Michael Gallagher, Hubert von Sonnenberg, Dorothy Mahon, George Bisacca, and Charlotte Hale.

To my security management team, Ed Devlin, Jose Rivero, Mario Piccolino, Sean Simpson, John Packert, David Canu, Amies Vasquez, Ana Tolentino, Leslye Saenz, Olivia Boudet, Lambert Fernando, Sean Begley, Theo Kypriotis, William Neckar, and Anthony Camarda, and all the security personnel past and present,

thank you for your professionalism and dedication to our department and the museum.

To all my colleagues in law enforcement, domestic and international, thanks for your support. Especially NYPD Deputy Commissioner John Miller. With the NYPD, Kevin O'Conner, Kevin Hallinan, Thomas Hallinan, and Dan Mullin. In the FBI, James Kallstrom, John O'Neill, Margot Dennedy, Cathey Bagley, Dan McCaffrey, James Wynn, Ed Petersen, Thomas Ruocco, Rodney Davis, Ed Kelly, Tim Rembijas, and Adam Roeser. At Scotland Yard, Peter Flaherty, Mickey Banks, Colin Bunnett, David Powis, Peter Taylor, Claire Hutcheon, and Ray Swan.

Thanks to all at Rowman & Littlefield, Globe Pequot, and Lyons Press, especially Rick Rinehart, Alex Bordelon, Neil Cotterill, and Jessica Kastner.

Thanks to my good friends Larry Potts and especially Ron Smith and Joaquin Jocko Garcia who supported and guided me in the publishing process.

And finally, to all the members of the security management team that proceeded me Allen Gore, Joseph Volpato, Edward Ryan, Jack Maloney, Louis Vallejo, Richard Covello, Jim Perry, and Pierce McManus.

Bibliography

INTRODUCTION

Booklet, Thomas and Dorothy. "The Crimes of Paris." Bison Books. Nebraska. 2010.

Interview with a professional thief, Adam Page, in Blundeston Prison, Lowestoft, England. 1984.

The Metropolitan Museum of Art Facilities and Construction Department.

The Metropolitan Museum of Art Annual Report 2016.

The Metropolitan Museum of Art Digital Media.

The Metropolitan Museum of Art Security Department.

CHAPTER 1

Hennessy, Sir John Pope. "Cellini." Abbeville Press. New York. 1985.

Symonds, John A., trans. "The Autobiography of Benvenuto Cellini." Doubleday & Company, Inc. New York. 1946.

"Treasures of Tutankhamen." The Metropolitan Museum of Art exhibition catalog. 1976.

Cater, Howard, and Mace, A. C. "The Tomb of Tut.Ankh.Amen." George H. Doran Company. New York. Volume 1. 1923.

"The Salt Cellar of Benvenuto Cellini." Herausgher, Kunsthistorisches Museum, wizen. 2006.

"Thieves Take Cellini Sculpture from Art Museum in Vienna." By Mark Sandler. *New York Times*. May 13, 2003.

"Theft of the Cellini Salt Cellar." By Richard Bernstein. *New York Times*. January 25, 2006.

"$150,000 Art Theft Is Reported by the Met." By Pranay Gupta. *New York Times*. February 11, 1979.

"Met's Missing Bust Turns Up." By Sam Rosensohn. *New York Post*. February 15, 1979.

The Metropolitan Museum of Art. Greek head theft. Participant investigator, police reports (public record). February 9 through February 14, 1979.

Conversation with Joan Mertens, curator, Greek and Roman Department at the Metropolitan Museum of Art. 2017.

CHAPTER 2

Reeves, Nicholas, and Wilkinson, Richard. "The Complete Valley of the Kings. Tombs and Treasures of Egypt's Greatest Pharos." Thames & Hudson. London. 1996. Pp. 164–165.

Temple of Dendur, the Metropolitan Museum of Art. 2016 publication.

"Reflection of Ramesses VI." *Journal of Egyptian Archeology*. Vol. 71, pp. 66–70. 1985.

"Three Held in Theft of Gold Ring from the Met." *New York Times*. February 16, 1980.

The Metropolitan Museum of Art. Theft of the Ramesses VI gold ring. Police reports, court documents (public records). Participant investigator. February 1980.

Conversation and correspondence with retired Met Egyptian curator Christine Lilyquist. 2018.

The Metropolitan Museum of Art. Theft of two Degas sculptures. *New York Times*. February 6, 1980.

The Metropolitan Museum of Art. Recovery of Degas sculptures. *New York Times*. February 10, 1980.

The Metropolitan Museum of Art. Degas sculptures theft investigation. Participant lead investigator. 1980.

The Metropolitan Museum of Art. Partisan blade theft investigation. Participant investigator. Police reports (public records). December 1980.

CHAPTER 3

The Metropolitan Museum of Art. Medieval Art theft of two Celtic gold coins, two gold dress fasteners, two gold pins, and one bronze brooch. NYPD police reports, New York City court documents (public records). Participant investigator. 1980.

The Metropolitan Museum of Art. Recent acquisitions publication. 1986–87. Pp. 20–21.

"Police Trace Pistols to Royal Owner, Catherine the Great." By Barbara Basler. *New York Times*. March 18,1982.

CHAPTER 4

Barelli, John. "On Understanding the Business of Art and Antique Theft: An Exploratory Study." Fordham University, New York. PhD dissertation.1985.

Wyler, Seymour, B. "The Book of Old Silver English, American, and Foreign." Crown Publishers, Inc. New York. 1937.

Participant observer at the Bermondsey Market. Arrest and recovery of English silver. May 1982.

Interview with John Randolph, a professional thief. Bristol, England. 1984.

Experience in England with the Scotland Yard Art and Antiques Squad, field research, participant observation, and data gathering. 1982, 1984, 1988, 1992, 2013, 2015.

CHAPTER 5

Standen, Edith. "For Ministers or King: Two 17th Century, Gobelins Tapestries after Charles Le Brun." The Metropolitan Museum of Art, bulletin, volume 34/1999, pp. 125–134.

"2 Tapestries Taken by Burglars." *New York Times*, the City Section. June 24, 1982.

Theft of two Gobelins tapestries from the New York University, Fine Arts Institute, on loan from the Metropolitan Museum of Art. Participant investigator, police report (public records), recovery reports from Scotland Yards Art and Antiques Squad. June 1982 and 1994.

Conversations with Thomas Campbell, former director of the Metropolitan Museum of Art. 2018.

Conversation with retired Scotland Yard inspector Charles Hill. 2018.

Correspondence with the Frances Institute, London, England. 2018.

CHAPTER 6

Blanding, Michael. "The Map Thief." Gotham Books, New York. 2014.

The Metropolitan Museum of Art. Baseball card theft. Police reports, NYPD recovery report, assistant district attorney Manhattan reports, (public records). Participant investigator. 1992.

The Metropolitan Museum of Art. Theft of numerous prints. Police reports. 1972.

"Lawyer Arrested in Theft in $10,000 in Art Prints." By Glenn Fowler. *New York Times*. September 7, 1972.

"A Plain Brown Wrapper." By Paul Richard. *Washington Post*. September 26, 1972.

CHAPTER 7

"For Gorbachev Met Museum and Trump Tower Visits Due." *New York Times*. December 1, 1988.

CHAPTER 8

Beccaria, Cesare. "Dei Delitti e Delle Pene" ("On Crime and Punishment"). Published anonymously in 1764.

The Metropolitan Museum of Art. "The Vatican Collections: The Papacy and Art." Harry Abrams, Inc. New York. 1983.

The Metropolitan Museum of Art. Theft of a lid from an Islamic perfume sprinkler. FBI reports, court documents (public records). Participant investigator. 2013.

Banksy investigation. Participant investigator. 2005.

"Hang and Run Artist Strikes NYC Museums." *Art and Life*. March 24, 2005.

"Need Talent to Exhibit in Museums? Not This Prankster." By Randy Kennedy, *New York Times*. March 24, 2005.

INDEX

Note: Page numbers in italics refer to photographs or their captions.